The Art Institute of Chicago

MUSEUM STUDIES

VOLUME 14, NO. 2

The Art Institute of Chicago Museum Studies

Volume 14, No. 2

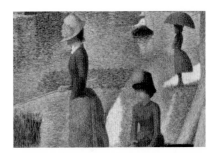

Foreword

Meditating upon the life of a painting once it has entered a museum's collection, the Museum of Modern Art's first director, Alfred H. Barr, Jr., wrote in 1944:

Whether the work of art subsequently lives or dies depends partly on its intrinsic qualities, partly on the attention we are able to give it by our continued interest. Take for example what I suppose to be the most valuable object in the Art Institute of Chicago, Seurat's *Grande Jatte*. It is for some of us one of the great works of European art. It would be absurd to believe that Rich's monograph on the picture has added so greatly to our knowledge and understanding of it that, ten years after its accession, he may be said to have helped renew and enrich its life. One felt that this little book in which he published not only his information but also his enthusiasm was in fact the homage of a scholar for a great work of art.[1]

Entitled *Seurat and the Evolution of "La Grande Jatte,"* this important "little book," perhaps one of the first studies devoted to a single painting, was written in 1935 by Daniel Catton Rich, the Art Institute's distinguished director from 1938 to 1958. In it Rich provided a thorough formal analysis of the picture and its Pointillist technique. Bringing to bear fifty preparatory oil studies and drawings and another twenty-four related works, he described the evolution of the canvas from casual, Impressionistic views done on site to a rigorously structured puzzle of intricately related, purified forms. Dismissing as inadequate and misleading the tendency to relate a work of art to its artist's biography, he saw the art of Seurat as part of the ineluctible march of modern art toward pure abstraction and of the increasing importance placed by modern artists upon process and method. He wrote: "It is time for us to see the work itself, and so in this approach little attempt will be made to relate Seurat to the society in which he lived or to the 'spirit' of his time. The problem is chiefly formal. . . ."[2]

Responding to Rich's book the year it appeared, the noted art historian Meyer Schapiro objected that "Because of his formalist views of Seurat, Mr. Rich has made no effort to grasp the relation of the structure of the painting to its content." He concluded by positing that the "political and social inclinations of Signac and Pissarro [may be important] for the light they may perhaps throw some day on the social factors in the formation of Seurat's great art."[3]

Rich's approach, which we have come to call modernist and which predominated in the literature on Seurat for many decades after his book, has come to be challenged and, to a great degree, replaced in recent years by a way of thinking that is closer to Schapiro's. Recent studies of the art of Seurat take into account the social, political, and economical forces operating in the period in which his work was produced. Today, a work of art is understood to be a very complex set of signals and meanings, sometimes contradictory and always relative, embedded in the object not only at the moment of its creation (and then not always consciously by its creator) but also by its subsequent life and by what we bring to it from other times and places.

A work of art such as the *Grande Jatte*, which has absorbed the attention and confounded the interpretations of several generations since its creation nearly 103 years ago, can be seen then as a kind of palimpsest, continually layered with

new meanings and with the traces of myths that have been stripped away. It is for this reason that we have selected as our cover image for this issue, which is dedicated to the painting, not a reproduction of the picture itself but of a later work by Seurat, *The Models* (1888; see also pl. 5), in which the *Grande Jatte* has become a picture within a picture, the artist re-creating it himself. (This painting also shows the simple white molding that the artist chose to frame his experimental picture; it was reframed according to this model in 1982).

This special issue of *The Art Institute of Chicago Museum Studies* reflects the celebration the Art Institute staged in honor of the painting's centenary anniversary. With the generous support of the Fry Foundation, a symposium was organized by Richard R. Brettell, then Searle Curator of European Painting, entitled "Seurat and *La Grande Jatte*: The New Scholarship," held on May 15–16, 1987. Included here are several articles that evolved from lectures given at that two-day event. John House, S. Hollis Clayson, and Richard Thomson have studied the literature, criticism, popular imagery, and pictorial traditions of the period in order to suggest ways in which the painting embodies the social, class, and familial tensions of the newly developing urban world. Michael Zimmermann's paper offers new insights into the theoretical basis for much of Seurat's thinking about his art. The Fry Foundation also contributed funds that help make possible the publication here of several additional papers not read at the symposium. Stephen F. Eisenman takes up Schapiro's challenge to define the radical political meanings of the *Grande Jatte*. Linda Nochlin's article was delivered in October 1988 as the first presentation in a lecture series for the School of the Art Institute in memory of art-history instructor Norma U. Lifton, who died in January 1988. (We hope that this annual lecture series, by distinguished art historians, will produce future articles for this journal on aspects of the Art Institute's collections.) Nochlin demonstrates the ways in which Seurat subverted visual traditions to explore the inequities and oppressiveness of an increasingly consumerist culture. Conservation Scientist Inge Fiedler explains a number of fascinating discoveries about Seurat's method and the problems of pigment deterioration plaguing the *Grande Jatte*. The Art Institute's conservation staff made these discoveries when the painting was removed from view and unglazed at the time of its reframing. Finally we have included two responses to the papers presented at the symposium. Mary Gedo argues against dismissing the biography and psychology of the artist, and offers evidence that questions the emphasis being placed on sociological and political interpretation. John Russell, who authored a concise, elegant, and incisive book on Seurat in 1965, recalls in an afterword his experiences of earlier Seurat scholars and ruminates on the continuing ability of this masterpiece to elude categorization and definition. The issue concludes with a history of the *Grande Jatte*'s provenance and exhibitions, and a selected bibliography.

Many people helped with this ambitious undertaking. I would like to thank Margherita Andreotti, Betty Binns, Rachel Dressler, Gloria Groom, Katherine Houck, Robert B. Lifton, Cris Ligenza, Terry Ann R. Neff, Elizabeth Pratt, Robert Sharp, Susan Snodgrass, and Barry Swenson for the enthusiasm they brought to the project and the effort they expended to see it realized.

SUSAN F. ROSSEN
Editor of *Museum Studies*

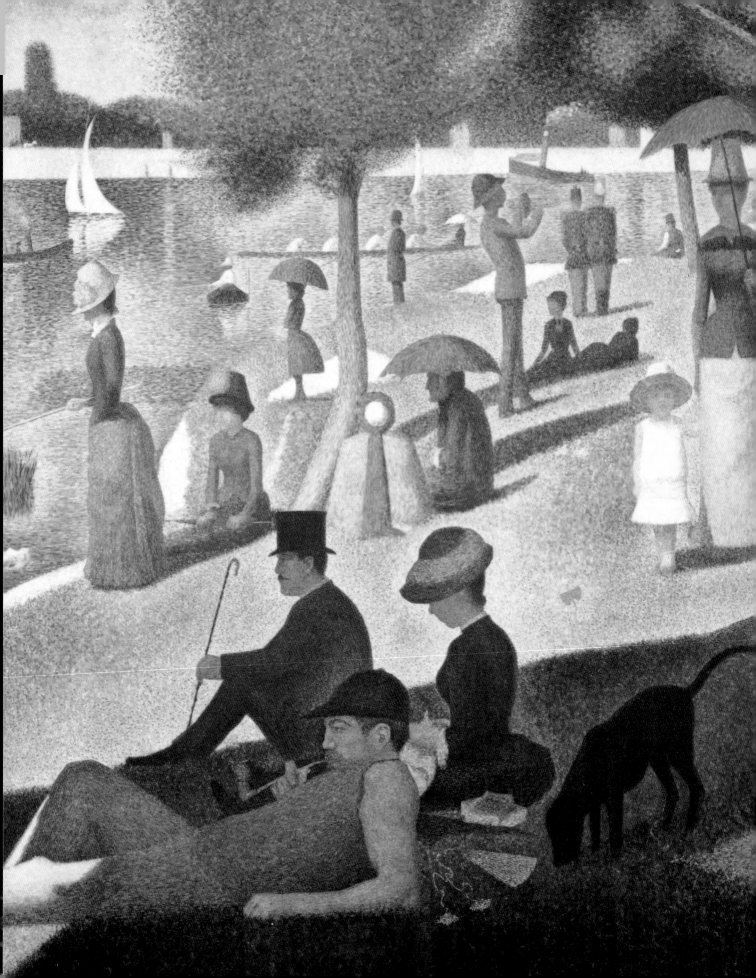

Reading the *Grande Jatte*

JOHN HOUSE, *Courtauld Institute of Art*

ON October 9, 1894, Paul Signac wrote in his journal:

The question of literature in art is such an idiocy! What the "advanced critics" in the epoch of naturalism most admired in the *Grande Jatte* was the woman on the right, walking with a young man and a monkey; they admired her "brazen air of a woman who can't be duped by anyone." Nowadays, the young Symbolists like the picture for the "stiffness of its figures whom one would say were descended from an Egyptian bas-relief or a fresco by Benozzo Gozzoli." None of the critics of 1886 or 1894 saw in it the superb, purely *painterly* qualities of poor Seurat.[1]

Signac presented here three distinct readings of Georges Seurat's *Sunday Afternoon on the Island of the Grande Jatte* (pl. 2): in contrast to the "Symbolist" interpretation that had replaced the "naturalist" one, he proposed a "painterly" *Grande Jatte* to supplant the other two as the correct reading. We will consider here all three of these interpretations: the naturalist one, concerned with the painting's subject; the Symbolist one, concerned

with the stylization of its forms; and the painterly (or, as we would now say, modernist) one, concerned with texture and color on its two-dimensional surface. Signac returned to the question of rival interpretations of the picture forty years later, in 1935, in an essay in the *Encyclopédie française*; he added to his 1894 comments and, in one important way, modified them:

When Seurat exhibited his manifesto painting *A Sunday on the Grande Jatte* in 1886, the two schools that were then dominant, the naturalist and the symbolist, judged it according to their own tendencies. J. K. Huysmans, Paul Alexis, and Robert Caze saw in it a Sunday spree of drapers' assistants, apprentice *charcutiers*, and women in search of adventure, while Paul Adam admired the pharaonic procession of its stiff figures, and the Hellenist [Jean] Moréas saw panathenaic processions in it. But Seurat was simply seeking a luminous, cheerful composition, with a balance between verticals and horizontals, and dominantly warm, luminous colors with the most luminous white at the center. Only the infallible Félix Fénéon appropriately studied the technical contribution of the painting. Seurat's interest in the subject was so slight that he told his friends: "I could equally have painted, in a different harmony, the combat between the Horatii and Curiatii." He had chosen a naturalist subject in order to tease the Impressionists, all of whose pictures he proposed to redo, in his own manner.[2]

FIGURE 1. Georges Seurat (French, 1859–1891). *Sunday Afternoon on the Island of the Grande Jatte* (detail of pl. 2).

Again Signac was quite emphatic that the technique-oriented reading of the painting was the correct one, and he cited Seurat himself in support of this view, even though Seurat's comments, remembered fifty years after he had made them, raise as many problems as they solve. The interesting change in Signac's remarks in 1935 is that he presented the three approaches to the *Grande Jatte* as coexisting at the time of the picture's original exhibition in 1886, rather than succeeding one another. But he still saw the three as mutually exclusive.

In fact, at the time of the painting's first showing, several critics combined all three readings. Among them was Fénéon, the pioneer of the technical/modernist reading that Signac championed. In addition to his extended discussions of technique, Fénéon briefly described both the naturalist subject and its hieratic treatment. And other reviewers, including Adam (Signac's Symbolist), mixed comments on technique with discussions that carefully examine the relationship between the picture's social points of reference and the way in which the figures were presented.[3]

What is the present-day historian to make of these readings? The symposium that gave rise to four of the essays published herein was entitled "Seurat and *La Grande Jatte*: The New Scholarship." But what is new about this scholarship? Put simply, historians have recently become far more attentive to the original contexts of the picture. First, they have investigated the physical context of the island of the Grande Jatte itself, located on the river Seine in the suburbs northwest of Paris. Second, they have tried to define the painting's social context by determining what types of people are represented in it. Third, they have examined its institutional context as a manifesto for an artistic splinter group that was first presented in the independent forum of the final Impressionist group exhibition. And fourth, they have looked at its critical context, at the ways in which painting was received when it was first exhibited.

Few today would endorse the confident verdict of Daniel Catton Rich in his 1935 book on the *Grande Jatte*: "Nature to him merely furnished the data from which to select and invent. . . . As Seurat proceeds, we become more and more aware that the only relationship that interests him is the purely formal one."[4] This unabashed assertion of what we would now call a high modernist viewpoint was published in the same year as Signac's retrospective commentary on the painting, which itself lent authority to a formal reading, but Rich

did not cite Signac's comments. It was in 1935 too that we find the germs of present-day concerns expressed in an essay by Meyer Schapiro in which he insisted on the inseparability of the formal language and arrangement of the picture from its social references. Schapiro reiterated this argument in 1958 in an eloquent passage:

The richness of Seurat lies not only in the variety of forms, but in the unexpected range of qualities and content within the same work: from the articulated and formed to its ground in the relatively homogenous dots; an austere construction, yet so much of nature and human life; the cool observer, occupied with his abstruse problems of art, and the common world of the crowds and amusements of Paris with its whimsical, even comic, elements; the exact mind, fanatic about its methods and theories, and the poetic visionary absorbed in contemplating the mysterious light and shadow of a transfigured domain.[5]

These avenues of thinking have since been developed in Robert Herbert's work on the social iconography of Seurat and Impressionism, alongside his masterly elucidations of Seurat's technique, and, most recently, in studies by T. J. Clark, Richard Thomson, and Martha Ward.[6]

The attention to the picture's original contexts means that one can no longer sustain the traditional modernist or formalist view that the work of art carries an essential meaning or message that transcends not only the moment at which it was executed but also the contexts in which it is seen. Certainly the picture makes an enormous impact on present-day viewers, and the historian's activity does nothing to challenge the validity of these responses in their own terms, responses such as Stephen Sondheim's recent musical *Sunday in the Park with George*. But the range of expectations and presuppositions of viewers today is very different from those of its original viewers in Paris a century ago, and of course no one today has had any direct experience of the social actualities to which the picture relates.

At the same time, the historian cannot ignore the ways in which today's viewpoints affect our reading of the past. This is particularly relevant in discussions of the *Grande Jatte*, because the object itself has irredeemably changed, not so much through the evident discoloration of its pigment,[7] but because it has become a celebrated, canonical museum object at great remove from its origins as an experimental statement in a minority-interest group exhibition. We cannot of course rid ourselves to-

tally of such changes, but we must be alert to the ways in which they inform our approaches to the picture.

The four issues upon which recent discussion of the *Grande Jatte* has focused—the island setting, the people on it, its exhibition, and the critical response to the painting—are concerned with the picture's original contexts in two distinct ways. The first two pass through the image to the notion of a reality behind or beyond it—the geographical site of the island and the social identity of its occupants at a moment in time. The second two remain centrally concerned with the picture itself as a medium and as a focus of debate that generated meanings.

Any viable social history of art has to assign a central role to the frameworks in which meanings are attributed to works of art and the conventions by which particular groups of viewers make sense of them. In particular we must avoid the tendency to juxtapose works of art with ostensibly objective, neutral information about the subject they depict. The non-visual sources we cite in order to document a subject are never objective or neutral. The treatment of the island of the Grande Jatte in a lavish travel book such as Louis Barron's *Environs de Paris* of 1886 is quite different from a Baedeker guide or a simple listing of the facilities and prices in the cafés on the island. Even the driest of statistics are inevitably interpretive, through their selection and presentation. Such material cannot be used as the ultimate yardstick against which to measure Seurat's veracity; yet it is important. Like the picture itself, these other media contributed to the ways in which suburban recreational sites were seen. The viewpoint on these sites was Parisian. Recurring descriptions of the islands in the Seine as a "garden of Eden" or "isle of Cythera" indicate an idealizing, urban attitude that became an important part of a debate in which the *Grande Jatte* and other paintings of suburban Paris figured. As the diversity of the accounts of the Grande Jatte makes clear, its significance was not clear-cut or uniform: Was it an oasis, an idyllic refuge from the city, or rather a seedy resort for day trippers?[8]

A social history of art must keep in view the way pictures are understood in relationship to other paintings or images. A picture creates, rather than reflects, a reality, and the initial terms of reference of this reality involve other visual representations. Specifically the ways in which the themes suggested in the *Grande Jatte* were habitually treated in paintings of contemporary life in the early to mid-1880s allow us to isolate aspects of Seurat's work that would have seemed different and dis-

tinctive, aberrant even, to its first viewers. Many of the picture's themes were common in Salon paintings by the mid-1880s: the world of fashion and the relationship between the sexes; soldiers and men smoking or playing music; women, children, nursemaids, and pets—all depicted out of doors, involved in seasonal or weekend recreations such as taking walks, boating, or fishing.

Salon paintings contemporary with the *Grande Jatte* deploy a consistent repertory of devices to convey their messages, formulating a set of interrelated structures presented as a tableau of contemporary life, of the "real world." The prime characteristic of these Salon paintings is their legibility, achieved by a number of means: by titles, by the identifiability of the types of people depicted and the setting in which they are placed, by details of gesture and physiognomy that reveal the nature of the interchange between people, and by the coherence of the figure groupings, organized so that the focus of attention is readily apparent.

This legibility was meant to enable the metropolitan, middle-class viewers who attended Salon exhibitions to label and classify what they saw there—a whole scenario encapsulated in a painting. Not only did this involve the identification of types and of a narrative, but also of the relations between classes, always interpreted according to the dominant viewpoint of the middle class. At times the urban bourgeoisie itself is depicted, or rather a very restricted range of its activities; rarely do we see bourgeois men at work or fathers in the family, and rarely scenes of illness and suffering in a bourgeois setting. More often though the figures in the paintings belong to another class, to the peasantry or (increasingly during the 1880s) to the urban working class. When a painting presents a mixture of classes or social groups, the relationships and distinctions between them are unambiguously spelled out, for instance in scenes of the giving of charity or of domestic service.

Like the *Grande Jatte*, Albert Aublet's *On the Shingle at Le Tréport* (fig. 2), exhibited at the 1883 Salon, is a panoramic composition, encompassing small groups of figures that include courting couples and families with children. Like Seurat, Aublet cut elements off at the edge of the picture to suggest that the scene continues beyond its margins. By the 1880s, this device was commonplace in images of contemporary life. In Aublet's painting, the figures' expressions and gestures are clearly readable and the individual groups are self-contained, their attention focused on elements within the image: the sea, sand, and

other groups on the shingle. In the *Grande Jatte* in contrast, there is little sign of communication between the figures, their expressions are impassive and neutral, their gestures minimal and unclear, and most of them direct their gaze outside the picture, to the left.

Ferdinand Heilbuth's *Saturday: On the Banks of the Seine* (fig. 3), shown in the Salon of 1886, is a scenario very like Seurat's, though the site seems to be further downstream, at Bougival, with the celebrated pleasure-spot La Grenouillère beneath the trees on the far bank. Like the *Grande Jatte*, the image includes men with women, women together, women and children. The title, identifying the day of the week, is comparable to that under which the *Grande Jatte* was first shown in 1886, *A Sunday on the Grande-Jatte (1884)*.[9] And yet the painting by Heilbuth resembles Aublet's more than Seurat's in the way the figures clearly communicate with one another and in the composition's unifying focus, a journey across the Seine to a landing stage on the opposite bank.

Another contemporary image suggests a different perspective onto the *Grande Jatte*. Ferdinand Humbert's *End of the Day* (fig. 4) was shown at the 1885 Salon before being installed as a mural in the marriage chamber in the town hall of the fifteenth arrondissement of Paris. Here familial stability has been symbolized in two distinct, contrasting spheres: man and work on one side;

woman, family, and home on the other. We witness the meeting point between the two at day's end, presented as if the homecoming were a sort of ritual. The bourgeois ideology of work and home has been naturalized by being set in a timeless, rural landscape (a far cry from the urban, working-class milieu of the fifteenth arrondissement); it was made relevant by being located in the room where marriages took place. The solemnity and monumentality of Humbert's figures stand in marked contrast to the sophistication and elegance of the figures in Heilbuth's *Saturday*, the formal language of each picture clearly complementing its specific theme.

Humbert's painting, together with other town-hall decorations of Paris and its suburbs of the early Third Republic, form an essential part of the context of the *Grande Jatte*.[10] Cumulatively these images propose a set of interrelated, normative patterns for the regulation of society. They express a particular middle-class belief in the institutions of family life and labor as the basis of responsible, worthwhile existence. This belief of course represents the values and interests of the employers, the entrepreneurial bourgeoisie, whose success depended upon a contented, diligent work force.

Systematically rejecting and subverting these patterns, the *Grande Jatte* constitutes a travesty of the ennobling rhetoric of Humbert's classicizing poses and formalized, centered composition. In Seurat's painting, we see not

FIGURE 2. Albert Aublet (French, 1851–1938). *On the Shingle at Le Tréport*, Salon of 1883. Oil on canvas; size and present whereabouts unknown. Photo: Ph. Burty, *Salon de 1883* (Paris, 1883).

FIGURE 3. Ferdinand Heilbuth (French, 1826–1889). *A Saturday: On the Banks of the Seine*, Salon of 1886. Oil on canvas; size and present whereabouts unknown. Photo: Georges Olmer and Saint-Juirs, *Salon de 1886* (Paris, 1886).

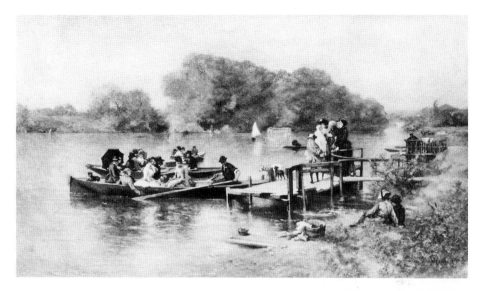

FIGURE 4. Ferdinand Humbert (French, 1842–1934). *The End of the Day*, Salon of 1885. Oil on canvas; size unknown. Paris, Mairie of the fifteenth arrondissement. Photo: Henri Havard, *Salon de 1885* (Paris, 1885).

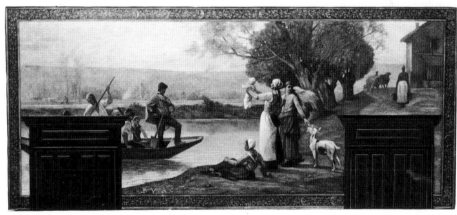

workers but members of the bourgeoisie and demi-monde; not work and a working day, but recreation and Sunday; not homogeneous or clearly defined social units, but varied and often ambiguous groupings, with only a very insignificant place for the family unit;[11] not a shared focus, but little communication or demonstration of common interest.

Some of the modern-life paintings exhibited at the Salons of the 1880s present, without anecdotal elements, a view of the typical behavior of particular social groups, while others are what might be called "situation pictures," canvases that invite the viewer to imagine a before and after, a potential narrative sequence on either side of the situation depicted. In both types of pictures, the viewer is guided by the compositional groupings, and by the use of signs and details to identify types and

the nature of the interchange between figures. This is not true of the protagonists in the *Grande Jatte*: even those whose identity can be determined have been combined in ways that make their interrelationships uncertain.

That Seurat omitted legible signs of communication and avoided pairings that were virtual clichés can be seen by comparing the *Grande Jatte* to other contemporary works. The theme of the relationship between man and woman reveals most vividly the stock formulae that were current in the late nineteenth century. Jules Bastien-Lepage's *Village Love* (fig. 5), exhibited at the Salon of 1884, is typical of courtship images from this period: love is presented as inseparable from the idea of nature. There is a seamless interplay between the peasant lovers and the cottages and church that seem to preside over their solemn vows. A number of images also show

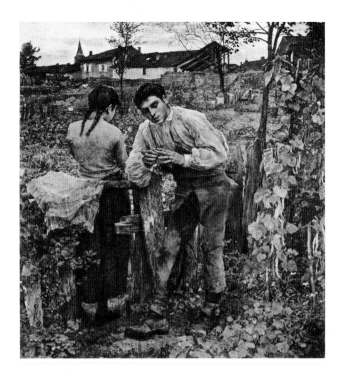

FIGURE 5. Jules Bastien-Lepage (French, 1848–1884). *Village Love*, Salon of 1884. Oil on canvas; 199 × 181 cm. Moscow, Pushkin Museum.

courtship among the middle class and demimonde, such as Heilbuth's *Summer Day* (fig. 6), seen in the 1887 Salon. The picture is similar to Seurat's in the way that its fashionably dressed figures intrude into a natural setting, but the physiognomies and attributes in it are defined in detail and the figures are clearly engaged with one another. Their gestures and expressions however give little indication of the precise nature of their relationship: the alert dog acts as a barrier between them, as a guardian of the woman.[12] This uncertainty though is quite unlike the wholesale illegibility of the relationships in the *Grande Jatte*: Heilbuth's figures invite a narrative reading but deny a single, clear-cut interpretation, whereas Seurat's schematic, non-communicative silhouettes are a wholesale challenge to this method of comprehending pictures through gesture and expression.

Heilbuth's canvas raises an issue of central importance for the *Grande Jatte*: Would viewers of the mid-1880s have interpreted any unchaperoned woman as being in a morally questionable position, and therefore as a member of the demimonde? The nature of the historical evidence is inevitably partisan: male estimates of the status of unaccompanied or unchaperoned women were rooted in moral fears or sexual hopes that might have had little to do with any actual or imagined signs of availability, while, for a respectable woman, the predatory male flâneur presented two options: confinement or potential harassment. These uncertainties were compounded by

the legal system and by tastes in fashion. Registered prostitutes were not permitted to signal their availability in any way by their clothing, and the unregistered needed to dress unobtrusively so as not to attract the attention of the police.[13] At the same time, as many commentators noted, contemporary fashion contributed to a lack of differentiation between women of different status. In part this was the result of mass-produced clothing imitating high fashion. But, as Richard Sennett has argued, the homogeneity of public appearance must be viewed in relation to the contemporary belief that expression and gesture can be analyzed scientifically: if the body could show so much to an alert observer, some mask was needed to protect the individual from involuntary self-revelation in public. Thus an observer was forced to seek clues to a person's "real" identity in small details of clothing and nuances of manner.[14]

Two comments, one from a man and one from a woman, hint at the practical implications of such uncertainties. Writing in the 1890s, the popular writer and man-about-town Octave Uzanne cited the belief of an "impenitent libertine" that perhaps forty percent of unchaperoned women in Paris were potentially available for some sort of sexual traffic. In 1879 the young painter Marie Bashkirtseff noted in her journal:

What I so want is the freedom to walk about all on my own. . . . I'll dress up in bourgeois clothes and a wig; I'll make myself so ugly that I will be as free as a man. That's the freedom I lack, without which one can never seriously make anything of oneself. . . . But even if I disguised myself and made myself ugly, I would only be half free, and any woman who goes out on her own is committing an imprudence.[15]

In Uzanne's opinion, most women could legitimately be propositioned. For the haute-bourgeoise Bashkirtseff, even the anonymity of bourgeois clothing offered no real protection: Uzanne's libertine denied Bashkirtseff her space. But what both of these comments tacitly recognize is that in practice many respectable women did go out alone.

The Salon paintings offered the sort of certainty that commentators sought in vain in the world around them. In the pictorial world, the bourgeois viewer could read the signs and deliver the verdict. Jules Scalbert's *Fishing Party* (fig. 7), from the 1886 Salon, makes overt reference to demimondaine recreation, with the woman's coquettish smile and the reference to the pun in French on *pêcher* (to fish) and *pécher* (to sin) which, as Richard Thomson has pointed out, was common currency at the time.[16] Comparable figures appear in the *Grande Jatte*: the woman with the fishing rod at the far left, and the man in the near-left foreground who was identified by contemporaries as a *canotier*.[17] But, in Seurat's work, the woman fishing plays no special part in the composition and is not placed in the close relationship to a man as was common in *pêcher/pécher* jokes. Likewise the *canotier* pays no attention to the woman seated next to him. She can be understood equally well to be the companion of the top-hatted man beyond her.

Joseph Caraud's *Woman Fishing* (fig. 8), exhibited at the 1884 Salon, plays with the same stereotypes: a solitary woman is fishing on a stretch of the Seine very like that alongside the Grande Jatte; she is fashionably dressed, with a stool and picnic basket behind her; a man and a woman are seated together on the river bank

beyond her; and, on the right, a small ferry boat is seen through the foliage, apparently carrying a single male passenger. Though no overt connection is made, the placing of the figures and their attributes and gestures invite the viewer to imagine a meeting between this man and the fisherwoman.

Other types are presented in the *Grande Jatte* with a similar disregard for their standard roles in modern-life tableaux. Clearly recognizable by her costume, the wet nurse seen from the back on the left is accompanied not by a child but by an older woman. A typical image of nurses and children appears in Albert Edelfelt's *Luxembourg Garden* (fig. 9), shown at Georges Petit's Exposition Internationale in 1887. In Edelfelt's painting, expression and gesture appeal to the sentimental responses of the viewer. While the painting is not specifically narrative, its unified, enclosed space and the protective presence of watchful adults assure us that the innocence and safety of these children are secure. In the *Grande Jatte*, on the other hand, we cannot be sure where the little girl to the right is running, or who is looking after her. Wet nurses also appeared in contemporary imagery in another stock situation, as the object of the sexual attentions of soldiers.[18] Yet the two soldiers in the background of the *Grande Jatte* seem wholly unrelated to the

FIGURE 6. Ferdinand Heilbuth. *Summer Day*, Salon of 1887. Oil on canvas; size and present whereabouts unknown. Photo: G. Ollendorf, *Salon de 1887* (Paris, 1887).

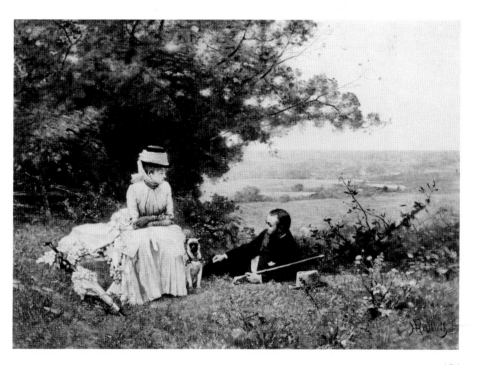

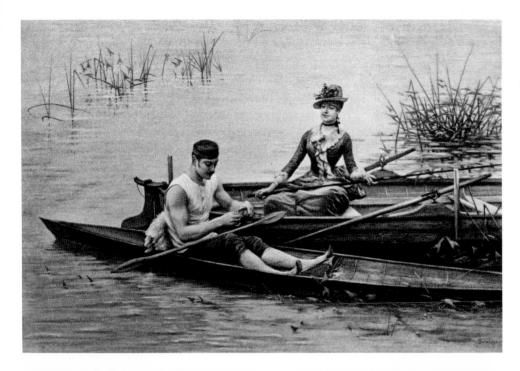

FIGURE 7. Jules Scalbert (French, 1851–?). *Fishing Party*, Salon of 1886. Oil on canvas; size and present whereabouts unknown. Photo: Georges Olmer and Saint-Juirs, *Salon de 1886* (Paris, 1886).

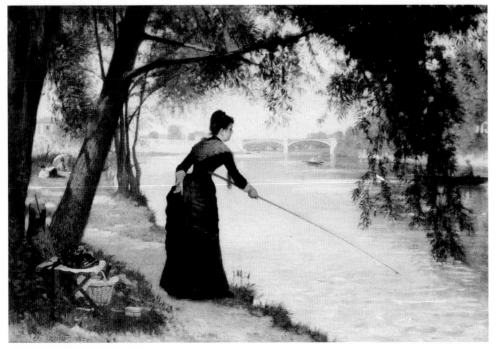

FIGURE 8. Joseph Caraud (French, 1821–1905). *Woman Fishing*, Salon of 1884. Oil on canvas; 50.5 × 74.5 cm. Photo: sale cat., London, Christie's, Mar. 25, 1988, lot 50.

wet nurse or to any other figure in the picture. The musician too does not assume his usual role as the focus of an attentive group; and, as already noted, the nuclear family has been relegated to virtual invisibility.

There are good reasons for associating the principal couple in the right foreground with the demimonde.[19] Many contemporary reviewers noted the monkey on a leash, as if a reference to the woman's exotic pet would somehow allow the reader to pick up a sign that the reviewer was unwilling or unable to spell out explicitly. Only George Moore, in an avant-garde English magazine of 1886, explicitly identified the woman as a tart (*cocotte*).[20] A painting such as Carl Nys's *Woman with a Monkey* (fig. 10), shown in the Salon of 1887, is direct about this association, which emphasizes again how Seurat avoided conventional rhetoric.[21]

The exaggerated contour Seurat gave his major female figure, emphasizing her corsetry, was absolutely up to date, yet he treated her dress very simply, paying little attention to its folds and ornamentation. A similar silhouette appears in another work exhibited in the spring of 1886, Louise Abbéma's *Comedy*, shown with the art-

ist's *Tragedy* at the Salon of 1886 (fig. 11). The setting of *Tragedy* is the ancient world, while that of *Comedy* is a panorama of modern Paris. Abbéma presented the figure of Comedy in a sumptuous dress and surrounded her with an elaborate set of signs (notably the male face seen through the barred window in the ruin behind her) that, together with her facial expression, evokes the stereotype of the luxurious courtesan. Again what Abbéma included reveals what Seurat omitted.

One further comparison points up the contrast between the art of Seurat and contemporary Salon painting. Charles Giron's *Two Sisters* (fig. 12), exhibited at the Salon of 1883, is one of the most comprehensive images of virtue and vice of the 1880s, employing a compositional arrangement and a series of details that compare the fallen woman in her fine carriage with her honest but poor sister, who is accompanied by her working-class husband and children. We are meant to understand that retribution awaits the sinner, for the scene takes place in front of the church of La Madeleine in Paris. As Thomson has noted, the contrast here is echoed by the two dogs in the foreground, comparable to the pairing of

FIGURE 9. Albert Edelfelt (Finnish, 1854–1905). *The Luxembourg Garden*, 1887. Oil on canvas; 144 × 188 cm. Helsinki, Ateneum.

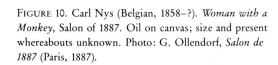

FIGURE 10. Carl Nys (Belgian, 1858–?). *Woman with a Monkey*, Salon of 1887. Oil on canvas; size and present whereabouts unknown. Photo: G. Ollendorf, *Salon de 1887* (Paris, 1887).

dogs in the foreground of the *Grande Jatte*, where a pampered pug rushes toward the mongrel at the left.[22] But even here, Seurat undermined any clear interpretation of this detail by giving no hint of the ownership of the mongrel: we cannot, as in Giron's picture, link their dumb show to the relationships between the humans alongside them.

In discussions about the range of types depicted in the *Grande Jatte*, one problem continues to be debated: Is the working class present? Clark has insisted that Seurat's subject was the "intermingling of classes"—the worker alongside the bourgeois.[23] However, as Ward has pointed out, only one critic, Jules Christophe, mentioned the inclusion of workers when the picture was exhibited in 1886, and he did not identify them. Christophe did not repeat this claim in his otherwise more detailed account of the painting published in 1890.[24] The social parameters suggested in the *Grande Jatte* do not seem to be as wide as Clark supposed. We see the bourgeoisie and the demimonde, with certain indications of distinctions within these groups, most notably in the high fashion of the couple in the right foreground and the hint of the petite bourgeoisie in the pair of hatless girls just beyond the musician.[25] The nursemaid, musician, and soldiers come from outside this world but assume roles that grant them some entrée to it. Thus the picture does not present a comprehensive class mix or set of legible social indicators. Indeed this very anonymity was evident to Seurat's friend Jean Ajalbert when he discussed the painting in his review of the 1886 Impressionist exhibition: "All these people who hardly differ, dressed up in the same clothes, give a real impression of the intense life that flows, on Sundays in summer, from Paris to its outskirts."[26]

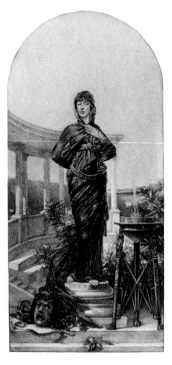

FIGURE 11. Louise Abbéma (French, 1858–1914). *Tragedy* and *Comedy*, Salon of 1886. Oil on canvas; size and present whereabouts unknown. Photo: Georges Olmer and Saint-Juirs, *Salon de 1886* (Paris, 1886).

In Roger Jourdain's *Sunday* and *Monday* (figs. 13 and 14), both shown in the Salon of 1878, the bourgeoisie and working class are contrasted in the setting of the island of the Grande Jatte.[27] Middle-class picnickers are seen in *Sunday* and absentee workers in *Monday*.[28] Clark quoted parts of the caption that accompanies reproductions of the pictures in an issue of *L'Illustration* in 1878, but omitted the passages that point up most vividly the differences between *Sunday* and the *Grande Jatte*: the caption explains at length the differing responses of the women to the man who arrives with champagne. The details of this sentimental interpretation are unimportant, but it demonstrates a narrative potential in Jourdain's work that is totally lacking in Seurat's.[29]

Jourdain's pair raises the question of the relationship between the *Grande Jatte* and its predecessor, *Bathing, Asnières* (pl. 1), rejected for the Salon and shown instead at the Salon des Indépendants in 1884. Unlike the paintings by Jourdain, these two canvases by Seurat cannot be viewed as a literal pair, because their horizon lines do not match and Seurat never exhibited them together.[30] There are however crucial links between the two, over and above the fact that they show opposite banks of the same stretch of river. Paul Smith has demonstrated that the figures in *Bathing* are wearing working-class or artisans' clothes; thus they represent the class that has been excluded from the *Grande Jatte*.[31] Moreover, in both works, the attention of most of the figures is directed

FIGURE 12. Charles Giron (Swiss, 1850–1914). *The Two Sisters*, Salon of 1883. Oil on canvas; 443 × 653 cm. Present whereabouts unknown. Photo: Ph. Burty, *Salon de 1883* (Paris, 1883).

FIGURE 13. Roger Jourdain (French, 1845–1918). *Sunday*, Salon of 1878. Oil on canvas; size and present whereabouts unknown. Photo: engraving from *L'Illustration*, June 15, 1878.

FIGURE 14. Roger Jourdain. *Monday*, Salon of 1878. Oil on canvas; size and present whereabouts unknown. Photo: engraving from *L'Illustration*, June 15, 1878.

outside the painting into the space shown in the other picture. The spatial and compositional structure of each painting assumes the presence of the other bank, if not literally of the personages in the other picture.[32]

Like the *Grande Jatte*, *Bathing* rejects conventions of focus, activity, gesture, expression, and detail.[33] A few comparisons demonstrate this. The focus of Henri Gervex's *Dock at La Villette* (fig. 15), exhibited in the 1882 Salon, is clear: manual labor done under the controlling eye of a uniformed figure on the right.[34] In *The Chatterboxes* (fig. 16), shown in the Salon of 1885, Daniel Ridgway Knight gave his young country girls legible, playful expressions and a clear, centralized focus. They are at one with their surroundings, a part of "nature."

The contrast between the relaxed, rounded forms of the figures in *Bathing* and the stilted poses seen in the *Grande Jatte* is integrally linked to the different social milieus depicted.[35] However, stiff figures like those in the *Grande Jatte* do appear in *Bathing*: the fashionable couple shown on the ferry boat, identifiable as the same type of vessel seen in the *Grande Jatte* because of its tricolor. This suggests that the *Grande Jatte* project may have been in Seurat's mind by the time he completed *Bathing* in the spring of 1884. Both pictures imply not only the existence of the opposite bank but also the social contrasts between them.

Seurat's challenge to legibility in the *Grande Jatte* was a challenge to the values that legibility upheld. The world of the Salon paintings was one of clear-cut relationships and social, economic, and moral hierarchies. Integral to these was the presence—often invisible in the pictures themselves—of the viewing class, the urban bourgeoisie, who could readily identify what they saw in the pictures with their own value systems. Seurat's picture by contrast denied the viewing class its foothold, its clear viewpoint. The relationships within the picture are illegible, and the viewer's own stance in relation to the subject ambivalent: Are we or are we not a part of and party to what is or is not going on?

These uncertainties presented a dual challenge. They undermined the myth of an ordered, legible world where everyone knew his place—a myth that daily life, in the street, challenged at every step. And they challenged the ideology that presented this mythic order as natural, as a social hierarchy based on principles of natural selection, of self-help, and of the survival of the fit-

FIGURE 15. Henri Gervex (French, 1852–1929). *Dock at La Villette*, Salon of 1882. Oil on canvas; size unknown. Paris, Mairie of the nineteenth arrondissement. Photo: *Salon de 1882* (Paris, 1882).

FIGURE 16. Daniel Ridgway Knight (American, 1839–1924). *The Chatterboxes*, Salon of 1885. Oil on canvas; size and present whereabouts unknown. Photo: Henri Havard, *Salon de 1885* (Paris, 1885).

test: the ideology of the entrepreneurial bourgeoisie. In its challenge to structures of classification and control, the implications of the picture were unquestionably radical in political terms; it belongs with other contemporary critiques of bourgeois values and commentaries that focused on anonymity and alienation as the essence of the modern urban experience. There is nothing though in the form that the picture took that allows us to identify it with any precise contemporary political standpoint.

Modern-life Salon painting is only one of the contexts in which the *Grande Jatte* must be considered, but it is a crucial one, since it was within this framework that such a monumental image of contemporary recreation would have been viewed. Other questions can also be asked, about the stylistic affinities of the composition, about its

painterly technique, and about the avant-garde context in which it first appeared. For those original viewers who recorded their thoughts in print, the formal language of the *Grande Jatte* was inseparable from its social meanings. Henry Fèvre moved from a comparison with wooden puppets to an evocation of the "stiltedness of the Parisian promenade, stiff and distorted; even its recreation is affected." Alfred Paulet compared the figures to lead soldiers and went on to say: "The painter has sought to show the routine of the banal promenade of Sunday visitors who stroll without pleasure in the places where it is agreed that one should stroll on Sunday." Maurice Hermel commented: "The Sunday strollers in the shade under the trees on the Grande Jatte assume the simplified, definitive posture of a cortège of pharaohs." Adam vividly spelled out the relationships between form and content: ". . . the stiffness of the figures and their punched-out forms contribute to the note of modernity, reminding us of our badly cut clothes which cling to our bodies and our reserved gestures, the British cant imitated everywhere. We strike poses like those of the figures of Memling. Monsieur Seurat has seen this perfectly, has understood, conceived, and translated it with the pure drawing of the primitives."[36]

Any meaningful discussion of the *Grande Jatte*'s stylistic affinities must focus on such connections: how was it that such a primitivizing and radically anti-naturalistic style—one that made critics think of Egyptian and Greek friezes and early Flemish painting as well as of fashion plates—could be so readily viewed as a metaphor for the essence of modernity? As we have seen, Seurat rejected the fashionable norms for presenting the modern world. The notion of the modern proposed by the critics as a parade of scarcely distinguishable puppets was in opposition to the legibility and coherence prescribed by the dominant bourgeois world view.

To emphasize how specific this hieratic style was to the *Grande Jatte*, we can turn to Seurat's next major effort, *The Models* (see pl. 5), exhibited at the Société des Indépendants in 1888. Its figures, their lines relaxed and cursive, are juxtaposed with the wooden figures in the *Grande Jatte*, shown on the studio wall next to them. This contrast plays on oppositions between nature and artifice: the *Grande Jatte*'s figures assume the artificial guise of fashion in order to appear in the "natural" setting of the island; next to them are three nudes who can only reveal their natural selves in the ultimately artificial

circumstances of posing for "art" in a painter's studio.[37] Judging from the opposition Seurat made here, the stiffness in the *Grande Jatte* cannot be treated as an internal stylistic development in Seurat's art, but must be seen as a calculated, expressive device conceived for that particular project.

Seurat's rejection in the *Grande Jatte* of the dominant codes of contemporary naturalism opens another avenue of exploration—the relationship of the picture to notions of what Hermel characterized as "synthesis" and "modern symbolism." Likewise Paulet wrote of Seurat's abandonment of "pure sensation" in favor of "line" and "idea," and of his concern with the essence of things, rather than with their surface appearance.[38] Smith has convincingly shown that these links with idealist aesthetics and with the emergent Symbolist movement are of central importance for the *Grande Jatte*.[39]

Thus far this discussion of the problems of legibility that the *Grande Jatte* poses has explored the implications of the naturalist and Symbolist points of view. The third, the painterly or proto-modernist, viewpoint cannot be pried apart from discussion of the contexts in which the Pointillist technique emerged. In the *Grande Jatte*, both the modeling of the figures and the handling of the paint emphasize that the picture is a fiction. Together with the hieratic treatment of the figures, Seurat's technique was the material expression of his rejection of the unassertive handling and ostensibly unproblematic "naturalness" of the depictions of modern life that appeared in Salon exhibitions. But Seurat's approach also demands consideration in relation to Impressionism, which the artist sought to supplant as the vanguard style and whose insights he wished to develop and correct. We must ask what was the significance of the Neo-Impressionists' rejection of the dynamic, virtuoso touch of the Impressionists, and their insistence on the "scientific" as against the "romantic."

In the 1860s, criticism of avant-garde painting, and particularly the work of Edouard Manet, focused on the use of the *tache* (touch or patch of color), by which artists attributed equal optical significance to every element in a picture. For Théophile Thoré, writing in 1868, Manet's *Portrait of Emile Zola* (1868; Paris, Musée d'Orsay) manifested "a sort of pantheism that places no higher value on a head than on a slipper," and refused to give "their relative value to the essential parts of human beings." In 1876 Stéphane Mallarmé viewed the "imper-

sonal" manner of Manet and the Impressionists in political terms, as the art of radicalism and democracy capable of speaking to those who "consent to be an unknown unit in the mighty numbers of a universal suffrage."[40]

However, by the early 1880s, this art of egalitarianism had changed: the Impressionists had largely abandoned urban and suburban subjects, and the pantheistic brush-stroke had given way, particularly in Claude Monet's work, to a more virtuoso display of individual sensation and temperament. Moreover, by this time, the *tache* had become an emblem of fashionable modernity in chic Salon portraits such as John Singer Sargent's notorious *Madame X (Portrait of Madame Gautreau)* (New York, The Metropolitan Museum of Art), shown in 1884. The Neo-Impressionist *petit point*, or dot, as it evolved in 1885–86 during the execution of the *Grande Jatte*, was corrective, a new, impersonal technique opposed to the romantic individualism of Manet's legacy and of later Impressionism. As Fénéon insisted in 1886, the dot leaves "no scope for bravura passages; the hand is stiff, but the eye is agile, perceptive, and knowing." The *petit-point*, even more than the *tache*, treats everything similarly, without giving "their relative value to the essential parts of human beings."[41]

However by 1895 Signac declared: "We are emerging from the hard and useful period of analysis, when our subjects resembled each other, and entering that of varied and personal creation." Once again the rhetoric of individualism was replacing a detached, impersonal vision. In 1891 Signac had already put forward a very similar viewpoint in an anarchist magazine, arguing that the true artistic revolutionaries were the "pure aesthetes . . . who, striking off the beaten track, paint what they see, as they feel it, and very often unconsciously supply a solid axe-blow to the creaking social edifice."[42]

The history of avant-garde movements has shown a recurrent pattern: a short phase of collective enterprise followed by the members of the group asserting their individuality—the individual transcending the collective. As Thomas Crow has pointed out, this shift from impersonality to individualism is crucially bound up with wider questions about the role of artistic creativity in relation to the politics of the left.[43] Can art best serve the left by united, collective effort and by seeking visual form for a political agenda, or rather by a blatant declaration of autonomy, of the individual's independence from the dominant ideology? These issues were central to discussions of the role of art within anarchist politics

in France in the 1880s and 1890s, and they are crucial to the examination of the aesthetic and political positions taken by Neo-Impressionist painters. But we cannot simply equate Neo-Impressionist technique with anarchist politics or use such arguments to settle the question of Seurat's political commitments.[44]

Nor can we treat the Neo-Impressionists' "impersonal" touch of the 1880s separately from their imagery and the visual language they adopted or from their commitment to the jury-free exhibitions of the Indépendants from 1884 onward. As we have seen, the first critics to write on the *Grande Jatte* understood its naturalist-related theme; its synthetic, hieratic form; and its technical complexities as inseparable elements in an expressive whole.

But should the historian today seek to combine the naturalist, Symbolist, and proto-modernist *Grande Jatte* to provide a single comprehensive reading of the picture in its original contexts? Even its first viewers came to the picture from different perspectives and with different expectations, and we should explore the range of meanings it carried for them and the ways in which they approached and sought to resolve its complexities. Meaning is not inherent in a work of art, but is found in it by its viewers, from its first appearance up to the present day. The historian's task is to seek the range of meanings that can be found in a work at a particular historical moment and to highlight the assumptions that underlie the various ways in which it has been interpreted, both in the past and in the present.[45]

But what of Seurat's intention? There are two immediate problems: first, historical investigations can suggest only a fraction of the artist's conscious intent; second, many unspoken presuppositions determine the artist's decisions in ways of which he or she is not explicitly aware. As historians we should not seek a single, homogeneous picture of the artist's authorial consciousness. Rather we should explore the underlying assumptions behind the making of a particular object—the factors of social conditioning as well as the personal concerns; and separately we should study the artist's deliberate strategy in presenting that object in a particular context. We cannot reconstruct this public strategy by hypotheses about inner personal intentions and private meanings, but rather by tracing the intervention that the work of art made in its original contexts, and the terms in which that intervention was made; that has been the purpose of this essay. We may argue that Seurat was well

aware of many of the complex meanings and associations that the *Grande Jatte* would evoke, and indeed that the painting was a highly calculated intervention into the politics of avant-garde painting in Paris in 1886. But we should not seek a hypothesis about a unified authorial consciousness and then treat this as the yardstick by which all meanings must be judged. It is the life of the work, not the life of the artist, that must command our attention.

Seurat's *Grande Jatte*: An Anti-Utopian Allegory

LINDA NOCHLIN, *City University of New York Graduate Center*

T HE IDEA that Georges Seurat's masterpiece, *Sunday Afternoon on the Island of the Grande Jatte* (pl. 2), was in some sense anti-utopian came to me when reading a chapter entitled "The Wishful Landscape Portrayed in Painting, Opera, Literature" in *The Principle of Hope*, the *magnum opus* of the German Marxist historian and philosopher Ernst Bloch. Here is what Bloch, writing in the first half of this century, had to say:

The negative foil to Manet's *Déjeuner sur l'herbe*, or rather its mood of gaity gone sour, is embodied in Seurat's promenade piece: *Un Dimanche à la Grande-Jatte*. This picture is one single mosaic of boredom, a masterful rendering of the disappointed longing and the incongruities of a *dolce far niente*. The painting depicts a middle-class Sunday morning [*sic*] on an island in the Seine near Paris; and that is just the point: it depicts this merely with scorn. Empty-faced people rest in the foreground; most of the others have been grouped into wooden verticals like dolls from the toybox, intensely involved in a stiff little walk. Behind them is the pale river with sailboats, a sculling match, sightseeing

boats—a background that, despite the recreation going on there, seems to belong more to Hades than to a Sunday. A great load of joyless leisure is in the image, in the bright matt glare of its atmosphere and in the expressionless water of the Sunday Seine, the object of an equally expressionless contemplation. . . . As the work a day world recedes, so does every other world, everything, recede into watery torpidness. The result is endless boredom, the little man's hellish utopia of skirting the Sabbath and holding onto it, too; his Sunday succeeds only as a bothersome must, not as a brief taste of the Promised Land. Middle-class Sunday afternoons like these are landscapes of painted suicide which does not come off [even at that] because it lacks resolve. In short, this *dolce far niente*, if it is conscious at all, has the consciousness of an absolute non-Sunday in what remains of a Sunday utopia.[1]

The anti-utopian signification about which Bloch wrote is not merely a matter of iconography, subject matter, or social history transcribed to canvas. Seurat's painting should not be seen as merely passively reflecting the new urban realities of the 1880s or the most advanced stages of the alienation associated with capitalism's radical revision of urban spatial divisions and social hierarchies of his time. Rather the *Grande Jatte* must be seen as actively producing cultural meanings through the invention of visual codes for the modern experience of the

FIGURE 1. Georges Seurat (French, 1859–1891). *Sunday Afternoon on the Island of the Grande Jatte* (detail of pl. 2).

133

city. This explains the inclusion of the word "allegory" in the title of this article. It is through the pictorial construction of the work—its formal strategies—that the anti-utopian is allegorized in the *Grande Jatte*. This is what makes Seurat's production—and the *Grande Jatte*—unique. Of all the Post-Impressionists, he is the only one to have inscribed the modern condition—with its alienation and anomie, the experience of living in the society of the spectacle,[2] of making a living in a market economy in which exchange value took the place of use value and mass production that of artisinal production—in the very fabric and structure of his pictorial production.

If Seurat, rather than Paul Cézanne, had been positioned as the paradigmatic modernist painter, the face of modern art would have been vastly different. But such a statement is of course itself utopian, or, at the very least, insufficiently historical. It was part of advanced art's historical destiny in the later nineteenth and early twentieth centuries to retreat from the worldly, the social, and above all from the negative and objectively critical position iterated in Seurat's art and establish the realm of the atemporal, the non-social, the subjective, and the phenomenological—in other words, a "pure" painting—as synonymous with modernism. This paradoxical instatement of pure visibility and the flat surface of the canvas

as the modern is, as we shall see, at the polar opposite of Seurat's project in the *Grande Jatte* and in his other works as well.

It has been the aim of ambitious Western art from the High Renaissance onward to establish a pictorial structure that suggests a rational narrative and above all an expressive coherence relating part and part, and part and whole, at the same time that it establishes a meaningful relationship with the spectator. A painting is understood to "express," to externalize, by means of its structural coherence, some inner meaning, to function as the visible manifestation of a core or a depth of which the representational fabric constitutes but a surface appearance, albeit an all-important one. In Raphael's *School of Athens* (fig. 2), the figures are constructed to react and interact, thereby suggesting, indeed determining, a meaning beyond the mere surface of the painting, to create an expression of complex signification that is at once comprehensible yet, at the same time, transcends the historical circumstances that produced it. In a sense, Edouard Manet's *Luncheon on the Grass* (p. 227, fig. 3) constitutes the end of that Western tradition of high art as expressive narrative: the shadow begins to thicken up, the priority accorded to the surface denies the implication of transcendence, the gestures fail of their usual dialogic mission. But even here, as Bloch pointed out in

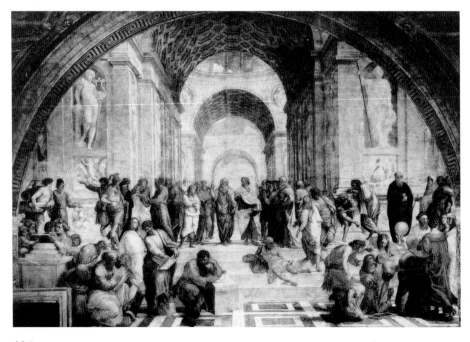

Figure 2. Raphael (Italian, 1483–1520), *School of Athens*, 1510–11. Fresco. Rome, Vatican Palace, Stanza della Segnatura. Photo: Clarence Kennedy.

the same chapter in which he discussed the *Grande Jatte*, there remain utopian emanations. Indeed he read the *Luncheon* as a counterfoil to the *Grande Jatte*, interpreting it as a "wishful scene of epicurean happiness," and describing it in the most lyrical of terms: "Soft light, as only Impressionism could create, flows through the trees, surrounds the two couples, the naked woman and the one undressing to bathe, the dark male figures. What is portrayed is an extraordinarily French, extraordinarily lingering situation, full of innocence, supreme ease, unobtrusive enjoyment of life, and carefree seriousness." Bloch assigned the *Luncheon* to the same category as the *Grande Jatte*'s, that of the Sunday picture. "Its subject is: an immediate other world, beyond hardship. Though this subject could no longer be easily painted in the nineteenth century, Manet's *Luncheon on the Grass* constitutes an exception precisely because of its naïveté and presence. Its wholesome Sunday would hardly be possible [in 1863, when it was painted] with the petit-bourgeois; thus it could not exist without artists and their models." Bloch then moved on to the negative description of the *Grande Jatte* cited above: "The real bourgeois Sunday, even a painted one, thus looks even less desirable or varied. The *negative* foil to Manet's *Luncheon on the Grass*, in other words, the *merriness that has become powerless*, is presented in *Seurat's* promenade piece. . . ."[3] Not until the 1880s, it would seem, was it possible to produce a work that so completely, so brilliantly and convincingly inscribed the condition of modernity itself.

In Seurat's painting, there is almost no interaction between the figures, no sense of them as articulate, unique, and full human presences. The Western tradition of representation has been undermined, if not nullified, here by a dominant language that is resolutely anti-expressive, rejecting the notion of a hidden inner meaning to be externalized by the artist. Rather, in these machine-turned profiles, defined by regularized dots, we may discover coded references to modern science, to modern industry with its mass production, to the department store with its cheap and multiple copies, to the mass press with its endless pictorial reproductions. In short there is here a critical sense of modernity embodied in sardonic, decorative invention and in the emphatic, even over-emphatic, contemporaneity of costumes and accouterments.[4] For the *Grande Jatte*—and this too constitutes its anti-utopianism—is resolutely located in history rather than being atemporal and universalizing.

This objective historical presence of the painting is above all embodied in the notorious dotted brushstroke—the *petit point*—which is and was of course the first thing everyone noticed about the work—and which in fact constitutes the irreducible atomic particle of the new vision. For Seurat, with the dot, resolutely and consciously removed himself as a unique being projected by a personal handwriting. He himself is absent from his stroke: there is no sense of the existential choice implied by Cézanne's constructive brushwork; of the deep, personal *angst* implied by van Gogh's; nor of the decorative, mystical dematerialization of form of Gauguin.[5] The paint application is matter-of-fact, a near- or would-be mechanical reiteration of the functional "dot" of pigment. Meyer Schapiro, in what is perhaps the most perceptive single article ever written about the *Grande Jatte*, referred to Seurat as a "humble, laborious, intelligent technician," coming from the "sober lower middle class of Paris from which issue the engineers, the technicians, and the clerks of industrial society," and pointed out that Seurat "derived from the more advanced industrial development of his time a profound respect for rationalized work, scientific technique and progress through invention."[6] But before examining the *Grande Jatte* in detail to see how the anti-utopian message is inscribed in every aspect of the painting's stylistic structure, we must examine what counted for "utopian" in the visual production of the nineteenth century. It is only by contextualizing the *Grande Jatte* within that which was seen by Seurat and his contemporaries as utopian that the oppositional character of his creation can be fully understood.

There is of course the classical utopia of the flesh established by J. A. D. Ingres in his *Golden Age* (fig. 3). Harmonious line, smooth and ageless bodies, a pleasing symmetry of composition, a frictionless grouping of inoffensively nude or classically draped figures in a landscape of Poussinesque unspecificity—this is not so much a representation of utopia as it is nostalgia for a distant past that never was and never can be recaptured—not so much utopia (meaning no or beyond place) as u-chronia (meaning no or beyond time). Completely lacking is the social message we usually associate with utopian discourse. This is rather a utopia of (idealized) desire.

The same incidentally might be said of Gauguin's much later renditions of tropical paradise (see fig. 4): here it is not distance in time, but geographic distance that functions as the utopian catalyst. But, as in Ingres's

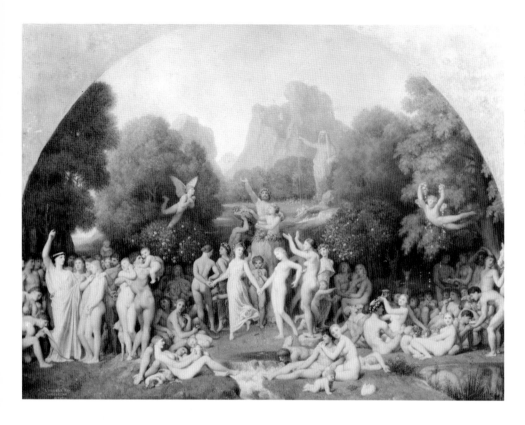

FIGURE 3. J. A. D. Ingres (French, 1780–1867). *The Golden Age*, 1862. Oil on paper; 47.8 × 62 cm. Cambridge, The Harvard University Art Museums.

FIGURE 4. Paul Gauguin (French, 1848–1903). *Day of the Gods (Mahana No Atua)*, 1894. Oil on canvas; 68.3 × 91.5 cm. The Art Institute of Chicago, Helen Birch Bartlett Collection (1926.198).

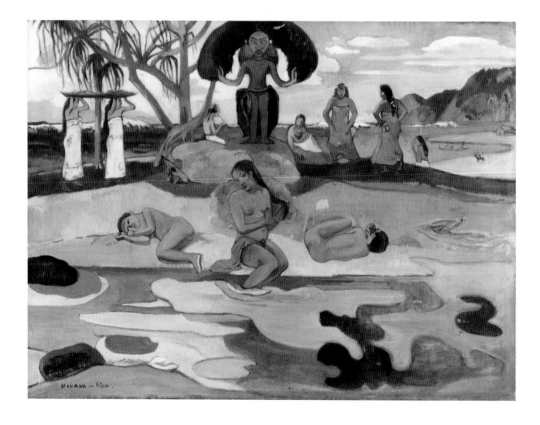

FIGURE 5. Dominique Papety
(French, 1815–1849). *Dream of
Happiness*, 1843. Oil on canvas.
Compiègne, Musée Vivenel.
Photo: *Art History* 2, 3
(Sept. 1979), pl. 29.

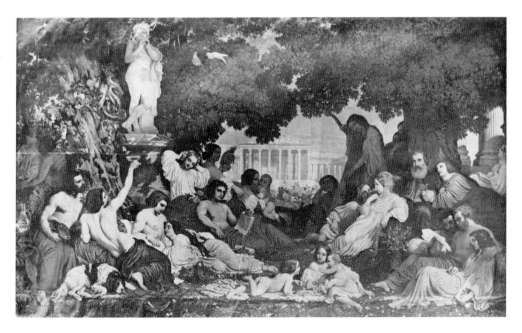

version, it is the naked or lightly veiled human body,
female above all, in non-contemporary costume, that
constitutes the utopian signifier; still, as in the work by
Ingres, this is manifestly an apolitical utopia, whose ref-
erence point is male desire and whose signifier is female
flesh.

Far more apposite in constructing a context of utopian
representation to serve as a foil to Seurat's anti-utopian
allegory is a work like Dominique Papety's *Dream of
Happiness* (fig. 5), shown in the Salon of 1843. Utopian
in form and content, this work is explicitly Fourierist in
its iconographic intentions and classically idealizing in
its style, which is not very different from that of Ingres,
Papety's master at the Académie française in Rome.[7] Yet
there is a significant difference between Papety's and In-
gres's utopian conceptions: although the Fourierists
considered the present—the so-called realm of civiliza-
tion—depraved and unnatural, the past for them was
little better. The true golden age lay not in the past, but
in the future. The explicitly Fourierist content of this
utopian allegory is corroborated by the inscription
"Harmonie" on the base of the statue to the left, which
refers "both to the Fourierist state and to the music of
the satyr," and a second inscription, "Unité univers-
elle," on the book studied by the youthful scholars, a
direct allusion to Fourierist doctrine and the name of
one of Fourier's theoretical treatises.[8] Indeed it is pos-

sible to read certain aspects of the *Grande Jatte* as an
explicit refutation of Fourierist utopianism, or more ac-
curately of utopianism, *tout court*. In Papety's painting,
this was allegorized by the inclusion of figures person-
ifying the poet "singing harmony"; a group embodying
"maternal tenderness," another referring to friendship
under the graces of childhood, and, at the sides, various
aspects of love between the sexes. All are conspicuous by
their omission in the *Grande Jatte*. Other embodiments
of virtuous satisfaction are the "working thinkers" (*la-
borieux penseurs*) engaged in studies, a beautiful woman
asleep on the chest of her husband, and a noble, old man
stretching his hand out in blessing over the head of his
daughter and her fiancé. The architecture is resolutely
classical, although the painting at one time suggested the
futurity of this utopian vision by the inclusion of a
steamboat and an electric telegraph, later removed by the
artist.[9] The figures are smooth and harmonious, classical
or neoclassical in their poses; the paint is conventionally
applied; the signs of modernity, at least in this version,
erased in favor of a utopian dream which, however
Fourierist, is firmly rooted in references to a long-
vanished past and an extremely traditional, not to say
conservative, mode of representation.

Far more apposite to Seurat's anti-utopian project is
the work of his older contemporary Pierre Puvis de
Chavannes. Indeed one might say that, without the pre-

cedent provided by Puvis, in works such as his huge canvas *The Sacred Grove* (fig. 6), exhibited at the Salon of 1884, the very year that Seurat began work on the *Grande Jatte*, the latter might never have come into being, or might have been different. From a certain standpoint, the *Grande Jatte* may be considered a giant parody of Puvis's *Sacred Grove*, calling into question the validity of such a painting and its relevance to modern times—in both its form and content. For Puvis's timeless muses and universalized classical setting and drapery, Seurat substituted the most contemporary fashions, the most up-to-date settings and accessories. Seurat's women wear bustles and modish hats rather than classical drapery; his most prominent male figure holds a coarse cigar and a cane rather than the pipes of Pan; the architectural background is in the mode of modern urbanity rather than that of pastoral antiquity.

A work such as *Summer* (fig. 7), painted by Puvis in 1873, two years after the defeat of France in the Franco-Prussian war and the terrible, socially divisive events of the Commune and its aftermath, represents the utopian vision at its purest. Although the recognizable depiction of a distant past, the imagery of *Summer* suggests, as

FIGURE 6. Pierre Puvis de Chavannes (French, 1824–1898). *The Sacred Grove*, c. 1884. Oil on canvas; 92.8 × 231 cm. The Art Institute of Chicago, Potter Palmer Collection (22.445).

Claudine Mitchell has recently pointed out, a more general, even a universal time scale, the representation of what is true of human society generally. To quote the critic Théophile Gautier, who pondered Puvis and his works deeply: "Puvis seeks the ideal beyond time, space, costumes, or particular details. He likes to paint primitive humanity, as they [*sic*] perform one of those functions that we could call sacred, so close to Nature they are." He praised Puvis for avoiding the contingent and the accidental, pointing out that his compositions always have an abstract and general title: Peace, War, Repose, Work, Sleep, or, in this case, Summer. Gautier suggested that for Puvis the signifiers of a distant, primitive, purer past serve to define a more universal order, the order of Nature itself.[10]

This then is the nineteenth century's prototypical pictorial version of classical utopia. If Puvis's world is beyond time and space, Seurat's *Grande Jatte* is definitely and even aggressively of his. Indeed one wonders whether the mundane specificity of Seurat's original title—*A Sunday on the Grande-Jatte (1884)*, in its chronological and geographical exactitude, does not constitute an anti-utopian critique of Puvis's and other allegorical classicists vague and idealized names for paintings.

It is perhaps above all the utopian harmoniousness of Puvis's construction that Seurat most forcefully challenged in his canvas. Although Puvis may have deployed his figures in separate groups, this in no sense implies

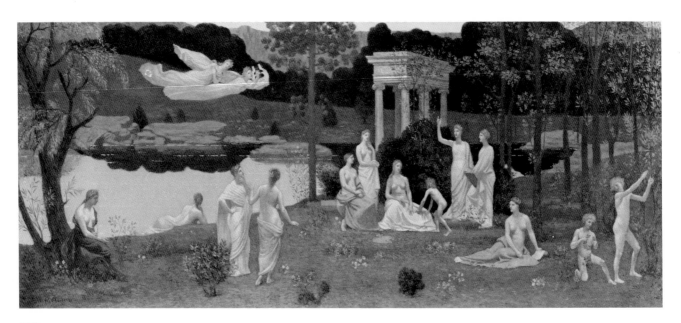

FIGURE 7. Pierre Puvis de Chavannes. *Summer*, 1873. Oil on canvas; 305 × 507 cm. Chartres, Musée des Beaux-Arts.

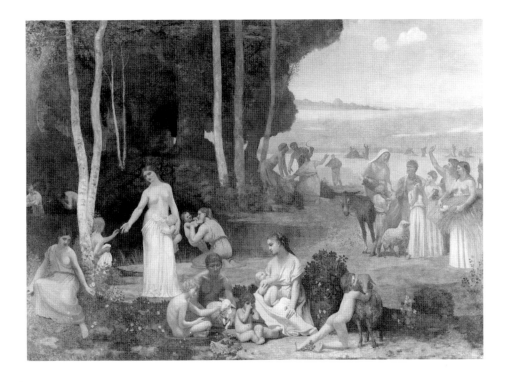

social fragmentation or psychic alienation. Rather the painting serves to idealize the value of the family and that of communal productivity, in which each trade, each age, and above all each gender serves its allotted task. In effect Puvis's works function ideologically to produce an aesthetic harmony out of what in contemporary society is a source of disharmony, conflict, and contradiction: issues like the position of the worker, class struggle, or the status of women. Thus for example in the formal structure of his art, the moral value of maternity for women and that of work for men are represented as inscribed in, and indistinguishable from, the order of Nature rather than figured as highly volatile, contentious issues. This is the crux of Puvis's utopian vision. In Seurat's work, as we shall see, the classical elements are deliberately disharmonized, exaggerated into self-revealing artifice or deliberately frozen and isolated. This is part of its anti-utopian strategy, its bringing of contradictions into focus.

But it is not only the classical and more traditional work of Puvis that offers a startling contrast with Seurat's anti-utopianism. More advanced painters, like Auguste Renoir, had created semi-utopian visions based on contemporary reality, images of the joys of ordinary urban existence posited on the pleasures of healthy sensuality and youthful joie de vivre in a work such as the *Moulin de la Galette* of 1876 (fig. 8). Here the melting colors, broken brushwork, and swirling, dynamic rhythms play out in formal terms, in their joyous intermingling, the eradication of class and gender divisions in a context of idealized recreation in contemporary Paris. As such Renoir's work offers the most pointed opposition to Seurat's sardonic view of the New Leisure. Renoir naturalized daily life in the great modern city; Seurat, on the other hand, made it strange.

But perhaps it is the work of Seurat's disciple and fellow Neo-Impressionist Paul Signac that is most apposite in establishing the context of utopian imagery against which the *Grande Jatte* stands out most forcefully. Signac was fully aware of the social import of his friend's oeuvre. In an article of June 1891, which appeared in the anarchist publication *La Révolte*, he declared that, by painting scenes of working-class life, "or, better still, the pleasures of decadence . . . as the painter Seurat did, who had such a vivid perception of the degeneration of our transitional era—they will bear witness to the great social trial that is taking place between workers and Capital."[11]

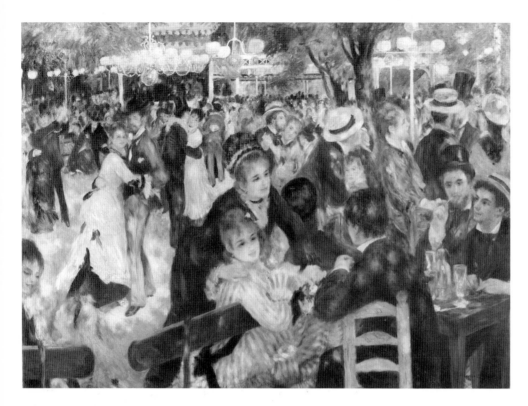

FIGURE 8. Pierre Auguste Renoir (French, 1841–1919). *Moulin de la Galette*, 1876. Oil on canvas; 130.8 × 175.3 cm. Paris, Musée d'Orsay.

Signac, in *In the Time of Harmony*, an oil sketch for a mural created in about 1893–95 for the town hall of Montreuil, seems to have been constructing a response to the specifically capitalist conditions of anomie and absurdity—in other words, the "Time of Disharmony"—represented by his late friend's most famous painting. The very use of the term "harmony" in the title refers to the specifically Fourierist and later, more generally socialist and anarchist designations of social utopia. (The Fourierist colony established in the United States was called New Harmony.) In a lithographed version of his mural entitled *The Pleasures of Summer*, intended for Jean Grave's *Les Temps nouveaux* (fig. 9), Signac created his anarchist-socialist version of a classless utopia, substituting wholesome recreation and human interaction for the stasis and figural isolation of the *Grande Jatte*, emphasizing the joys of the family in place of Seurat's relative muting of them, and replacing the suburban setting of the Art Institute's painting with a more pastoral, rural setting in keeping with the utopian project as a whole. Clearly the style of the figures, despite the more or less contemporary clothing they wear, owes more to Puvis in its flowing idealization than to Seurat's stylishness. The flowing, curvilinear composition and its

decorative iterations suavely emphasize the theme of togetherness—of the couple or the community as a whole—in some utopian future, a Never-Never land. Even the hen and the rooster in the foreground play out the theme of mutual aid and interaction spelled out by the work as a whole, and so deliberately excluded by Seurat's vision.

But it is not merely through contrasting Seurat's *Grande Jatte* with appropriate utopian imagery of his time that one can come to an anti-utopian interpretation of the work. This is corroborated in the viewer reaction of the time, as can be seen in the critical reactions of Seurat's contemporaries who established a negative critique of the modern condition as embodied in the painting.[12] "Reviewers," to borrow the words of Martha Ward in a recent catalogue essay, "interpreted the expressionless faces, isolated stances, and rigid postures to be a more or less subtle parody of the *banality and pretensions of contemporary leisure* [emphasis mine]."[13] For example one critic, Henry Fèvre, remarked that after looking at the image for a while, "then one understands the stiltedness of the Parisian promenade, stiff and distorted; even its recreation is affected."[14] Another critic, Paul Adam, equated the stiff outlines and attitudinizing pos-

tures of the figures with the modern condition itself: "Even the stiffness of the figures and their punched-out forms contribute to the note of modernity, reminding us of our badly cut clothes which cling to our bodies and our reserved gestures, the British cant imitated everywhere. We strike poses like those of the figures of Memling."[15] And still another critic, Alfred Paulet, maintained that "The artist has given his figures the automatic gestures of lead soldiers, moving about on regimented squares. Maids, clerks, soldiers all move around with a similar slow, banal, identical step, which captures the character of the scene exactly"[16]

This notion of the monotony, the dehumanizing rigidity of modern urban existence as the founding trope of the *Grande Jatte* inscribes itself even in the re-

lentlessly formal analysis of the most important of the *Grande Jatte*'s critics, Félix Fénéon, when he described the uniformity of the technique as "a monotonous and patient tapestry"—the pathetic fallacy with a vengeance.[17] In Fénéon's memorable figure of speech, the monotony and patience of the technique of Pointillism allegorize not merely an artistic practice, but rather the dominant quality of modern urban life itself.

FIGURE 9. Paul Signac (French, 1863–1935). *The Pleasures of Summer*, 1895/96. Colored lithograph; 37.6 × 50.2 cm. The Cleveland Museum of Art. This lithograph was executed as part of a series of illustrations of the ideal socialist state for the anarchist journal *Les Temps nouveaux*, ed. by Jean Grave.

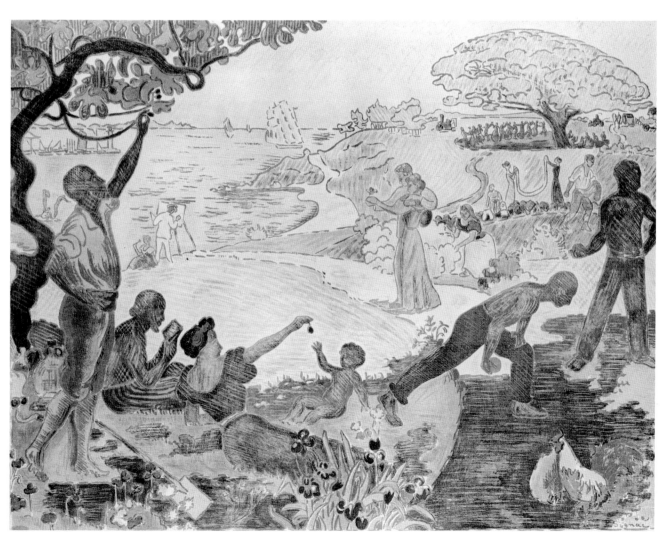

FIGURE 10a-b. Straight-line and curved-line diagrams of the composition of the *Grande Jatte* (pl. 2) in Rich 1935, pp. 27 and 29, respectively.

And what of Seurat's formal language in the *Grande Jatte*? How does it mediate and construct and, in some sense, allegorize the social malaise of its time? Daniel Catton Rich was absolutely correct when, in his seminal book on the painting of 1935, he stressed the primacy of Seurat's formal innovations in what he termed the "transcendent" achievement of the *Grande Jatte*,[18] using reductive diagrams (figs. 10a-b) so typical of that moment of formalist, "scientific" art analysis, to reduce further Seurat's already diagrammatic compositional structure.[19] But as Schapiro pointed out, in his brilliant rebuttal to this study, Rich was wrong to eliminate on the basis of the precedence of formal concerns, the all-important social and critical implications of Seurat's practice.[20] Equally misguided, in Schapiro's view, was Rich's correlative attempt to impose a spurious classicizing, traditionalist, and harmonizing reading on the work, thereby, in the best art-historical fashion, assimilating Seurat's provocative innovations into the peaceful and law-abiding mainstream of pictorial tradition.

The peculiarly modern idea of "system" must be dealt with in separating Seurat from that mainstream of tradition and in approaching his formal innovations. The notion should be understood under at least two modalities: (1) the systematic application of a certain color theory, scientific or would-be scientific, according to the authority one reads, in his Chromo-luminarist method;[21] or (2) the related Pointillist system of paint application in small, regularized dots. As Norma Broude has recently pointed out, Seurat may actually have borrowed his systematic paint application from one of the most recent techniques of mass-diffusion in the visual communication industry of his time, so-called *chromotypogravure*. The choice of this "mechanical" technique served to critique the objectified spectacle of modern life and thereby, as Broude stated, "proved understandably offensive not only to the public at large but also to many artists of the Impressionist and Post-Impressionist generations, artists whose attachment to a romantic conception of originality and spontaneous self-expression in painting was threatened by the apparently impersonal attitude of Seurat and his followers." "It was, in fact," as Broude pointed out, "precisely the 'mechanical' aspect of the technique, so foreign to contemporary notions of fine taste and 'high art,' that, in these terms, may ultimately have proved attractive to Seurat, whose radical political leanings and 'democratic' predilection for popular art forms had already become important formative

factors in the evolution of his attitudes toward his own art." One might go even farther and say that, in some sense, all of the systematizing factors in Seurat's project—from his pseudo-scientific color theory and his "mechanized" technique to his later adaption of Charles Henry's scientifically legitimated aesthetic protractor to achieve fool-proof equilibration of compositional factors and expressive effects—all could ultimately serve a democratizing purpose. He sought a method—a fool-proof method—of creating successful art available to everyone, a sort of democratically oriented, high-type painting by dots that would totally wipe out the role of genius, the exceptional creative figure, in the making of art, even "great art" (although the very term might become superfluous). This indeed is a utopian project from a radical standpoint, although a totally banalizing and anti-utopian one from a more elitist one.[22]

Nothing could be more revealing of Seurat's deliberate rejection of charming spontaneity in favor of incisive distancing than to compare elements from the large final sketch for the *Grande Jatte* (p. 195, fig. 26), with those of the final version. Can anything be farther from the generalizing tendencies of classicism than the diagrammatic concision and up-to-date stylishness of Seurat's construction here, as potent in nailing down a concrete referent as any advertising logo? Or can any image be further from the bland idealizations of a later Neoclassicist like Puvis than the sharp, critical detailing of the motif of a hand holding a cigar and the mechanical roundness of the head of a cane, both forms aggressively signifying the class-coded masculinity of the male "diagram" as opposed to the systematically circular shapes iterated by the clothing, almost topiary its relentless shearing down of the living raw material, of his equally socially specific female companion? Gender difference too is objectified and systematized by means of obvious artifice.

I would like to demonstrate with one figure, that of the wet nurse (fig. 11), the way Seurat worked on one character in his sardonic pageant of frozen recreation, honing the image down to its signifying minimum, reducing the vital and charming irregularity of the original painted sketch to a visual hieroglyph. Ward, in a word-picture as beautifully concise as the image itself, has described the final version as "a faceless configuration: an irregular quadrangle bisected by a triangular wedge and capped with circumscribed circles."[23] The *nourrice*, more familiarly known as "Nounou," had become a stock character in the proliferation of visual typologies

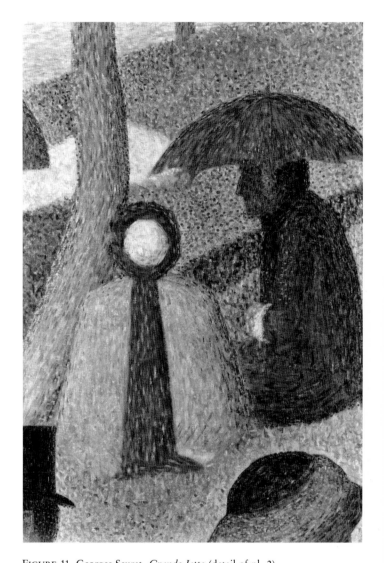

FIGURE 11. Georges Seurat, *Grande Jatte* (detail of pl. 2).

Marie la Picarde : Tête un peu dure ; le geste ne l'est guère. Trop de parents dans les environs.

Jeanne la Bourguignonne : Une demoiselle qui a eu des malheurs ; c'est la troisième. Ma belle mère prélère les nourrices demoiselles au moins, pas de mari à surveiller.

Françoise la Normande : Les dents ne sont pas très belles, par rapport au cidre. Mais de la chair sérieuse et du muscle.

Miette la Provençale : Soleil distillé. Correctif indiqué pour les produits lymphatiques du Nord — rare sur la place.

Pierrette la Bressane : Air pur des montagnes ; à la renommée de l'engraissement précoce.

— C'est moi que je sommes Gérôme, le mari de Jeannette, la nourrice, et je venons histoire de lui dire deux mots.
— Pas de bavardage chez moi, c'est entendu. Filez vite et qu'on ne vous revoie plus.

Le petit chéri va prendre la petite goigoutte. C'est étonnant comme il est avancé pour son âge.

Il faut soigner Jeannette. Le filet est excellent comme plus riche en fibrine ; il faut surtout du bon Bourgogne, c'est des couleurs pour l'enfant.

FIGURE 12. "Cartoon: Choosing a Wet Nurse," in *La Vie parisienne*, 1866. Lithograph. Photo: Fay-Sallois 1980.

FIGURE 13. Engraved by Louis Joseph Amedée Daudenarde (French, died 1907) after Miranda, 1874. "Arrivals at the Wet Nurse Bureau," 1874. Photo: Fay-Sallois 1980.

144

disseminated by the popular press during the second half of the nineteenth century (see fig. 12). Seurat of course avoided this sort of vulgar caricaturing, as he did the naturalistic representation of the wet-nursing profession as a social practice, a relatively popular theme in the salon art of the time (see fig. 13).

Then there is Berthe Morisot, whose representation of her daughter Julie being fed by a wet nurse, a painting of 1879 (fig. 14), presents us with the activity of nursing itself. The nurse is frontal, exposed, spontaneously painted and, despite the diffusion of her form through the brushwork, evokes a vivid sort of biological immediacy. In contrast, by choosing a back view, Seurat erased all concrete evidence of the wet nurse's professional activity and her relation to a suckling infant, leaving us with a minimal sign—her long-ribboned hat and cloak—not a human process.[24] Seurat really worked at

FIGURE 14. Berthe Morisot (French, 1841–1895). *Nursing,* 1879. Oil on canvas; 50×61 cm. Washington, D.C., private collection.

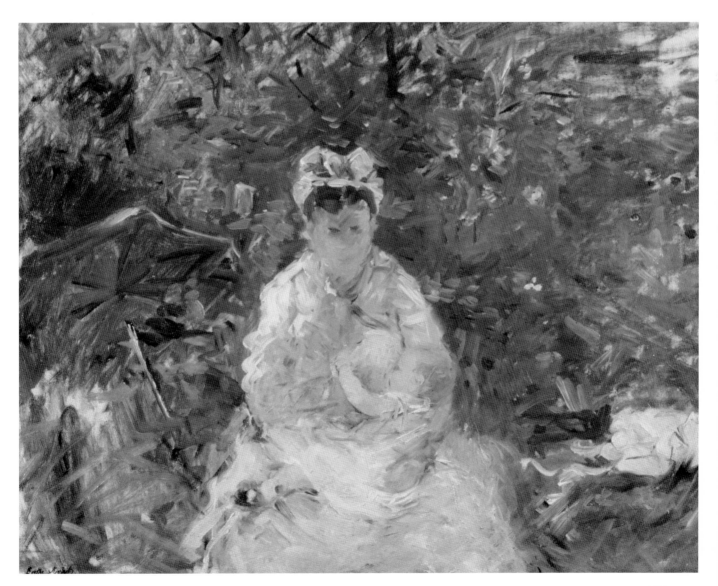

FIGURE 15. Georges Seurat, *Nounou in Profile*, c. 1882. Conté crayon; 30 × 24 cm. Albert Rothbart Collection. Photo: Russell 1965, p. 140.

FIGURE 17. Georges Seurat, *Back View with Baby*, c. 1882. Conté crayon; 32 × 25 cm. Switzerland, private collection. Photo: Franz and Growe 1983, fig. 35.

FIGURE 16. Georges Seurat, *Nurse with Carriage*, c. 1884. Conté crayon; 31 × 25 cm. New Jersey, Eugene Thaw Collection. Photo: Herbert 1962, p. 115.

FIGURE 18. Georges Seurat, *Nounou*, 1884–85. Conté crayon; 23.5 × 31.1 cm. Goodyear Collection. Photo: Franz and Growe 1983, fig. 69.

this figure; we can see the process of reduction in a series of conté-crayon drawings, ranging from a relatively descriptive and empathetic one (fig. 15) to a monumental back view (fig. 16). Despite the fact that the body in *Nurse with Carriage* is constructed of a few black-and-white curves and rectangles, joined by the most subtle nuances of tone marking the wet nurse's identifying ribbon (doubling as a kind of tonal spinal column), the wet nurse is nevertheless represented as connected to her charge, pushing a pram. In *Back View with Baby* (fig. 17), the baby has become a faceless echo of the nurse's circular cap; her body, though still standing, begins to assume the symmetrical, wedge-shaped form of the wet nurse in the final version of the *Grande Jatte*.

Finally we come to *Nounou* (fig. 18), closely related to the final figure in the *Grande Jatte*. Of her Robert Herbert remarked: "The nurse, seen from behind, is as chunky as a boulder. Only her cap and ribbon, flattened into the vertical plane, make us sure she is indeed a seated woman."[25] Seurat in short reduced the wet nurse to a minimal function. There is no question, in the final version, of her role as a nurturer, of a tender relation between suckling infant and "second mother," as the wet nurse was known. Here we do not witness her nurturant

action. The signs of her trade—cap, ribbon, cloak—*are* her reality: it is as though no others exist to represent the individual in mass society. Seurat then may be said to have reduced, not to classicize or generalize, as Rich believed, but to dehumanize, to transform human individuality into a critical index of social malaise. Types are no longer figured as picturesquely irregular, as in the old codes of caricature, but flattened into sardonically eloquent logos of their trades—as does capitalism itself, as Signac might have said.

I must then end as I began, reading the *Grande Jatte* darkly, seeing in its compositional stasis and formal reduction an allegorical negation of the promise of modernity—in short, an anti-utopian allegory. To me the *Grande Jatte* would seem, as it did to Roger Fry in 1926, to represent "a world from which life and movement are banished and all is fixed forever in the rigid frame of its geometry."[26] And yet there is a detail that contradicts this reading—small but inflecting its meaning with a dialectical complexity and lying at the very heart of the *Grande Jatte*: the little girl with the hoop (fig. 1). This figure was hardly conceived in its present form in the large, final sketch (p. 195, fig. 26). In the earlier version, it is hard to tell she is running at all. The figure is less

diagonal, more merged with surrounding strokes; she seems connected to a brown-and-white dog, which is missing or displaced in the final version. The little girl is unique in that she is dynamic, her dynamism emphasized by her diagonal pose, her flowing hair, and her fluttering sash. She exists in total contrast with the other child contained under a geometric umbrella, passive, dependent, almost a clone of her mother. The running child is free, mobile, and goal-directed, chasing after something we cannot see. She also forms the apex of a triangle formed by the prancing dog in the foreground and a soaring, reddish butterfly to the left. Indeed the pose of the pug (like the running child, added late in the process of composition) seems to have been made in response to the dynamic contour of the running child.[27] She signifies Hope, in Bloch's terms, the utopian impulse buried in the heart of its dialectical opposite, the antithesis of the thesis of the painting.[28]

How different is Seurat's dynamic figuration of Hope—not really an allegorical figure but one that can allegorize—from Puvis's stiff and conventional post-Franco-Prussian war and Commune version. Puvis's images of hope (see fig. 19) are hopeless, if we conceive of

hope as the possibility of change, of an unknown but optimistic futurity rather than a rigid, permanent essence, couched in a classical language of embarrassed nudity or chaste drapery.

Seurat's figuring of the child-as-hope, active in the midst of a sea of frozen passivity, brings to mind a similar figuration—the child artist busily at work hidden away in Courbet's *Painter's Studio* of 1855 (fig. 20), subtitled "a real allegory." Unlike the *Grande Jatte* though it may be in many other ways, it is the nineteenth-century work that comes closest to Seurat's in the way it envisions utopia as a problem rather than a ready-made solution, as well as in its resolutely contemporary setting, and paradoxically in its static, frozen composition. Like the *Grande Jatte*, the *Painter's Studio* is a work of great power and complexity in its inextricable blending of utopian and non- or anti-utopian elements, indeed its representation of the utopian and anti-utopian as dialectically implicated in each other. In the gloomy cavern of the studio, the child artist, half hidden on the floor to the right, is the only active figure aside from the working artist himself. His alter-ego, the little boy admiring Courbet's handiwork and occupying center stage, ac-

FIGURE 19. Pierre Puvis de Chavannes. *Hope*, 1872. Oil on canvas; 102 × 127.5 cm. Baltimore, Walters Art Gallery.

FIGURE 20. Gustave Courbet (French, 1819–1877). *The Painter's Studio*, 1855. Oil on canvas; 360.7 × 622.3 cm. Paris, Musée d'Orsay.

cording to the artist himself, stands for the admiration of future generations; like Seurat's little girl, this child can also be read as a figuration of hope—hope as embodied in an unknown future.[29]

Yet the negative vision of modernity, specifically urban modernity, predominates in Seurat's oeuvre. His project of social critique through the construction of a new, partly mass-based, scientific formal language continued throughout his short but impressive career: in *The Models* (pl. 5), a sardonically humorous statement of the contradictions involved in modern society in the relationship between life and art, contemporary models peel off their clothes in the artist's studio, baring their reality in the presence of an artwork, a portion of the *Grande Jatte*, which is more contemporary, more socially circumstantial than they are. Which element stands for art? The traditional nudity of the "three graces," systematically presented as frontal, profile, and back view, or the grand painting of modern life that foils them? In the profile study for *The Models* (fig. 21), the

formal language itself embodies contradiction, a clash of systems, so to speak, in the juxtaposition of the simple, diagrammatic form of the body, which is standardized in its curves and angles, with the veil of multicolored dots that obscures the boundaries of the form with an atomized diffuseness. In *Le Chahut* of 1889-90 (fig. 22), commodified entertainment, the coarse product of the mass-culture industry adopted by the cosmopolitan and less-sophisticated middle classes alike, is pictorially constructed as hollowness and artifice, rather than as spontaneous pleasure, as Renoir might have figured it, or even as spontaneous sexual energy, in the manner of Henri de Toulouse-Lautrec. The transformation of the nose of the man on the right into a piglike snout overtly

149

FIGURE 21. Georges Seurat. *Study for "The Models,"* 1887. Oil on panel; 24 × 14.6 cm. Paris, Musée d'Orsay.

FIGURE 22. Georges Seurat. *Le Chahut*, 1889–90. Oil on canvas; 169 × 139 cm. Otterlo, Rijksmuseum Kröller-Müller.

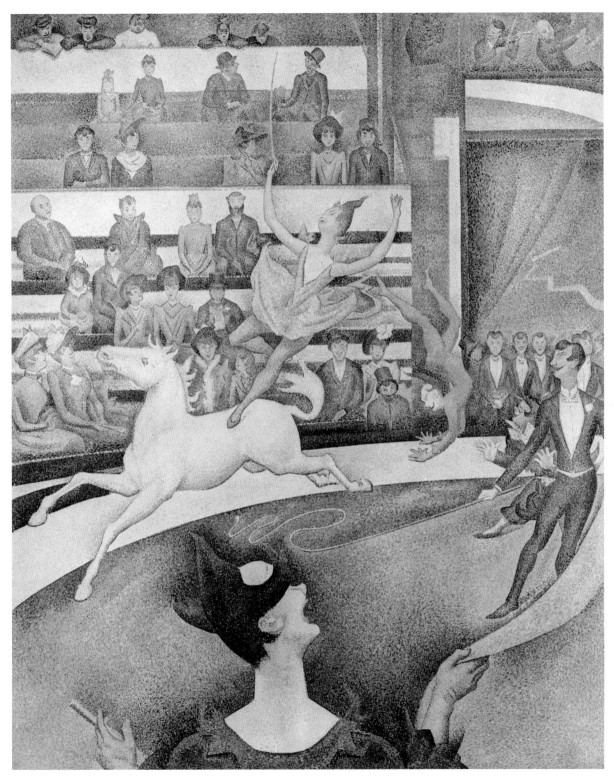

FIGURE 23. Georges Seurat. *The Circus*, 1891. Oil on canvas; 179.5 × 148 cm.
Paris, Musée d'Orsay.

FIGURE 24. Franz Wilhelm Seiwert (German, 1894–1933)
Peasant War, 1932. Oil on panel; 102 × 149 cm. Wupper-
tal, Von der Heydt-Museum der Stadt.

emphasizes the greedy consumption of pleasure. The
dancers are types, decorative diagrams, high-class adver-
tisements for slightly dangerous recreation.

In the *Circus* of 1891 (fig. 23), it is the modern phe-
nomenon of spectacle and its concomitant, passive spec-
tatorship, that are at issue. The picture parodies the
production of art, allegorized as a kind of public perfor-
mance, dazzling in its technique, turning somersaults to
gratify an immobilized audience. Even the performers
seem frozen in poses of dynamism, coerced into stan-
dardized arcs, disembodied diagrams of movement.
There are even more sinister interpretations of the rela-
tion of spectators to spectacle in the *Circus*. As well as
standing for the public of art consumers, that audience,
fixed in a state approaching hypnotic trance, may be

read as indicating the manipulation of the masses. In this
regard, Thomas Mann's sinister *Mario and the Magician*
comes to mind, or Hitler and the crowd at Nuremberg,
or more recently the American electorate and the per-
former-candidates who mouthed slogans and gesticu-
lated with practiced artistry on television. Thus the
meanings of the *Circus*, as an anti-utopian allegory, ex-
tend into time beyond inscribing the social problematic
of its day.

If the *Grande Jatte* and Seurat's work in general have
too often been enlisted in the "Great Tradition" of West-
ern art, force-marched from Piero to Poussin to Puvis,
they have all too little been related to some of the more
critical strategies characteristic of the avant-garde art of
the future. For example the work of an obscure group
of political radicals working in Germany in the 1920s
and early 1930s—the so-called Cologne Progressiven—
Seurat's radical formulation of modern experience finds

FIGURE 25. Gerd Arntz (1900–?).
Four prints from *Twelve Houses of
the Age*, 1927. Woodcut; 26 × 16 cm.
Berlin, Kunze Gallery. Photo:
Politische Kunstruktivisten 1975.

its inheritance—not its influence or continuation—in the twentieth century, although the Progressiven went much farther in their anti-utopianism than Seurat did himself. Political activists, they were equally against art for art's sake and the contemporaneous Expressionist inscription of social malaise in agitated paint surfaces or expressive distortions, which they felt to be simply individualist hyperbole. The group, including Franz Wilhelm Seiwert (see fig. 24), Heinrich Hoerle, Gerd Arntz, Peter Alma, and the photographer August Sander, turned to the dispassionate diagramming of social iniquity and class oppression in a style appropriated from the flow-charts used by capitalists themselves, as a weapon of revolutionary consciousness-raising (see fig. 25). Anti-utopians par excellence, they like Seurat used the codes of modernity to question the legitimacy of the contemporary social order. Unlike Seurat they called the legitimacy of high art itself into question; yet one might say that this too is inherent in certain aspects of the artist's practice. With his emphasis on the antiheroic rather than the gestural; on the "patient tapestry," with

its implications of machinelike repetitiveness rather than the impatient slash and scumble of what Fénéon denominated as "virtuoso painting";[30] and on his insistence on social critique rather than transcendent individualism, Seurat may be seen as the ancestor of all those who rejected the heroic, and apolitical, sublimity of modernist art in favor of a critical practice of the visual. The photomontages of Berlin Dada or the collaged constructions of Barbara Kruger are, from this vantage point, more in the line of Neo-Impressionist descent than the innocuous oil paintings of those who happened to use little dots of paint to construct otherwise conventional landscapes or sea scenes and called themselves Seurat's followers. The anti-utopian impulse lies at the heart of Seurat's achievement, in, as Bloch saw it, the "single mosaic of boredom," the "empty-faced . . . dolls," the "expressionless water of the Sunday Seine"—in short, the landscape "of painted suicide which does not come off because it lacks resolve." It is this legacy that Seurat left to his contemporaries and to those who came after him.

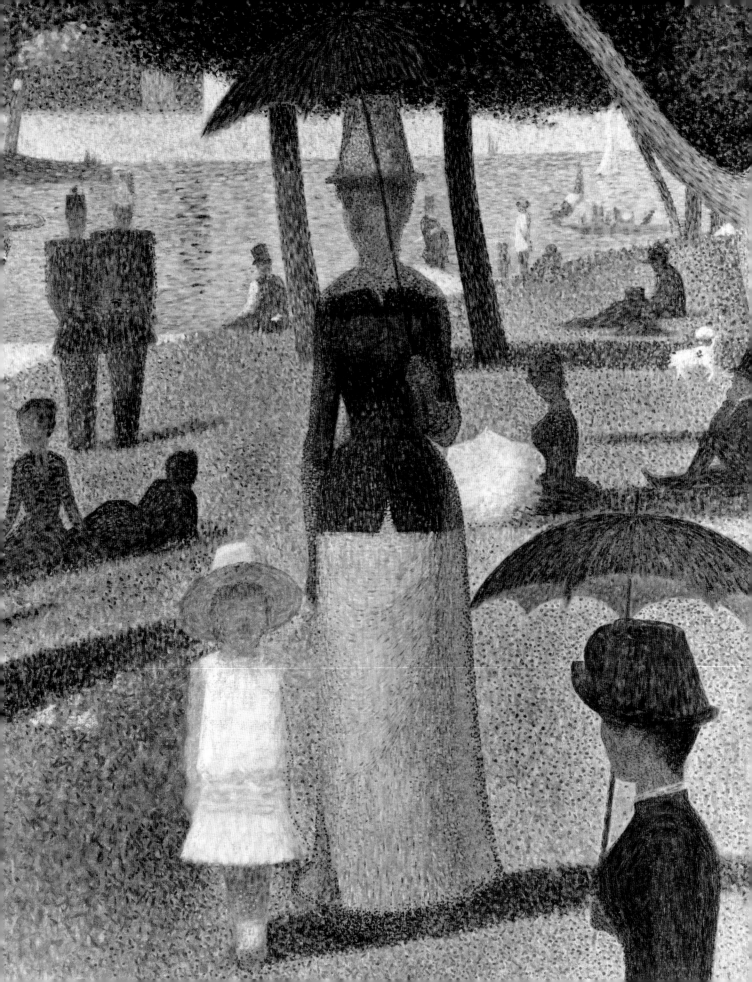

The Family and the Father:
The *Grande Jatte* and its Absences

S. HOLLIS CLAYSON, *Northwestern University*

AMATEUR and professional admirers of Georges Seurat's *Sunday Afternoon on the Island of the Grande Jatte* (pl. 2)[1] would agree that color blindness could decisively distort a clear vision of the painting. Another disabling condition is less often acknowledged: what I call "gender blindness" has consistently hindered our comprehension of Seurat's epic picture. Motivated by a desire to compensate for this blind spot in the art-historical literature, I have sought in this essay to establish a rereading of the painting in which issues of gender receive the consideration they deserve.

On Ascension Day (May 22) 1884, the twenty-four-year-old Georges Seurat began work on a project that resulted in an epic, almost seven-by-ten-foot painting (pl. 2) and eighty-odd related works, including more than forty oil sketches on small wooden panels known as *croquetons*, three larger studies on canvas, and about thirty conté-crayon drawings.[2] The large painting itself was completed in March 1885 for inclusion in the second

Indépendents' exhibition, but it was cancelled. Perhaps spurred on by advice from artist Camille Pissarro, Seurat set to work on the painting again in the fall. He finished his revisions by May 1886 in preparation for what turned out to be a double exhibition: it was part of the eighth and final Impressionist show (from May 15 to June 15) and the postponed second Indépendents' exhibition (from August 21 to September 21).

During the 1885–86 session of work on the painting, Seurat altered the contours of the major figures in the foreground of the composition.[3] A close look at portions of the painting in the Art Institute reveals demarcations between the work undertaken during the first and second campaigns, such as the back edge of the dress worn by the large woman at the right (fig. 2). The original, straight, vertical contour of her gray-blue skirt is still visible two to three inches inside the present, irregularly curving profile of the garment.

In choosing the theme of leisure activities out-of-doors, Seurat used what was in 1884 a familiar subject for Parisian modern-life painting, but he altered the way it had been used by its nineteenth-century pioneers, the Impressionists and some of their contemporaries. Indeed the difference between Seurat's and the Impres-

FIGURE 1. Georges Seurat (French, 1859–1891). *Sunday Afternoon on the Island of the Grande Jatte* (detail of pl. 2).

155

FIGURE 2. Georges Seurat. *Sunday Afternoon on the Island of the Grande Jatte* (detail of pl. 2).

sionists' articulation of this theme has been the focus of much *Grande Jatte* scholarship in the twentieth century. Meyer Schapiro was probably the first modern scholar to focus on this issue. In 1935 he noted the contrasts between the *Grande Jatte* and a typical work by Claude Monet of the mid-to-late 1860s (see fig. 3): "In Seurat the figures are isolated individuals, in Monet they are more sociable and are clustered in communicating groups."[4] Because Schapiro believed that both pictures were socially accurate descriptions, he argued that the key to their visual differences was social—that their differing styles owed directly to the contrast between the habits of Monet's upper-middle-class fun-seekers and Seurat's lower-class ones.

In recent iconographical studies of Seurat's *Grande Jatte*, battle lines have been drawn around the issue of whether or not the artist selected a social subject that deals with class contrasts. John House followed Schapiro's line of thinking in his 1980 discussion of the differences and continuities between Seurat's first two large-scale paintings—*Bathing, Asnières* (pl. 1) and the *Grande Jatte*—and most recently in his paper presented here.[5] House argued that the paintings were conceived as a pair, because they were originally exactly the same size (Seurat enlarged the *Grande Jatte* in 1890 by adding a painted "frame") and because of a topographical con-

tinuity between the two: the group in each picture faces the other one from the opposite bank of the same river. House also observed that the pictures vary in style and in representing different classes of people. He compared the lower-class figures of *Bathing* (who appear "very much at their ease" because, he implied, the lower classes were more accustomed to not working), to their somewhat vulgar social superiors on the *Grande Jatte* (who appear stiff and awkward, according to House, because they were still newcomers to the realm of leisure). As T. J. Clark has conclusively shown, in the late years of the nineteenth century, leisure was the symbolic field in which the lower middle class was actively attempting to be part of the bourgeoisie.[6] House recognized the symbolic and actual importance of leisure at the time and concluded that the distinct leisure style of each of the two populations accounts for the dissimilarities of style that Seurat adopted for each painting; but he offered a controversial explanation of the differing recreational behaviors shown in the two paintings: "Both are about leisure and recreation, and these are natural for one class but artificial for the other."[7]

Several other scholars who share Schapiro's belief in the appropriateness of Seurat's style to the class of the island's Sunday visitors have argued that the population of both the island and the painting was socially diversified rather than homogeneous. Griselda Pollock and Fred Orton suggested in 1980 that the subject of Seurat's picture may be "the confusions and contradictions of social relations and encounters that were part of the Grande Jatte at that time."[8] In his 1985 book on Seurat and in his article included here, Richard Thomson agrees that Seurat's Sunday afternoon pleasure-seekers are a socially diverse group.[9]

In 1984 Clark argued that the *Grande Jatte* quite definitely visualizes differences of class, showing worker and bourgeois sharing the same pleasures, most vividly in the group of three in the painting's lower-left corner.[10] For Clark recognizing and picturing social distinctions in this fashion is one of the unique features of Seurat's picture and marks the artist's salutary departure from what Clark sees as the mythologizing, evasive, and even duplicitous images of later nineteenth-century modernism. Clark was the first art historian to recognize the connection between certain social developments in the second half of the nineteenth century and the development of modern painting that is "blurred" both in its appearance and in its narrative.

Clark recognized that the emergence of a new class, the lower middle class (*petite bourgeoisie*), was the key social development of the period. The expanding number of government employees, white-collar workers in the private sector, and small shopkeepers were the three most important groups within this class, which nearly doubled in size between 1870 and 1910.[11] With origins in the working class and with aspirations to full membership in the bourgeoisie, it was "uncertain of its own social position, at once confronted with, but also actively cultivating, its own sense of rootlessness and marginality."[12] This introduced into life in Paris—which possessed an otherwise legibly stratified population—a new atmosphere of fluidity, especially in certain public sites of pleasure. According to Clark, too many Impressionist painters complacently registered the new ambiguities, and, in so doing, gave form to a spectacular fiction, "according to which 'class' no longer mattered or indeed no longer effectively existed."[13] It is in view of this disparaging verdict on many Impressionist pictures of Parisian life[14] that Clark found Seurat's *Grande Jatte* to be unusually and admirably truthful in its representation of the coexistence of different classes and the tensions that this produced.

Despite the probity of various discussions of Seurat's figuration of social variety in the painting,[15] its abstracted, formal language, with the clean edges of its forms and stylized costumes, has made difficult any decisive verdict on Seurat's depiction of class difference. Indeed it is somewhat ironic that the aspect of identity about which the painting is least distinct—social-class membership—is the item that scholars of iconography have scrutinized most extensively. The characteristic Marxist concern with social stratification has led scholars to focus on class in the painting, but so has an insensitivity to and general disinterest in issues of gender and age. Clearly the crowd in the painting contains people of both sexes and of a wide variety of ages. If we sort out the forty-odd figures in the painting by gender, the women outnumber the men. It is clear that Seurat decided to feature women and children. Of the painting's eighteen largest figures, fourteen are female.[16] Of the females, three are young children and one is an adolescent, leaving ten adult women sharing the foreground with only four adult men.

Certain figure groupings merit comment in this regard. The mother and child holding hands and facing the viewer at the center of the picture (fig. 1) underscore the thematic importance given here to family relations, and call attention to the contrasts between them and the partial family units that surround them. There are three additional pairs of mothers and daughters in the foreground space of the picture;[17] none is accompanied by a man. Only one complete nuclear-family group—man, woman, and child—can be found in the picture. Just to the right of the large, branched tree, near the picture's

FIGURE 3. Claude Monet (French, 1840–1926). *Garden of the Princess, Louvre*, 1867. Oil on canvas; 91.9 × 62.1 cm. Oberlin, Ohio, Allen Memorial Art Museum, Oberlin College, R. T. Miller, Jr., Fund (48.296).

FIGURE 4. Georges Seurat. *Sunday Afternoon on the Island of the Grande Jatte* (detail of pl. 2).

center, is a mother fussing over the blanket of the baby held by the father (fig. 4). Those women who are clearly accompanied by men do not have children with them. The most prominent of them is the large woman in the right foreground, leading a monkey on a leash and walking with a dandy sporting a monocle and smoking a cigar. Just to the left of their faces, the small figure of the other escorted woman (pl. 9) strolls, her back to the viewer, with a companion who holds his hands behind his back. Indeed, tracing our way back and forth, in and across the space of the picture, as its construction and staging invite us to do, we happen upon all manner of diverse, non-familial relationships: a nurse and an old woman, two soldiers, a young woman fishing accompanied by a female friend, a dreamy man leaning against a tree, a short-skirted girl with parasol gazing at the river, a young woman with white umbrella seated alone on the grass, and so forth.

The principal two-dimensional compositional device deployed to organize the painting's foreground population is an irregular triangle whose corners are formed by the three key groups of figures: the mother and child at the apex; the trio of two men, a woman, and a dog at the lower left; and the strolling couple with the monkey and leaping pug at the right. The deliberateness and obviousness of this organizational strategy and the large scale of the figures show that Seurat meant his epic account of contemporary social life to be read principally in these seven figures. In fact, what the painting says about contemporary social relations is spoken most loudly by them, or rather by the relations and differences between them, both in their small, separate groups and across the triangular structure.

In order to evaluate the significance of Seurat's elaborate choreography, we need to consider, if only briefly, the relationship between what is in the picture and what Seurat found on the island during his many visits to it.[18] The artist spent many summer and early fall mornings in 1884 painting on the island, and just as many afternoons working in his studio. In numerous painted sketches (done on-the-spot on his father's cigar-box lids), there is no suggestion of nuclear family groupings, let alone children (see fig. 5). Adult figures are generally not paired or grouped, but are shown seated or standing alone on the grassy banks. Many such solitary and relaxed figures did not survive Seurat's editorial procedures. Other motifs in the studies became keynotes of the large canvas. For example, sketching on the island, Seurat recorded a

FIGURE 5. Georges Seurat. *Seated Figures: Study for the "Grande Jatte,"* c. 1884/85. Oil on panel; 15.5 × 24.9 cm. Cambridge, Mass., The Harvard University Art Museums.

FIGURE 6. Georges Seurat. *Seated Women: Study for the "Grande Jatte,"* 1884. Oil on panel; 15.2 × 24 cm. Paris, Musée d'Orsay. Photo: Paris, Réunion des Musées Nationaux. Paris.

strolling mother and child which, as we have seen, became the central group of the finished work (fig. 1).[19] Another panel (fig. 6) shows two women seated side-by-side and facing into the landscape before a three-wheeled, rattan baby carriage. In the final painting, Seurat repeated the two women and baby carriage (partially overlapped by the silhouetted back of the woman with a monkey) and added a child, whom one of the women encircles with her arm. The placement of this intimate group was painstakingly studied in a conté

crayon drawing (fig. 7). In the finished composition, a little blond girl in red runs across the grass, presumably toward the seated threesome.

Even with only a glimpse of the painstaking procedure by which Seurat adjusted perception to conception, we can see how he gradually established the right half of the picture as a domain of women and children whose space is forcefully penetrated by the huge couple in the foreground. Why did Seurat include so many women and children and relatively few men in his picture of a sum-

FIGURE 7. Georges Seurat. *Three Women: Study for the "Grande Jatte,"* c. 1885–86. Conté crayon on Ingres paper; 23.5 × 30.5 cm. Northampton, Mass., Smith College Museum of Art.

mer Sunday? Perhaps he found the island filled up in this way, but the evidence of the small-scale studies suggests this was not so.[20] And since both concept and percept mattered equally to Seurat in the mid-1880s, we must stretch well beyond our knowledge of his subject in order to explain his painting of it. To find out why he devised this cast of characters and handled them the way he did, we need to focus on the painting's two principal social themes—the day off and the family—and how they are interrelated here.

The traditional practice of stopping work on the Sabbath and religious holidays changed during the nineteenth century. The practice was suspended after the revolution of 1789, but reinstated by law in 1814, at the start of the Bourbon Restoration. It was apparently allowed to lapse from about 1830.[21] The right to leisure was debated with fervor in 1871, during the Paris Commune, when work was attacked as social regimentation. This debate inspired Paul Lafargue's pointed and widely circulated 1880 critique of the obligation to work, entitled "The Right to Laziness."[22]

The Third Republic government was of two minds about Sundays off: it believed that the regularization of leisure was very important, but, not wanting to impose or recognize religious obligations, it formally repealed the 1814 law in 1880.[23] Afterward, the question was discussed vigorously in a variety of fora, partially in the context of the increasingly active labor-union movement in France. However, of the 4,560 strikes held in France between 1871 and 1890, only twenty-three were directly caused by a demand for a regular day off.[24] A law guaranteeing all female and child workers a day off was passed in 1892, and one securing the same right for male workers was passed in 1906.[25]

By the date of Seurat's picture, Sunday was virtually a universally shared day of rest, because almost all salaried workers and most day laborers were off, along with those who never worked because they did not need to.[26] But even though most Parisians had Sundays off, this did not mean that members of different social strata were likely to spend that day in the same way, in the same social groupings, and in the same sorts of places. In fact the ways in which Parisians of the lower classes were likely to spend Sundays at the time was a matter of principal concern to a number of highly placed parties in later nineteenth-century France.

160

In 1874, for example, the French Academy of Moral and Political Sciences announced an essay competition on the theme of "The weekly day of rest from the point of view of morality, intellectual culture, and industrial progress."[27] The winning entry, by a Parisian lawyer named Joseph Lefort, saw in the Sabbath the means of "revitalizing family life." He praised houses in the country, celebrated gardening, and proposed that French taverns shorten their hours. Of particular interest is the following disciplinary insight: "The secret of working-class morality lies in a Sunday day of rest."[28] The connection between revitalized family life and appropriate Sunday leisure is drawn in no uncertain terms in Lefort's sanctimonious essay. It is clear that Sunday was conceived as a showcase to demonstrate proper family behavior on the part of a population still on the road to respectability. During the World's Fair held in Paris in 1889, an international congress of weekly repose (Congrès international du repos hebdomadaire) was convened which praised the Sunday day of rest as a "liberal and democratic institution" that would yield favorable results for "the normal development of physical, intellectual, and moral life, family life, social peace, and the prosperity of the nation."[29] The phrase "the normal development . . . of family life" shows that the reformers firmly believed that proper Sundays would beget moral families.

Historians of nineteenth-century France have observed that the family was the object of regulations intended to control and discipline a heterogenous population by homogenizing the structure and values of French domestic life.[30] Lower-class French men and women were urged to embrace the "bourgeois mode of life," whose organizational and ideological touchstone was thought to be a rigorous home- and child-centered family structure.[31] The ideal family comprised one set of parents and their children, detached from other relatives and from the outside world. Children were therefore expected to learn everything from their parents; families were no longer to rely upon the network of the street, the traditional source of social, practical, and moral models and advice.

Such immersion in family was believed to be pleasurable as well as moral because of the emotionally satisfying companionship it can provide. (In other words, take this medicine because it will heal you, and, luckily for you, it tastes good, too.) Indeed the satisfactions of home life were held out to men as compensation for

deprivations they suffered in the realm of work. (Emotional satisfaction in the roles of spouse and parent was taken for granted for women.) By the mid-1880s, however, cracks were plainly visible in the facade of the domestic ideal: the *Loi Naquet*, passed in 1884, legalized divorce for the first time since the 1789 Revolution.

There were of course large and small transgressions of the family ideal short of divorce court. Since, to paraphrase Lefort, working-class morality resided in a properly spent Sunday, one way of disobeying the family mandate was misbehaving on Sunday. For the reformers, a misspent Sunday was synonymous with male absence from family activity, because the assumption was that most women would naturally stick close to home. A transgressive practice of long-standing among working-class men was taking off work on Monday in celebration of *Saint Lundi*, in addition to Sunday.[32] On Monday one extended one's absence from the workplace by enjoying the company of friends. It was widely believed that workers who took both days off often spent them in the same way: drinking with friends and therefore badly. Thus the moralists' agenda was to eliminate altogether the pursuits of Monday and to make Sunday into a time spent with family.

A missed day of work was an economic loss for employer and laborer alike: the patron lost a man's labor; the worker lost a day's wages. In 1875 an American observer of European workers queried: "May not even the loss of this one day's wage suffice to put a stop to all possibility of saving, or even in some cases be sufficient in itself to throw a family into inextricable difficulties?"[33] Although the forceful voices of the time recognized the unfortunate financial consequences of worker disobedience, they believed that the health of family life was what ultimately mattered. Indeed, not spending time relaxing with one's wife and children (the consequence of an incorrectly spent Sunday) was considered just as bad as having no money for clothes and food (the effect of missing work on Monday).

Ironically the problematic demands of the bourgeois family united the absentee worker and his disapproving employer by bonds of maleness. Although social leaders and theorists believed that the family is or should be the center of society's intelligibility, men tended to regard the position as an unacceptable limitation of their masculine freedoms, as patent emasculation. Sundays off required them to act like women, who were always expected to emphasize their family-defined roles of wife

and mother, even in the workplace.[34] Lower- and middle-class men alike resisted the pressure to spend spare time in the company of their families, preferring the society of men friends or other women. And if workers did the right thing on Sunday, some resisted wholesale regimentation of their lives—by "society" and by their wives—by continuing to skip work on Monday.

Looking closely at the artist's earlier riverine leisure picture, *Bathing, Asnières*, will help us to better grasp his characterization of Sunday off in the *Grande Jatte*. House was the first to observe that the two paintings constitute a pair; I concur that they are connected, but I will argue that they represent Monday and Sunday, respectively.[35]

Bathing has never been labeled "Monday"; yet its tranquil assembly of men and boys resting against the backdrop of a working factory must have been inspired by the all-male work-stopping rituals of *Saint Lundi*. The link between *Bathing* and the celebration of *Saint Lundi* in the 1880s reveals the simultaneous contemporaneity and chronological incongruity (which I will call "anachronicity") of Seurat's social awareness and descriptive practice, a combination that shows up in the *Grande Jatte* as well.

By the time Seurat completed *Bathing* in May 1884, the working-class tradition of Mondays off was changing. Workers had come to associate its celebration not with resistance to employers or to wives, but rather with the resignation and frustration of admitting to being a worker.[36] During the Second Empire, for example, workers preferred to take off Monday because, unlike Sunday, there was no need to dress up. But, by the 1880s, workers dreamed of escaping from their blue smocks and dressing like the middle class did.[37] Indeed, more and more workers managed to do precisely that: analysis of workers' budgets in the later nineteenth century shows that an increasingly large percentage of income was expended on leisure-time clothing in order to reduce the traditional sartorial distinctions visible between the classes on Sunday.[38]

As Thomson has shown, in its early stages, *Bathing* was conceived as a proletarian picture but was transformed into an image of shopkeepers and artisans in the course of the development of the project.[39] In the final canvas, knee-length white cloaks, tabbed leather boots, bowlers, and straw boaters (shopkeeper's garb) were substituted for the blue smocks and *casquettes* worn by the men in earlier sketches. Seurat updated the subject of his first major painting by replacing a working-class

population with members of the ascendant class of the day, the lower middle class—recruits from Léon Gambetta's "nouvelles couches sociales" (new social ranks).[40]

Right from the start, Seurat's version of the theme was somewhat idiosyncratic. A tavern was the customary setting for images of Monday, such as Jules Breton's (1858; St. Louis, Washington University Collection), but Seurat's errant, male workers do not drink while they bask in hazy sunshine alongside the river. He recast the conventional image of laborers on Monday by giving it an Impressionistic setting. His final move—to substitute *petit-bourgeois* shopkeepers for manual laborers—made the painting undeniably contemporary. By featuring *the* expanding class of the 1880s within the framework of a proletarian leisure tradition, Seurat presented it with forthrightness as an entity not entirely distinct from the proletariat. The origins of the *petite bourgeoisie* were working-class after all. While the painting's reference to *Saint Lundi* in the 1880s betrays Seurat's "anachronicity," the disposition of the men on the riverbank in the final composition avoided the old-fashioned iconography of tavern and drink.

Because the class of the picture's occupants has always been such an important issue, the absence of women from the composition has passed unnoticed, which has in turn retarded efforts to identify its subject. In fact the single sex of the painting's population is its surest link with the theme of Mondays off, which, as we have seen, was an exclusively male form of resistance against the related ethics of work and family responsibility. Gender blindness has again taken its toll.

The least clearly familial and most anti-social of any of the groups in the *Grande Jatte* is the trio at lower left. The three appear to be strangers who temporarily share a patch of shaded grass. Their sharing of the space and time for leisure, according to Clark, "does not result . . . in an infinite shifting so much as an effort at reaching a *modus vivendi*, agreeing to ignore one another, marking out invisible boundaries and keeping oneself to oneself."[41] The woman passes the time by reading and sewing, while the men spend it gazing off toward the river. The smaller man, in bourgeois dress from head to toe, appears uncomfortably hot, and tense, suggesting the special effort he exerted to be well turned out on Sunday. The other male idler is sprawled out and relaxed like the reclining man in *Bathing*, and his sleevelessness connotes an ostentatious disregard for standards of dress of the others on the island. He is also the most massive and detailed male figure in the painting.

Surely Seurat accorded him such prominence because he seems to have recognized the role that such a character played in the classed and gendered game of Sundays off, straddling, as he does, the dividing line between the lower middle class and the proletariat. For workers in the 1880s who maintained an old-fashioned mentality, the shame of not being able to afford being well dressed kept them away from bourgeois parts of the city on Sundays. On the other hand, the credo for the progressive majority of workers was: "I might only be a worker, but I can certainly turn myself out as well as any bourgeois."[42] These laborers made a no-holds-barred attempt to efface signs of class in their Sunday dress. This certainly applied to lower-middle-class leisure-seekers as well, such as the small, top-hatted man in the *Grande Jatte*. And there were the hardcore hold-outs, such as the sprawling, muscular sportsman in the painting, who wore workers' clothes with swaggering and obstinate affection, defying those who wished to moralize and transform them.[43] Just as Seurat showed his modernity (and perhaps his politics) by replacing the lower-class figures in sketches for *Bathing* with shopkeepers in the final canvas, he gave a defiant, proletarian body to his foreground male figure in the *Grande Jatte*, but provided him with a less explosive wrapping: clothing that indicates his affiliation with a then-popular, physically demanding form of Sunday leisure—rowing. His body retains the memory of "old-fashioned" proletarian sartorial protest, while his dress converts him into a believable, if nonconformist, member of the crowd. While he is the odd-man-out in this image of island society, his protest is accommodated without a fuss by the new, cool means of dealing with encounters in a public park.[44] In addition he challenges the social order by lounging about without any apparent family. Elsewhere in the painting, as we have seen, it is the *absence* of men that expresses this challenge.

The large couple profiled at the right of the painting furnishes the most explicit deviation from the prescribed mode of family behavior. From the painting's first showing in 1886, the female figure with the large bustle and the monkey has been identified as a loose woman (*cocotte*).[45] She and her dandified companion are the painting's leading emblems of venality and indecency. The man may be a husband and father spending the day with a woman who flaunts her disregard for society's maternal script. The right half of the picture, with its group of women flanking the foreground couple, seems to have been structured to emphasize the *cocotte's* defiance of

bourgeois ethics. The constraints upon the close-knit group of women and children sitting on the grass at the right are further reinforced by the dandy's cane, which hems in and sharply delimits their space. And the general fragility of family-based social relations seems to be expressed in the way that the clusters of women doing their best to oversee children while enjoying the park appear overwhelmed by the size, placement, volume, and darker tonality of the foreground couple.

The woman with the monkey is the moral opposite of the mother. As such she poses problems for men, as well as for women and children. She all but obscures her companion, and, placed as she is directly in the path of the little girl in red running across the grass, she becomes an ominous obstacle to "innocence." Because the composition seems to emphasize the vulnerability of unaccompanied women and children, and because the picture's population of leisure-seekers does not conform to normative patterns, we might ask just what Seurat had in mind concerning the Sundays of his day.

Seurat's personal history does not explain his position on these issues, but aspects of his life are illuminating nevertheless.[46] His family was very well off. Three years before Georges's birth in 1859, his father, Antoine Seurat, at the age of forty-one, sold his lucrative notary business[47] at La Villette, then an independent commune north of Paris, to spend the rest of his days as a wealthy, nonworking Parisian. Georges was the third child of four (but he resumed the position of youngest child when his younger sibling died at the age of five). By all appearances, he was a respectful son in an active and close-knit extended family. Throughout his adulthood, when his family was in residence in Paris, he ate every night at his mother's dinner table. When Edgar Degas spotted him, dressed-to-kill, walking from his studio to his parents' apartment at dinner time, he lampooned Seurat's conventionality by calling him a notary.[48] When the Seurat clan was off to this or that chic vacation spot, Georges usually went along.

His sister, Marie Berthe, delighted her parents by marrying an engineer who became a wealthy industrialist; Georges and his amateur playwright, older brother, Emile, took no such steps toward financial and social prominence and security. Begrudgingly their father granted them each a living allowance. It is difficult to determine whether Georges Seurat, the obedient participant in the social rituals of the Seurat and Faivre clans (his mother was born Ernestine Faivre), found it all an onerous obligation or a pleasure. He is reported to have

taken obvious delight in the company of his cousins' children, but no other record of the artist's feelings on this subject survives. One thing we do know of course is that he lived a completely secret personal life, utterly unknown to and unsuspected by his parents. When he appeared mortally ill at the family apartment at 110 Boulevard Magenta, on March 17, 1891, he was accompanied by his pregnant mistress, Madeleine Knobloch, and their thirteen-month-old son, Pierre Georges. Within one, extraordinary, thirty-six-hour period, Antoine and Ernestine Seurat learned of Georges's liaison and child and witnessed their younger son's death at the age of thirty-one.

Seurat's membership in a wealthy family of Second Empire and early Third Republic Paris is no guarantee of his espousal of bourgeois values and biases, especially since his personal life seems to have been a rejection of the expectations built into the circumstances of his own origins. Another big question mark remains the artist's politics and the degree to which he shared the anarcho-communist ideas of other Neo-Impressionists.[49] Since labor historians suggest that anarcho-communist worker organizers may have called for a return to the regular celebration of *Saint Lundi* as a form of resistance,[50] this is a particularly significant gap in our knowledge that could bear directly upon his intentions for *Bathing* and the *Grande Jatte*.

Certainly Seurat's painting of the Sunday rituals of relaxation among the lower middle classes went against the grain of the practices of his own family. The image also opposes the moralists' campaign for correct leisure, because it resists presenting the family as a bounded universe that guarantees society's coherence and stability. At the same time, the fracturing of the family and the coexistence with strangers visible in the picture are not shown as emotional or psychological gains for these Parisians. Their release from family ties has won them freedom, but at a cost: it is freedom without relaxation, without apparent fun, without meaningful connections to one another.

In the *Grande Jatte*, the institutions of the family and of the Sunday holiday—the former defined principally by gender, the latter by class—interfere with one another. In effect leisure seems to disrupt families. As a group, the population of the picture is made to appear more ardent about the pursuit of Sunday sunshine and

freedom than about the preservation of family togetherness on a shared day off. Given the fundamental mismatch here between family-structured and day-off activities, it could be argued that the oft-remarked immobility of the *Grande Jatte*'s population records an emotional and social stalemate resulting from the tensions and conflicts between the determinedly upwardly mobile men and women in the painting.

For Seurat it seems that once women are part of the day off, problems begin and tensions multiply. A critical difference between *Bathing* and the *Grande Jatte* is that one picture is all male and the other mostly female. The presence of women with children in the *Grande Jatte* introduces the responsibilities of the home, which men considered constraining. In fact it seems as though men are not on the island because children and their mothers are. Mother-child relations, however, are sympathetically recorded. There are only three instances of people touching one another in the entire painting, and they are all between mothers and children. It seems that for Seurat the absence of fathers is the prerequisite for parent-child warmth, even coexistence.[51]

One yearns to be able to equate the *Grande Jatte* with a position fully inside or against the ideology of correct leisure, but the visual contradictions and complexities of the picture do not let it be categorized quite so tidily. Its classical structure, smoothly sculptural figures, and scientific surface appear to be respectful of its subject, while the inconsistencies of its scale, space, handling, and detail seem to denote the absurdities of the customs and appearances portrayed.[52] But because relations are so obviously tense in the *Grande Jatte*, Seurat may have wanted to comment on the emotionally unrewarding unorthodoxy of lower-class pursuits, or to remark upon the incommensurability of a lower-middle-class Sunday and a middle-class one.

For most of the people in Seurat's *Grande Jatte*, the desire to spend a day in the sun—to have what a bourgeois deserves—has won out over a concern to comply with the terms of another bourgeois ritual: tending the flame of domesticity in order to maintain the conventions of respectable family life. Leisure has overwhelmed the family. Small wonder that the all-male assembly of *Bathing*—given its relatively uncomplicated theme—appears so calm and relaxed by comparison.

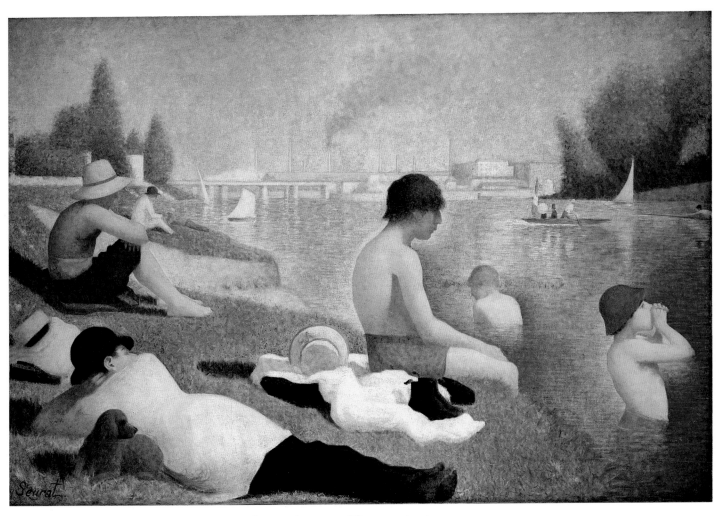

PLATE 1. Georges Seurat (French, 1859–1891). *Bathing, Asnières*, 1883. Oil on canvas;
200 × 300 cm. London, National Gallery.

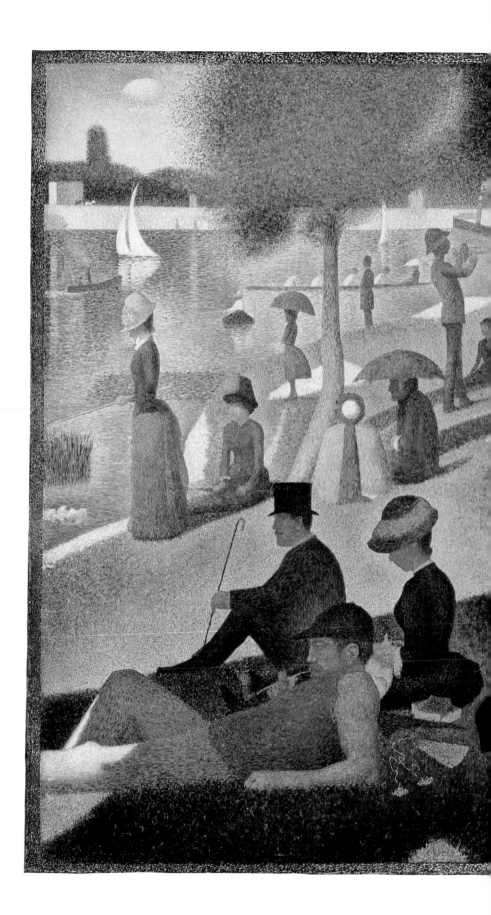

166

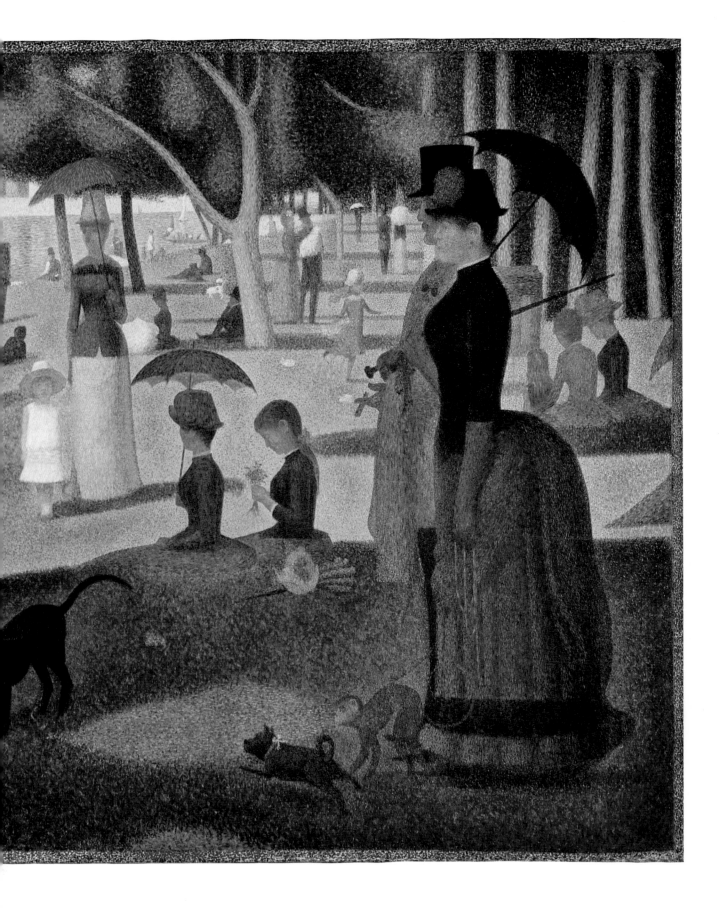

PLATE 3. Georges Seurat. *Oil Sketch for the "Grande Jatte,"* 1884. Oil on panel; 15.5 × 24.3 cm. The Art Institute of Chicago, Gift of Mary and Leigh Block (1981.15).

PLATE 4. Georges Seurat. *Study for the "Grande Jatte,"* 1884. Oil on canvas; 64.7 × 81.2 cm. New York, Mrs. John Hay Whitney.

168

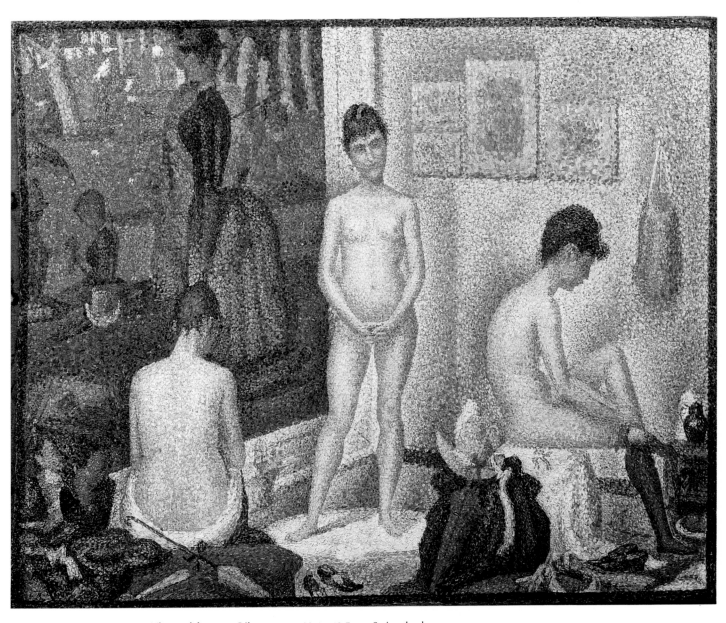

PLATE 5. Georges Seurat. *The Models*, 1888. Oil on canvas; 39.4 × 48.7 cm. Switzerland, private collection.

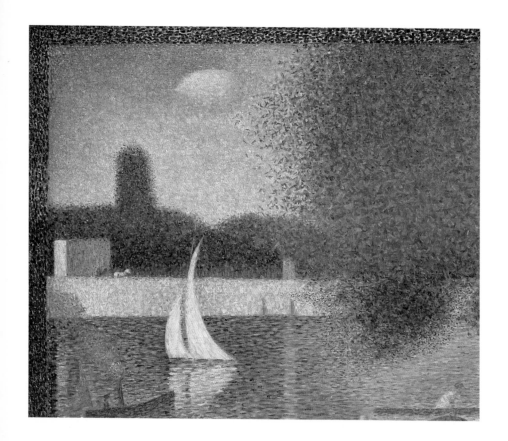

PLATE 6. Georges Seurat. Detail of the upper-left corner of the *Grande Jatte* (see p. 174, figure 1).

PLATE 7. Photomicrographs were taken of portions of the *Grande Jatte* at magnifications of 5.6 to 11 times, to present details that are not readily visible to the eye. In a section of water (see p. 174, fig. 1), magnified here 5.6 times, Seurat's first-stage technique can be seen. He applied partially blended, horizontal strokes in thin layers. The apparent dot pattern seen here actually reveals the canvas weave underlying the paint. Due to the constraints involved in photographing aspects of this large canvas, the angles of this and the following photomicrographs do not always align with the painting as seen on page 174, figure 1. All photomicrographs were taken by Inge Fiedler.

PLATE 8. Georges Seurat. Detail of the lower-left corner of the *Grande Jatte* (see page 174, figure 1).

PLATE 9. Georges Seurat. Detail of the couple in the upper-right section of the *Grande Jatte* (see page 174, figure 1).

PLATE 10. In this photomicrograph taken from the top of the fisherwoman's hat (see page 174, figure 1), magnified 7 times, can be seen dots that were originally orange and yellow. These almost circular dots, similar in shape and spacing, are a good example of the brushwork involved in Seurat's Divisionist technique and can be compared with his more blended first-stage brushwork for the water at the left of this photograph. Though the dots are fairly closely spaced, the coverage is somewhat incomplete, leaving portions of the first-stage brushwork still visible beneath the small, round strokes.

PLATE 11. This photomicrograph illustrates a portion of the boundary between highlights and shadow in the grass at the lower right of the painting (see page 174, figure 1), magnified 7 times. Here there is darkening of zinc yellow dots (to ocher color) and zinc yellow combined with emerald green, which resulted in the olive-green tone mentioned by critic Félix Fénéon in 1892. These two pigments show partial mixing, as is evident by the unblended yellow in the lower portion of the green stroke; underlying first-stage brushwork can be seen as well.

PLATE 12. Georges Seurat. Detail of the middle left section of the *Grande Jatte* (see page 174, figure 1). This detail shows a portion of the border and adjacent water area. The closely placed red, orange, and blue dots that comprise the border are accompanied in this section by a band of more widely spaced dots that shift in color depending on the color areas with which they are juxtaposed. The water, with its blended, horizontal brushstrokes, was done during the first stage of work on the painting.

PLATE 13. Seurat applied large, elongated dots and dashes in the borders; these are typical of his brush-work in 1889–90. This is a photomicrograph of the border (see p. 174, fig. 1) magnified 7 times. The larger strokes, running parallel to the picture's edge, are covered occasionally by smaller, rounded dots.

PLATE 14. Most sections adjacent to the border, as seen in plates 6 and 12, have a parallel series of large dots that echo the line of the border in the painting. The majority of these dots are orange or yellow, though a fraction, as here, are blue and green. The dots are simple mixtures. This area, magnified 11 times, shows an orange dot consisting of brushmarks of chrome yellow and vermilion combined with lead white; parts of a blue and green dot in the band are also visible.

A Technical Evaluation of the *Grande Jatte*

INGE FIEDLER, *The Art Institute of Chicago*

*I*N OCTOBER 1982, Georges Seurat's *Sunday Afternoon on the Island of the Grande Jatte* (pl. 2) came to the Art Institute's Conservation Department for examination and analysis while a white frame replicating that which Seurat originally designed for the painting was constructed for its rehanging. This presented the conservation staff with a rare opportunity to perform the most comprehensive technical study of this work in its history. It had not undergone a complete examination since its treatment in 1957.[1] We thoroughly examined the painting using infrared reflectography, ultraviolet fluorescence, and x-radiography. Pigment samples were taken and analyzed in order to determine the overall palette and the different materials Seurat used in three separate campaigns on the picture. We also hoped to elucidate the types of unstable pigments that Seurat was reported by contemporaries to have used. In addition, stereomicroscopy enabled us to document Seurat's technique.

Working with a surgical scalpel, we removed 180 microscopic pigment samples using a stereomicroscope at magnifications ranging from sixteen to forty times actual size (the large size of the *Grande Jatte* precluded adequate sampling near the center of the canvas). We then immediately transferred the samples to microscope slides and permanently mounted them in a special medium whose properties assisted us in our subsequent analysis. To determine the exact types of pigments present, we used polarized light microscopy, which employs specific interactions with light vibrating in a known direction. This allows us to measure the optical and physical properties of a specific material such as color, shape, size, sample homogeneity, and some highly complex optical phenomena.[2]

Seurat began the *Grande Jatte* on Ascension Day in May 1884 in preparation for the Société des Indépendants' exhibition scheduled for March 1885. The technique he used was similar to that of his first large composition, *Bathing, Asnières* (pl. 1). However, the exhibition was subsequently cancelled and Seurat suspended work on the painting in the spring of 1885. In the following October, the artist resumed work on the *Grande Jatte*, incorporating concepts of Chromo-luminarism which he had first applied to his pictures during

173

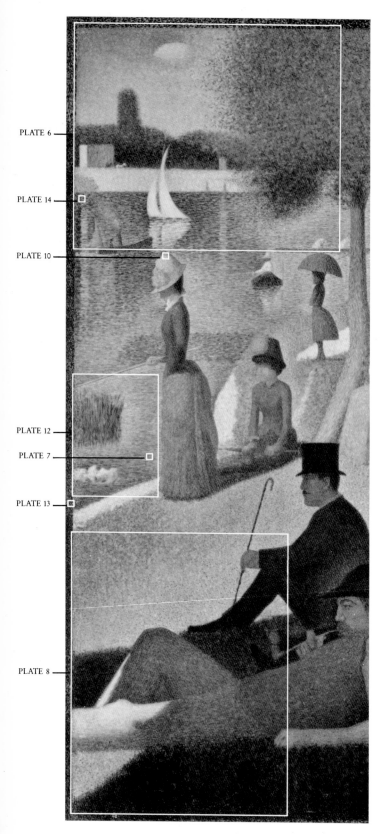

PLATE 6

PLATE 14

PLATE 10

PLATE 12

PLATE 7

PLATE 13

PLATE 8

PLATE 9

PLATE 11

174

FIGURE 1. Georges Seurat (French, 1859–1891). *Sunday Afternoon on the Island of the Grande Jatte* (see pl. 2). The squared sections of the painting indicated here are keyed to the details and photomicrographs seen in plates 6–14.

the summer in Grandcamp (see fig. 2). These concepts were derived from his readings of color theorists Michel Eugène Chevreul and Ogden N. Rood, preceded by his study of the writings of Charles Blanc on the work of Eugène Delacroix and on color theory.[3] It was during this second campaign that the artist added the more or less regularized dots of color to the painting's surface. In actuality these dots should be considered small brushstrokes, for they were not always perfectly round. He chose to work this way as the best means to achieve optimum optical-mixing effects.[4] In many instances, these dots were placed so as to outline or delineate existing first-stage features. Seurat also enlarged and altered the silhouettes of many of the main figures by adding bands of variable width or outlines executed in his Divi-

sionist technique.[5] In addition he added thin outlines to some figures; these outlines (mainly in pink) are among the few, essentially continuous, linear features in this work. The painting was exhibited in its revised form in May 1886 at the eighth Impressionist exhibition. The third and final stage consists of a border added sometime after 1889. The border comprises a band of large dashes and dots in colors approximately complementary to the adjacent portion of the painting. To provide room for this border, Seurat had to restretch the canvas to include what had previously been the tacking margins. In order to better understand the three stages of development of the *Grande Jatte*, the reader can study, in plates 6–14, details of the painting whose location in the overall work is indicated in figure one.

By the late nineteenth century, commercially prepared canvases had become increasingly popular and were available in a variety of fabric types with standard sizes, weaves, and surface textures. In France such preprimed canvases were generally mounted on stretchers whose size was determined by eventual use: there were different formats for portraits, landscapes, and seascapes.[6] Be-

FIGURE 2. Georges Seurat. *Bec du Hoc, Grandcamp,* 1885. Oil on canvas; 66 × 82.5 cm. London, Tate Gallery.

cause of the *Grande Jatte's* monumental size, Seurat probably had to order a special, oversized canvas—a single piece of coarse linen that had been commercially primed with a relatively thin layer of lead white tinted to a neutral off-white tone and mounted on a seven-member stretcher frame. The combination here of a coarsely woven canvas and a thin ground layer created a relatively grainy surface. Despite Seurat's reworking of many areas of the painting, the paint layers are generally thin and the texture of the linen discernible through the painted surface (see pl. 7).

Initially Seurat probably roughly sketched or blocked in the overall composition. This can be seen in three small areas in the grass where later layers were lost, to reveal a continuous, thin green underlayer. Seurat used yellow-green in sunlit grass and a darker green in shadow. While the exact manner of Seurat's paint application and the extent to which it originally covered the canvas cannot be fully ascertained, due to the very small fraction of underpainting visible, it seems that he used a technique similar to that of some of his preliminary studies for the *Grande Jatte*, in particular *A Couple and Three Women* (p. 194, fig. 25). This small canvas is sketched in with broad, rectangular strokes. Much of the priming layer was left uncovered and is readily visible between the brushstrokes. Since Seurat probably used a similar layer in the *Grande Jatte* to indicate the placement of the surrounding landscape, it seems possible that he worked out the entire composition in a like manner.

The types of pigments (see Table, p. 176) found in the *Grande Jatte* reveal how the work progressed and how the artist's evolving technique reflects contemporary writings and ideas about color. It is known that Seurat met the artist Paul Signac at the Salon des Indépendants in May 1884 (where *Bathing* was first exhibited); a fruitful period of friendship and intellectual collaboration followed. Various scientific endeavors to analyze color, color combinations, and optics were occurring at this time; artists were beginning to apply the discoveries of Chevreul, Rood, James Maxwell, and Hermann von Helmholtz directly to picture making.[7] Upon seeing *Bathing*, Signac noted that Seurat had used ochers and browns in addition to pure colors and that therefore "the picture was deadened and appeared less brilliant than those the Impressionists painted with a palette limited to prismatic colors."[8] He supposedly convinced Seurat, in the spring of 1884, to exclude earth colors from his palette and to use only those pigments that attempt to du-

Table: Comparison of Pigments in the *Grande Jatte*

	Stage 1 (1884–85)	Stage 2 (1885–86)	Stage 3 (Border)
Vermilion *(mercuric sulfide)*	X	X	X
Organic Red Lake *(unidentified)*	X	X	X
Burnt Sienna *(calcined iron oxide)*	X		
Iron Oxide Yellow *(hydrated iron oxide)*	X		
Chrome Yellow *(lead chromate)*	X	X	X
Zinc Yellow *(zinc potassium chromate)*		X	
Viridian *(hydrous chromium oxide)*	X	X	
Emerald Green *(copper acetoarsenite)*	X	X	
Ultramarine Blue *(sodium aluminum sulfo-silicate)*	X	X	
Cobalt Blue *(cobalt aluminate)*	X	X	X
Lead White *(basic lead carbonate)*	X	X	X
Black—Charcoal *(carbon)* or Bone *(carbon with calcium phosphate)*	X (minor)		

plicate the solar spectrum. Surprisingly, however, the samples from the first stage reveal the continued use of earth colors such as iron-oxide yellow and burnt sienna, as well as small quantities of black. Thus it appears that, during the first stage, Seurat was in transition to a palette consisting of only spectrally pure hues. The paint mixtures Seurat used during the first stage varied in complexity. He typically combined four or five components (though sometimes up to eight) to achieve the exact color he desired. For example, a first-stage brown tone from the small triangle in the upper-right corner incorporates burnt sienna, iron-oxide yellow, ultramarine blue, organic red lake, vermilion, lead white, and some black; an area of light blue-green water is composed mainly of lead white, with some viridian, emerald green, and a trace of ultramarine blue.

In contrast second-stage mixtures are generally comprised of fewer pigments. A light bluish-purple dot in the leaves of the tree at the left consists of lead white,

ultramarine blue, and a trace of organic red lake. According to the rules of Divisionism, a method Seurat developed, to the color intrinsic to a given object were added the effects of reflected light, perceived by Seurat as small, "solar," orange dots. Much emphasis was placed on the juxtaposition of complementary colors, reflecting Chevreul's ideas on simultaneous and successive contrasts. Simultaneous contrasts are achieved by placing complementary colors side by side, which exaggerates their differences and thus increases the brilliance of both; successive contrasts exploit retinal fatigue (the formation of an after-image, but of the opposite color) to create momentary, complementary halos around objects to enhance their luminosity. Seurat implemented this by painting thin, complementary-colored halos around some of the main figures, such as the couple with the monkey. He adopted his dots of color—small, separate points approaching circularity—to depict the effect of light rays emanating from an object. Since they were intended to be combined optically on the retina rather than physically on the palette, only a minimal mixing of adjacent colors was deemed necessary.[9] All of these effects are achieved with spectrally pure hues applied with a minimal mixing on the palette; these are applied as small, adjacent brushstrokes which optically fuse in the eye to create the desired vibrancy. In addition to eliminating earth colors and black from his palette, Seurat incorporated a variety of yellows and reds to achieve a more complete duplication of the solar spectrum. Seurat added zinc yellow as well as several red and chrome-yellow pigments in more than one shade, as determined by microscopic identification. The organic red lakes range from a very pale pink to a deep red. Vermilion is present in two forms; larger crystals yielding a red color and a smaller, red-orange variety. Chrome yellow also occurs as a pale yellow, in addition to a deeper yellow-to-orange pigment. A total of eleven colors and lead white have been identified as being part of the second stage. This may correspond to a description of Seurat's 1891 palette as having a row of eleven pure colors, another row directly underneath of the same pigments combined with white, and a third row of pure white for additional mixing.[10]

Seurat's brushwork varied significantly according to the types of forms he was depicting. His first-stage paint application was varied and often directional; for instance, he painted most of the foliage and grass in short, criss-crossed strokes; he rendered the water in disconnected, short, horizontal bands; and he used vertical, multicolored lines to represent tree trunks. To create the figures and their accessories, along with the animals in the foreground, he employed a combination of ellipses, short broken lines, and slashes, which follow the shapes, depict details within the figures, and indicate highlights and shadows. Most of these brushstrokes are linear, though there are some that curve to follow the shape of some of the forms. Many of these aspects are present in the second stage as well.

An example of first-stage technique with minimum coverage by subsequent additions can be seen in the upper-left portion of the *Grande Jatte* (pl. 6). While Seurat's method here is similar to that of the Impressionists, he rendered the objects more precisely. The wall on the opposite bank is a series of blended, criss-crossed strokes, while the water consists of short, horizontal bars of blue and various reflected colors (see pl. 7). The sail also consists of blended strokes that follow the form of the sailcloth. Some second-stage dots are apparent in areas such as the foliage above the embankment, along the top edge of the wall, in the wall around the edges of the sails, outlining the woman fishing, and in the adjacent water plants. The far left edge also has a band of dots to the right of the border; whether this was added during the second stage or during the creation of the border is unknown.

In his second campaign on the painting, the artist applied pigment over existing layers with differing degrees of coverage. Some of the principles of Seurat's new Divisionist method are illustrated in a detail of the bottom left corner (pl. 8). The shadowed grass was originally composed essentially of a dark green layer; in order to enhance the shadow effect, Seurat added blue slashes and dots to complement the illuminating color, solar orange. To the same end, he applied similar blue dots to the area representing the reclining man's trousers and added pink dots as highlights. Orange dots and slashes can be found in the brighter parts of the shadowed grass as well. These solar effects are virtually absent in the darkest shadows. Originally the yellow and yellow-green sunlit grass had many light yellow dots (they have shifted to yellow-brown; see below); a concentrated band of such dots is present where the sunlit and shadowed grass meet. Clearly Seurat wished to achieve the greatest luminosity in sunlit areas by means of an abundance of light yellow dots and lesser luminosity in the lighter portion of the shadows with orange dots, creating the darkest shadows by an absence of such highlights. To most sections of the painting, Seurat added dots ranging from yellow to

orange, representing solar reflections, and the complementary blue dots for shadow. Although these were generally applied randomly, there are instances where they were placed to follow specific forms. Among the most significant of the few linear features used by Seurat in the second stage are the thin outlines around many of the figures, such as those surrounding the couple in the upper right (pl. 9). The pink line that silhouettes them is partly covered or repeated by regularly spaced blue, dark green, and pink dots. These dots have been placed along the right and bottom edges of the figures in order to enhance their outlines and depict shadow. In addition to these outlines, Seurat also employed long dashes to define the contours of some of the forms.

In the *Grande Jatte*, the effect of pervasive solar reflections and luminous highlights created by yellow-to-orange dots has been seriously affected by some major changes in the pigments used by the artist. This shift occurred very quickly. In a review of Seurat's memorial exhibition written in April 1892, the artist's friend, the critic Félix Fénéon, observed: "Because of the colors which Seurat used [in the *Grande Jatte*] toward the end of 1885 and in 1886, this painting of historical importance has lost its luminous charm: while the reds and blues are preserved, the Veronese greens are now olive-greenish, and the orange tones which represented light now represent nothing but holes."[11] Examination of the painting corroborated the veracity of Fénéon's comments. The substance zinc yellow, in the chemical form of zinc potassium chromate, has changed most significantly, adversely affecting all the colors mixed with this pigment. Dots composed mainly of zinc yellow, which were originally a bright yellow, have become a yellow-brown that is almost ocher; zinc yellow mixed with vermilion, which had been orange, has turned to warm brown; and yellow-green dots, composed mainly of zinc yellow with varying amounts of emerald green, have shifted to olive (see pls. 10, 11). The alteration of the zinc yellow was probably caused by oxidative changes in the chromium.[12]

Emerald green (or Veronese green, as it was known in France) was extremely popular in the nineteenth century because of its unusual, brilliant blue-green color, though many artists expressed concerns about its instability. A copper compound, it was known to have a propensity to darken or blacken when in contact with pigments containing sulfur (such as cadmium yellow) or with sulfur compounds in the air.[13] If, as Fénéon attested, it changed

in the *Grande Jatte*, the fact that it was often mixed with a deeper green viridian, as in the shadowed grass area, makes an exact determination of darkening difficult. Fénéon could have been referring mainly to the yellow-green dots (in the sunlit grass), which have clearly altered. Robert Herbert mentioned Seurat's use of unstable pigments purchased from a certain "Maître Edouard." In fact the painter Camille Pissarro had advised Seurat to use such pigments for the reworking of the *Grande Jatte*.[14] In a similar vein, it is interesting to note Signac's comments in his diary about the few reworked areas in Seurat's *Bathing*: "On [*Bathing*], which dates from '83, Seurat added, around 1887, small touches, in order to fill in missing elements. (In this painting done for the Salon, he had made concessions as far as divisionism went.) The last brushstrokes, done with colors from the wretched Edouard, [have] completely blackened, while the background has remained pure."[15] Such references lead to speculation that some pigments known for their inferior quality were nevertheless being sold; on the other hand, it can not be entirely ruled out that the artist's, and perhaps even the color merchant's, limited knowledge of the chemical properties and innate instabilities of some of the material (much of which had only been recently introduced commercially) may have led to their unfortunate use.

The borders (see pl. 12) provide further insights into the kinds of experiments the artist incorporated into his paintings. Sometime after 1889, Seurat formulated the idea of colored borders and frames, and began adding these painted edges to most of his pictures, including many of his earlier works. With these additions, he wished to provide a visual transition between the interior of the painting and its frame by creating borders of colors that are approximately complementary to the adjacent areas of the painting proper.[16] The brushstrokes are simple, usually single colors, predominantly blue and red with some orange and yellow painted over a layer of lead white (see pl. 13). Many sections of the border are accompanied by a series of large dots within the painting, most of which are orange or yellow, though a fraction are blue or green (see pl. 14). This band of dots is not present along the entire border and its width and density vary. As mentioned above, Seurat had to increase the size of the *Grande Jatte* to provide space for the borders by exposing canvas that had originally been part of the tacking margins. He expanded the overall dimensions of the stretchers by adding four wooden strip

FIGURE 3. This x-ray of the upper-left edge of the *Grande Jatte* (plate 2) shows the faintly visible, white gesso-filled holes at intervals where the painting was attached to its stretcher before Seurat enlarged it to accommodate his painted borders, added in the third and last stage of his work on the picture. Since x-rays penetrate the entire painting, the wooden stretcher member appears as the wider band, with two large screws and a row of tacking nails embedded into the wood.

moldings to the existing stretcher members. It was noted during conservation treatment of the painting in 1957 that small, white, gesso-filled holes appear within the painted border area at regular intervals.[17] Recent x-radiography of the entire painting confirmed the existence of tacking holes in the borders. These gesso-filled holes are faintly seen in the thin band along the edge of an x-ray detail (fig. 3). After Seurat enlarged the surface, he applied a layer of lead white as a substratum for the colored dots. Many of the other paintings to which he added borders did not have extra canvas to accommodate them. On these he painted directly on the edges of the paintings.

Finally the matte surface of the *Grande Jatte* seems to have been intended by Seurat to enhance the effects of Divisionism. A matte surface displays the proper spectral colors from all viewing directions, whereas overcoating with a glossy varnish would both alter the relative saturation values of many of the pigments and result in glare when viewed at certain angles. Another detrimental effect of natural varnishes is their tendency to yellow with age. A yellow layer would totally change or mask the color interrelationships of the many elements that form a Chromo-luminarist image. The Neo-Im-pressionists, well aware of color-value distortion, glare, and darkening with time caused by varnish, specifically recommended against its use.[18]

As a result of the two months we were able to study the *Grande Jatte* in the Art Institute's Conservation Department, we have gained considerable knowledge of Seurat's working methods and the variety of materials he used in the *Grande Jatte* and related works painted between 1883 and 1889.[19] This information ultimately gives us a better overall understanding of nineteenth-century art history, especially as it was affected by technology and science. Much of what Seurat wrote regarding the time-frame in which the painting was created, as well as observations made by Fénéon and Signac about color changes that occurred soon after the painting was completed, was corroborated by our study, resolving questions that had been unanswered for many years. The precise cause of visual changes in the yellows and greens has been isolated to a single substance that spontaneously darkened. Obviously, the "chemical revolution" of industrial nineteenth-century Europe created pigments with inherent weaknesses, as well as stengths. Still unknown is whether Seurat used zinc yellow only in the *Grande Jatte* or whether he incorporated it into any of his other paintings. In this regard, Signac's mentioning of colors that darkened during Seurat's reworking of *Bathing* make it significant to find out whether or not Seurat used the same pigments in this painting. Our impression of the *Grande Jatte* would be very different if the color changes had not happened. If one imagines bright yellows, greens, and oranges instead of ochers, olive greens and browns, how luminous the painting would be—exactly as Seurat had intended. It is thus a testimony to the strength of his ideas and the mastery of his technique that the painting, despite inalterable changes, remains the vibrant work of art it is.

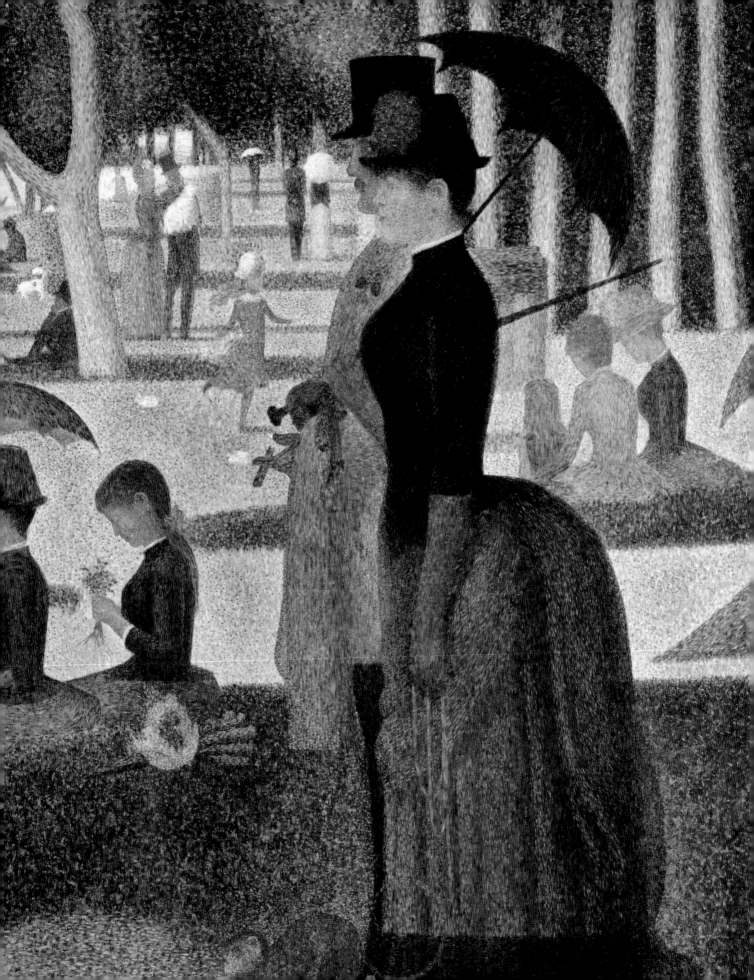

The *Grande Jatte*: Notes on Drawing and Meaning

RICHARD THOMSON, *University of Manchester, Manchester, England*

WE HAVE tended in the past to look at Georges Seurat's *Sunday Afternoon on the Island of the Grande Jatte* (pl. 2; he actually entitled the painting *A Sunday on the Grande-Jatte [1884]*) too exclusively within the fascinating continuum of Seurat's career. Because that career was so short, because his work has so many inner echoes and such internal logic, it has been tempting to concern ourselves with the progress of his technical and compositional development, emphasizing in particular the six large exhibition pictures from *Bathing, Asnières* (pl. 1) to *The Circus* (p. 151, fig. 23). In recent years, art historians have come increasingly to consider the problems of locating works of art within their socio-political context. In Seurat's case, this too has its frustrations, as well as its rewards, not least of which is the almost complete absence of comment or writings by the artist himself. Fortunately there was a substantial body of critical reaction to the *Grande Jatte* when it was first exhibited in 1886, and it is of great value to assess contemporaries' "unpacking" of the picture, their de-

coding of its meanings. However, this important exercise, just as much as exclusive concentration on technical matters, can drag us away from the painting itself, from the setting, motifs, juxtapositions, and emblems that Seurat chose to comprise his grand composition. In the *Grande Jatte*, he addressed himself directly to certain issues and obliquely or subliminally to others. The painting is evidently about the Sunday visitors to the island and also implicitly about the make-up, or chemistry, of that temporary population. It was surely intended as a picture with a point of view, an argument. To convey this, Seurat seems to have made use of imageries and codes that already existed in late nineteenth-century Paris for an artist to deploy or develop, for the spectator to comprehend, spurn, or misconstrue. The purpose of this article is twofold: to set the *Grande Jatte* alongside some of the works exhibited with it in 1886 in order to gauge its consistencies and inconsistencies with vanguard painting one hundred years ago, and to look specifically at the issue of drawing, of the articulation of form, for Seurat and other artists at this time. Once the imagery of the *Grande Jatte* is set in context, it becomes possible to look at the interrelationships of drawing and meaning.

FIGURE 1. Georges Seurat (French, 1859–1891). *Sunday Afternoon on the Island of the Grande Jatte* (detail of pl. 2).

181

The Population of Paris and its Suburbs: Representation and Allusion

Seurat set two major figure paintings in suburban localities to the northwest of Paris, *Bathing, Asnières* and the *Grande Jatte*. The earlier of the two pictures, *Bathing*, began as a proletarian image.[1] From the first *croquetons*, the little oil sketches farthest from the final composition, to those made about midway through the genesis of the picture, Seurat concentrated on figures who are evidently workers. In one sketch (fig. 2), for instance, the man on the bank wears the cap and the man in the water the blue smock customary to the laborer. These early sketches often feature horses used for pulling barges or carts; they seem to belong in front of the vista in the background of industrial Clichy, with its smoking factory chimneys and its road and railway bridges—the arteries of communication and commerce. But Seurat adjusted his conception as he went on. Perhaps, as he became gradually more accustomed to the riverbank at Asnières (for he was a native of an inner faubourg to the northeast of the city center), he realized that his representation was awry, inappropriate. Asnières itself had no heavy industry; it was essentially a lower middle-class bedroom community with greenhouses and small factories and workshops making items such as suitcases. Among its respectable population were also

FIGURE 3. Gustave Fraipont (French, 1849–?). Illustration of Asnières, 1886. Photo: L. Barron, *Les Environs de Paris* (Paris, 1886), p. 33.

FIGURE 2. Georges Seurat. *Seated and Reclining Figures, Black Horse* (study for *Bathing, Asnières*), c. 1883/84. Oil on panel; 16 × 25 cm. Edinburgh, National Gallery of Scotland.

some of the more louche elements of business and the demimonde, such as the shady Tom Levis in Alphonse Daudet's novel *Les Rois en exil* (1879).[2] As his work on *Bathing* progressed, Seurat adjusted his painting and its population. In the final canvas, the factories on the Clichy bank are still present, but bathed in a benevolent haze. The nearside bank has been extended. It shows more of the walled and turreted villa to the upper left, and the men and youths who relax along the riverside are no longer unequivocally proletarian but, with their straw hats, bowlers, and elastic-sided boots, apparently rather the lower middle-class clerks and shopkeepers who formed the core of Asnières's residents. Even the river has been implicitly changed. No longer is it identified with the horses, with the movement of goods, but

182

rather with sailing and sculling, with fresh air and leisure. *Bathing* seems to have ended up as a balance of forces, in which industry and leisure, the two essential elements of Parisian suburban life, exist in some kind of equilibrium.

Seurat's adjustment of his original scheme, the organic development of *Bathing*, probably made him aware of the flexibility, one might almost say the ungraspability, of the location in which he had elected to work. He probably became more conscious of the different constructions of meaning that might be placed upon suburbs such as Asnières. Louis Barron's luxurious guide of 1886, *Les Environs de Paris*, categorizes Asnières as a center for boating (*canotage*), supported in this by Gustave Fraipont's accompanying illustration (fig. 3):

During the week, visitors to Asnières can easily be made out in the streets: it is an amusing spectacle, a motley mixture of correct, clean-shaven gentlemen, obviously actors; of bearded artists, wearing huge hats; of cute women in outlandish clothes; and even the occasional canoeist in a boater, wearing flannels and a striped jersey, the outfit of the freshwater mariner. On Sundays this fixed population of visitors is joined by a tribe of habitual nomads determined to have a good time. Then the rowing boats, skiffs, yachts, and canoes moored along the banks are untied, and for the hundredth or the thousandth time, it's off to explore Surèsnes, Neuilly, the Grande Jatte, and the Ile des Ravageurs.[3]

There is irony here, the enthusiasm of the prose enhancing the sense of dreary, no-longer-fashionable pleasures. Barron was taken to task four years later, in 1890, by Edmé Périer, an inhabitant who characterized Asnières as an even drabber place, the home of petty businessmen, civil servants, employees of the railway company, as well as of market gardeners, artisans, artists, journalists, and the middle ranks of the demimonde.[4] It was a place on the move. Its population almost doubled in the five years before 1886. Comparison of the maps of the area from Baedeker's guidebooks of 1881 and 1900 (figs. 4, 5) indicates how, during the period Seurat worked there, the land between the suburban villages was being devoured by property development.

At the Salon des Indépendants in Paris in 1884, where *Bathing* was eventually shown, Seurat met Paul Signac, who had lived in Asnières since 1880. In one of his rare writings, Seurat made it clear that, on completion of *Bathing* in the spring of 1884, he began work on the *Grande Jatte* project.[5] He may well have felt that his

FIGURE 4. (*Top*) Map of Asnières and other northwestern suburbs of Paris, 1881. Photo: K. Baedeker, *Paris and Environs* (Leipzig, 1881), opp. p. 282.

FIGURE 5. (*Above*) Map of Asnières and other northwestern suburbs of Paris, 1900. Photo: K. Baedeker, *Paris and Environs* (Leipzig, 1900), opp. p. 292.

assimilation of the suburbs, very much under way in *Bathing*, offered still further pictorial promise; and the enthusiastic presence and local experience of Signac probably was an added stimulus. Signac himself painted in the Asnières locality while Seurat worked on the Grande Jatte in 1884 and 1885. One of Signac's most important pictures from 1885, exhibited at the Impressionist show the following year, is *The Seine at Asnières*

FIGURE 6. Paul Signac (French, 1863–1935). *The Seine at Asnières*, 1885. Oil on canvas; 60 × 89 cm. Paris, private collection.

(fig. 6). Painted from the Asnières bank, it looks upstream from the bridges seen in *Bathing* and includes, at the center in the distance, the trees on the northern tip of the Grande Jatte island, which Seurat featured in the upper right of *Bathing*. Its general conception of this suburban area is very like that of *Bathing*. Of course Signac's picture is a landscape, not a large-scale figure composition; but nevertheless its meshing of barge traffic, leisure craft, the distant factories of Levallois-Perret, the ordinary local people of Asnières, and the restaurants and riverside villas to accommodate the visitors achieves an integration corresponding closely to the sense of balance, one might almost say of harmony, in *Bathing*.

The *Grande Jatte* is a substantially more sophisticated painting than *Bathing*, both in terms of its execution and its subject. Some sense of its complexity can be gauged from the critical response to it at the 1886 Impressionist exhibition. The *Grande Jatte* was not badly received, but it was approached with caution, curiosity, and gradual comprehension. Henry Fèvre described his reaction in the *Revue de demain*:

Little by little, one understands the intention of the painter; the dazzle and blindness lift and one becomes familiar with, divines, sees, and admires the great yellow patch of grass eaten away by the sun, the clouds of golden dust in the treetops, the details that the retina, dazzled by light, cannot make out; then one understands the stiltedness of the Parisian promenade, stiff and distorted; even its recreation is affected.[6]

In 1886 the *Grande Jatte* was difficult to accept; it demanded an effort on the part of the spectators. Some were not prepared to make this effort. Naturalist critics such as Gustave Geffroy and Roger Marx, admirers of Claude Monet and Edgar Degas, simply ignored the painting. In 1887 J. K. Huysmans, who had not reviewed the eighth Impressionist show, expressed deep anxieties that Neo-Impressionism could not be adapted to the depiction of the figure, that it did not allow adequate modeling of figures. Those in the *Grande Jatte* he found "rigid and hard; everything is immobilized and congealed."[7] This was new painting: it did not speak to a slightly older generation; it developed from and addressed a new sensibility. Critics discussed it in two ways, generally speaking, and these were by no means mutually exclusive.[8] The *Grande Jatte* evidently needed explanation from a technical point of view to convey its innovations in touch, the luminosity of its color. It also demanded to be described, its fifty figures identified, the characteristics of its specific location decoded. But description, as Fèvre and other critics pointed out, was not enough, because, in this painting, it was not only *what*

was represented but *how* motifs were represented that counted. Alfred Paulet, writing in the republican newspaper *Paris*, expressed this straightforwardly:

The painting has sought to show the routine of the banal promenade of Sunday visitors who stroll without pleasure in the places where it is agreed that one should stroll on a Sunday. . . . Maids, clerks, and soldiers all move around with a similiar slow, banal, identical step, which captures the character of the scene exactly, but makes the point too insistently.[9]

Seurat peopled his island, his Sunday afternoon, neither with an anonymous, muddled crowd nor with individuals, but with types, and this was recognized by the critics. The type had been a standard method for the visual, or even the literary, codification of the urban population throughout the nineteenth century, and remained so in the 1880s. Figures were made to characterize common categories of people by their costume, accessories, and gestures. Seurat had rehearsed this well-tried visual language intensively in his early drawings; when deployed in the *Grande Jatte*, it struck an immediate chord with many reviewers. Five of the twenty or so critics who wrote about the picture in 1886 thought it worthwhile to list types they recognized. Maurice Hermel spoke in *La France libre* of Seurat's "modern symbolism, his schematic wet nurses, conscripts, and oarsmen," while the artist's friend Jules Christophe went farther. For him Seurat had "attempted to capture the diverse attitudes of the epoch, of sex, and of social class: elegant men and women, soldiers, nannies, bourgeois, workers."[10] Seurat's articulation of types was often abbreviated, but the language was so widely understood that this caused no problem. Thus the odd, geometric heap below the tree to the left was easily identified by the trailing ribbons of her bonnet as a wet nurse, and Seurat even made reference to the clichéd juxtaposition, common in this kind of imagery, of the wet nurse and a soldier, her stock suitor. Elsewhere the artist's allusions were equally economical. A caricature of 1883 by Henri Gray (fig. 7) identifies the essential attributes of the suave man-about-town (*boulevardier*): monocle, high collar, top hat, cane, and moustache. Seurat's "leading man," at the right of the canvas, is only partially glimpsed behind his woman friend, but is identifiable by precisely these accessories.

Other artists at the 1886 Impressionist exhibition used the device of the type, as well. Jean Louis Forain's *Place de la Concorde* (fig. 8), for example, juxtaposes pro-

FIGURE 7. Henri Gray (French, 1858–?). *V'lan*, 1883. Photo: *Exposition des arts incoherents. Catalogue illustré* (Paris, [1884?]), p. viii.

FIGURE 8. Jean Louis Forain (French, 1852–1931). *Place de la Concorde*, 1884. Oil on canvas; 71 × 50.8 cm. England, private collection.

FIGURE 9. Edgar Degas (French, 1834–1917). *Woman Trying on a Hat at her Milliner's*, 1882. Pastel on paper; 75.6 × 85.7 cm. New York, The Metropolitan Museum of Art.

letarian and upper middle-class types, the street-sweeper and *boulevardier*, identifying the latter by the details Gray and Seurat deployed for such figures. Forain also differentiated these types by an almost caricaturelike treatment of pose: his *boulevardier* is foppishly gangling, his worker slobbishly lumpen.[11] Degas too included images of types in the exhibition, notably in his pastels of milliners. In *Woman Trying on a Hat* (fig. 9), for example, the middle-class lady is allowed a certain individuality. She casually dominates the space as she preens, while the shop assistant is posed in demure symmetry, literally effaced as she awaits her customer's requirements. Evidently the type was a useful shorthand for signifying class, and critics responded to this.[12] Artists such as Forain and Degas kept the conventions of the type—accessories, costume, and so on—up-to-date by an active, explicitly contemporary articulation of body language and by giving their types a positive social function in an exchange between classes.

Seurat seems to have used other devices for implanting meanings into the *Grande Jatte* that were not directly signaled by the critics but that were intended—one might suggest—to inform contemporary readings of the painting. He seems to have incorporated verbal puns into the fabric of his picture, a device he had not essayed in *Bathing*. It may well be that the literary circles to which he had been introduced in 1884 by Signac, with their "naturalist" and "decadent" relish for argot and wordplay, encouraged Seurat to deploy such vernacular, verbal associations. A case in point is the woman to the right with a monkey. *Singesse*, or female monkey, was contemporary slang for a prostitute;[13] thus the ostentatious woman is identified, for the monkey was often included in licentious images by contemporaries such as Félicien Rops and Henri de Toulouse-Lautrec. Another example is the woman on the far left, salient in her orange dress against the blue water, ludicrously angling with no fishing tackle, yet clad in a chic costume. The

FIGURE 10. Edgar Degas. *Woman in a Tub*, 1884. Charcoal and pastel on paper; 45 × 65 cm. Glasgow, The Burrell Collection.

notion that a prostitute is someone who "fishes" for men was standard at the time, and was compounded by caricatures such as the one by a certain Leys that appeared in the gentleman's magazine *Le Boudoir* in 1880 (fig. 12). This makes a pun on the words *pêche* (fishing) and *peché* (sin), as the young woman flirtatiously asks her companion: "Veux-tu . . . que je pêche?" ("Do you want . . . me to fish [sin]?") Once again such verbal allusion was by no means restricted to Seurat. At the 1886 Impressionist show, a number of critics responded to Degas's nudes by describing them as "froglike," and indeed some are represented in squat, leggy postures that call such an analogy to mind (see fig. 10). Prostitutes who worked in the infamous seedy cafés (*brasseries de femmes*) at this period were often referred to as "bar frogs" (*grenouilles de brasserie*), and the association of a naked woman and a frog was often made in contemporary popular illustrations (see fig. 11).[14] Degas may not have intended this allusion as directly as Seurat did his, but the point here is that this kind of verbal reference or allusion was part of the exchange between artist and critic and, perhaps one can assume, between artist and public. An artist could provide an image with extra layers of meaning by alluding to common visual or metaphorical parlance, a vernacular that inevitably carried connotations of class. And Seurat was not alone in this.

Reviewers in 1886, such as Hermel, did not delay too long in alluding to the meanings and associations of individual elements in the *Grande Jatte*. They were not entirely silent about these associations of course, and the fact that they did not dwell on them may have been tactical, for the painting's technique needed to be explained. Perhaps the very currency of the puns and allusions made explanation unnecessary. However, they did stress the fusion of image and form, indicating this as a pivotal element in their assessment of the painting's meanings. Acquainted with Seurat by the spring of 1886, Paul Adam made this point most forcibly in his article

FIGURE 11. Galice (French, 19th century). *Vignette.* Photo: A. Silvestre, *Le Nu au Salon de 1889* (Paris, 1889).

FIGURE 12. Leys (French, 19th century). *Dis, Totor, veux-tu . . . que je pêche?* Photo: *Le Boudoir,* July 25, 1880, p. 103.

these sheets (see fig. 10) are their media, charcoal and pastel; their subject, the nude—that paradigm of academic draftsmanship—and the forceful pliability of contour. Much was made of this linearity. Octave Mirbeau praised "their prodigious synthetic power and linear abstraction," while, with his artist's eye, Georges Auriol admired how "the line is so supple it ceases to be a contour and becomes an enveloping aura."[17] Degas determinedly used line to order the body into the postures he required, postures that subverted contemporary norms for the nude and that manipulated the body into configurations that could evoke particular meanings or associations for the viewer. For Mirbeau they expressed "the terrifying sense of women under torture, of anatomies twisted and deformed by the violent contortions to which they are submitted."[18] (As he wrote his review, Mirbeau was composing *Le Calvaire,* a deeply misogynistic novel based on a recent love affair which had wounded him deeply, so his response to Degas's nudes was highly personal, wishful thinking.) For others they appeared to be the apogee of realism. Geffroy for instance considered the nudes utterly veristic and unstaged: drawings of a "woman who does not know she is being looked at, as if she were hidden behind a curtain or seen through a keyhole."[19] The poses of the nudes were considered crucial to their meaning. It was not just that they represented naked women washing, or that their flesh and surroundings could be read as proletarian or as bourgeois, but their poses were a factor in the interpretation of these nudes as bestial, as prostitutes, as subversions of the academic ideal.

Camille Pissarro was also praised for his drawing at the 1886 exhibition. This was an unusual response to his work, as, in previous years, his draftsmanship had often been considered rather gauche. But in 1886 his peasant figures were compared to those of Jean François Millet, and the word "robust" rather than "clumsy" was used in relation to his handling of form.[20] Pissarro's drawing had indeed developed over recent years. Around 1880 he had changed his preferred sketching medium from pencil to black chalk, which allowed him to achieve broader effects and more simplified forms. At that time, he had also begun to concentrate more on the figure, to a substantial extent with the encouragement and example of Degas, and so issues of draftsmanship had come to the fore in his work. His most important single picture in 1886 was *Apple Picking* (fig. 15). This was a reprise of a composition that had first appeared in his work in 1881 (fig. 13). In the earlier painting, he was concerned with

for the *Revue contemporaine.* He argued that "the stiffness of the figures and their punched-out forms contribute to the note of modernity, reminding us of our badly cut clothes which cling to our bodies and our reserved gestures, the British cant imitated everywhere."[15] Others compared the painting to Egyptian art, to the art of Memling, to lead soldiers. Fèvre used such words as "stiltedness," "stiff," "distorted," and "affected." What these writers were referring to is the emphatic positioning of the figures; the scant use of torsion or irregular movement in their postures; the preference for frontal or profile poses which imply stasis, not momentum; the repetition of arcs, contours, and silhouettes—all of which impose an apparent orthodoxy upon the forms, which seems to lull the viewer into a false sense of security. These are matters of drawing, arrived at by the making of lines that map out shapes, set them in ambient space, and allow clear-cut form a prominence over modeling (as Huysmans later bemoaned).

Drawing Forming Meaning

At this juncture, it is useful to look at drawing elsewhere in the 1886 Impressionist exhibition. Although Seurat's painting drew much attention at the show (however it was painted, on such a scale, it could hardly have done otherwise), as much, if not more, critical and public interest was raised by the pastels submitted by Degas. Central to this was the suite of nudes showing women washing; ten were listed in the catalogue for the exhibition, but it appears that only six were actually on view throughout the show, with a seventh added midway.[16] Contributing to the emphatically drawn character of

FIGURE 14. Camille Pissarro. *Study for "Apple Picking,"* c. 1885/86. Pastel on paper; 61.2 × 47 cm. Paris, Musée du Louvre, Cabinet des Dessins.

FIGURE 13. Camille Pissarro (French, 1830–1903). *Apple Picking,* 1881. Oil on canvas; 65.1 × 54 cm. New York, private collection.

FIGURE 15. Camille Pissarro. *Apple Picking,* 1886. Oil on canvas; 128 × 128 cm. Kurashiki, Ohara Museum of Art.

FIGURE 16. Paul Signac.
*Branch Line at Bois-
Colombes*, 1885. Oil on can-
vas; 46×55 cm. Photo: Sale
cat., London, Sotheby's,
Dec. 3, 1986, no. 168.

FIGURE 17. Paul Signac.
*Branch Line at Bois-
Colombes*, 1886. Oil on can-
vas; 33×47 cm. Leeds, City
Art Gallery.

variety of touch and effect. It is loose and airy; the figures have been placed with careful casualness in the orchard. In mid-decade he reworked the subject on a large, square canvas over a period of time. Prior to the 1886 exhibition, he retouched the painting to give it a tighter, more uniformly flecked surface, so it would be more consistent with the works with which it would hang, particularly the *Grande Jatte*. The genesis of the new variant had involved preparatory drawings from the model (fig. 14), and these are emphatically simplified, the artist eschewing detail for the general effect, keeping modeling to a minimum and stressing the silhouette of the figure. Pissarro's concern for an interlocking, decorative unity and for synthesis of form required him to pare down his drawing, to impose a clarity, even a rigidity, on it. In late 1885 and early 1886, as Pissarro strove to align his own pictures with the example being set by his younger colleague, drawing assumed an added importance for him. And it was the drawing of Pissarro's peasant figures that contributed to their identity as types, that helped classify them. As Jean Ajalbert enthused over *Apple Picking*: "These peasant women, their build, the fullness of their hips! They're not from the Batignolles [Paris], they smell of soil!"[21]

Signac's drawing also took a slight but measurable turn, apparently in response to Seurat's work. Between late 1885 and early 1886, as he prepared to exhibit with the Impressionists, the presentation of forms via contour became an issue in his work as well. This can be seen in comparing two paintings by him of the *Branch Line at Bois-Colombes* (figs. 16, 17). One would seem to have been painted over the summer or autumn of 1885, the other, with trees in leaf, during the spring of 1886; it was shown at the Impressionist exhibition as a recent work. In both, the strong diagonal of the fence thrusts into space, following the direction of the railway tracks. The earlier painting is more drab in color and freer in touch than the later work; it reminds us that, at the start of his career, Signac had been encouraged by the French landscape painter Jean Baptiste Guillaumin, whose rather casual touch and warm tonalities Signac followed here. For all the firmness of the composition, there is a gestural, improvisational quality about the canvas. This is not the case with the picture shown in 1886. Here the motifs are more regulated, the trees straighter, the spaces more controlled—subtle differences, admittedly, but nevertheless detectable. How might we explain this extra imposition of order on a suburban motif? The suburb of Bois-Colombes, slightly northwest of Asnières, had

once been an independent hamlet, but, by the 1880s, was rapidly being developed as a bedroom community. Even Barron, given to Panglossian prose, found its regimented estates insistently anti-picturesque: "a vast and flat symmetry, monotonous and dry, with perfectly aligned boulevards, straight streets, regular squares, boxlike houses, and carefully walled and railed plots of grass."[22] Perhaps Signac was reaching toward a means of representation that tallied as closely as possible with the dreary propriety of this lower middle-class suburb. The second version of the *Branch Line* is of course almost a resolved Neo-Impressionist painting. It does not yet have a uniformly dotted surface, but Signac was well on his way to achieving a consistent surface and tightly interlocking spatial zones. Perhaps too the very requirements of the new style—the painstaking conformity of touch, the equilibrium of forms, the logic of the spatial organization—demanded the control and discipline of drawing. We might ask similar questions about the major figure painting that Signac showed in 1886: the impressive *Apprêteuse et Garnisseuse (Dresser and Trimmer)* (fig. 20), an image of milliners at work. This painting originated in drawings (see fig. 18) executed in a shadowy, tonal style derived from Seurat's conté-crayon drawings. Signac's study of a woman sewing by lamplight was clearly a point of departure for the painting of milliners, though it was probably not originally intended as a preparatory study. Close as it is to Seurat's manner, it has a haziness, a flaccidity of form, that may be due to Signac's inexperience with drawing the figure (he was largely self-taught); certainly it lacks the "punched-out" quality of Seurat's conté-crayon drawings for the *Grande Jatte*. Signac may have decided to develop such studies on canvas in order to flex his muscles as a figure painter and perhaps to give himself the status of a peer of Seurat's, rather than that of a mere disciple. In a watercolor study for his composition (fig. 19), he emphasized contour, strongly outlining the figures. This harsh definition may have been due to his inexperience with figure painting and his need for a clear plan, or to the fact that the controlled touch with which he would execute his canvas would allow for no improvisation, no freedom of hand. Or perhaps he intended his figures to be "flat and crude," as Fèvre described *Apprêteuse et Garnisseuse*,[23] to convey some meaning, such as the monotony of the work he was depicting.

What about the *Grande Jatte* itself? How did drawing affect the way the picture looks? We must consider two aspects of the word "drawing," but not entirely sepa-

FIGURE 18. Paul Signac. *Apprêteuse et Garnisseuse (Dresser and Trimmer)*, 1885/86. Conté crayon on paper; 23 × 15 cm. Present location unknown.

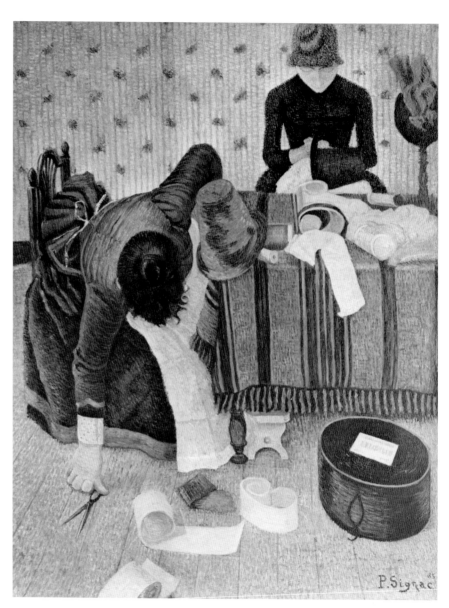

FIGURE 20. Paul Signac. *Apprêteuse et Garnisseuse (Dresser and Trimmer)*, 1885–86. Oil on canvas; 111.8 × 89 cm. Zurich, E. G. Bührle Collection.

FIGURE 19. Paul Signac. *Study for "Apprêteuse et Garnisseuse"* (*Dresser and Trimmer*), 1885/86. Pencil and watercolor on paper; 15 × 20 cm. Present location unknown.

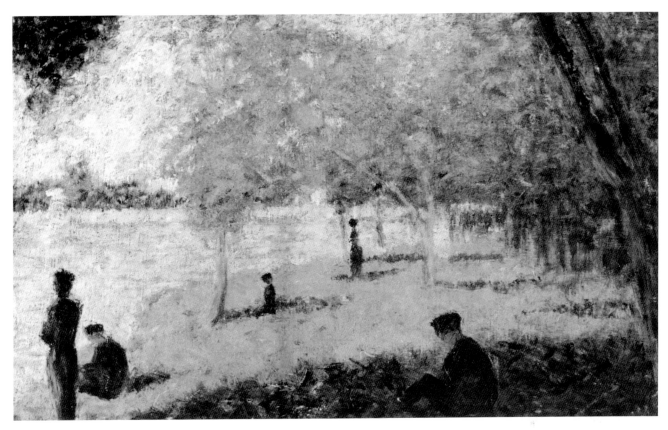

FIGURE 21. Georges Seurat. *Study for the "Grande Jatte": View of the Background with Several Figures*, c. 1884. Oil on panel; 15.5 × 24.1 cm. New York, The Metropolitan Museum of Art, Robert Lehman Collection.

rately, for they are not mutually exclusive: as the practical making of preparatory studies on paper, and also as the more notional ordering of shapes in space. Seurat began to work toward his second big exhibition picture in May 1884, producing first small-scale, loosely painted panels that he executed on site.[24] Drawing in the latter sense is of course built into these, as can be seen in the figures, with their simple silhouettes (see fig. 21). Seurat rapidly resolved the landscape, the stage on which he would parade his types, and, late in 1884, exhibited a canvas empty of figures (pl. 4) at the Salon des Indépendants. Although he had obviously toyed with the disposition of figures during the initial stages of the preparation, it was probably from late 1884 on that he concentrated on this. One can discern among the preliminary drawings some that precede others. *Woman with a Parasol* (fig. 22), although an uncluttered tonal motif, nevertheless exhibits greater idiosyncrasy, less robotlike poise, than another, surely later, drawing for the major female figure at the right of the composition

(fig. 23). This later sheet however did not serve as the final drawing for that figure. For Seurat made a further drawing which this time combined the woman with her escort and set her in relation to both the landscape and surrounding groups, thus establishing quite precisely the right-hand side of the composition (fig. 24). Marked in the margins at intervals that indicate half-meter units on the full-scale canvas, this drawing served as a cartoon for a preparatory canvas now in Cambridge (fig. 25), which was squared up to correspond with the drawing. The purpose of the Cambridge painting was to try out the main local-color relationships prior to the execution of the large canvas; it essentially adheres to the drawing's articulation of form.

▽
FIGURE 22. Georges Seurat.
Woman with a Parasol (study for
the *Grande Jatte*), c. 1884. Conté
crayon on paper; 41.2 × 24 cm.
New York, The Museum of
Modern Art.

◁
FIGURE 23. Georges Seurat.
Woman in Profile (study for the
Grande Jatte), c. 1884/85. Conté
crayon on paper; 31.4 × 19.1 cm.
Paris, private collection.

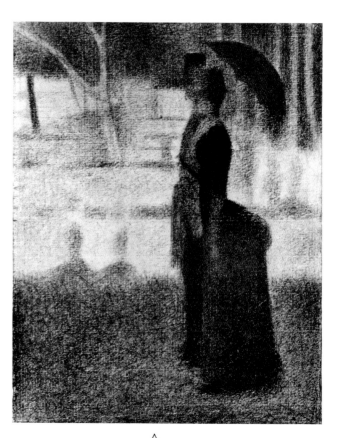

△
FIGURE 24. Georges Seurat. *A Couple*
(study for the *Grande Jatte*), 1884/85.
Conté crayon on paper; 31.3 × 23.8 cm.
London, British Museum.

◁
FIGURE 25. Georges Seurat. *A
Couple and Three Women* (study
for the *Grande Jatte*), c. 1884/85.
Oil on canvas; 81 × 65 cm. Cam-
bridge, Fitzwilliam Museum (on
loan from the Keynes Collection,
King's College, Cambridge).

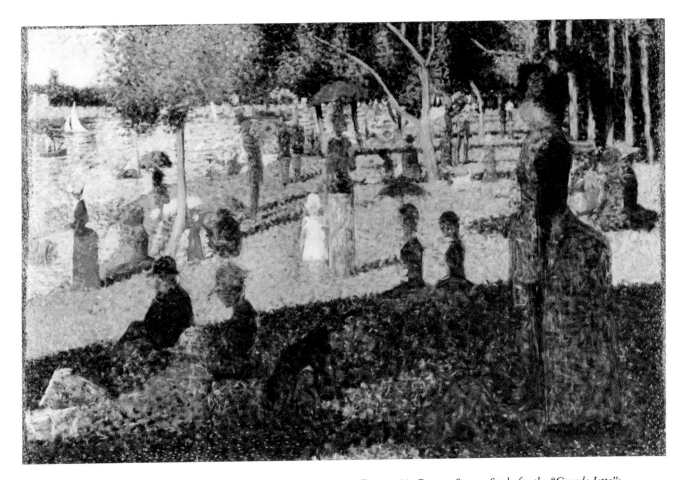

FIGURE 26. Georges Seurat. *Study for the "Grande Jatte": The Ensemble*, c. 1884/85. Oil on canvas; 68 × 104 cm. New York, The Metropolitan Museum of Art.

However, for reasons one can only guess, Seurat was not so scrupulous with his preparation of the *Grande Jatte*'s left-hand side. Looking at the oil sketch of the ensemble, the final study (fig. 26), one can see that, on the left, there are substantial imbalances of scale between the figures that do not occur on the right. The woman angling for instance is far too small in relation to the group in front of her, or to the woman with a parasol standing at the painting's center. On the full-sized canvas, Seurat did make adjustments in this area, but nevertheless imbalances of scale still persist on the left. The scale of the woman with the parasol still only coordinates with the right-hand side; the angler is still too petite and the horn player too huge in relation to adjacent groups. Perhaps, in his haste to complete the painting for the projected exhibition of the Indépendants in the spring of 1885 (he had it ready, but the show was cancelled), he had been too ambitious; after all he was still a very young painter, and the canvas on which he was working was large in scale and involved some fifty

figures. And, as Signac noted as early as 1887, the studio in which the *Grande Jatte* had been painted was too small for such a large canvas, making it impossible for Seurat to coordinate the proportions of the whole composition.[25]

Simplified as it may be, such a breakdown of the preparation and execution of the painting is valuable, because it helps explain how the picture that caused such a surprise in 1886 got to look like it does. The *Grande Jatte* was not created with relentless logic and intellectual rigor. The compositional imbalance was not planned: the sense of disjunction between the groups resulted from studio pressures. However, we are on different ground with the drawing. The "punched-out," simplified drawing of the figures cannot be described exactly

as a new device developed by Seurat to suit the ambitions of this picture, for such spare contours had been a characteristic of his draftsmanship since the Brest sketchbook of 1879–80 (see fig. 27). To a degree, such minimal articulation of form was a by-product of his method, as it was with the contemporary work of Pissarro and Signac. And yet Seurat did actively suppress detail, did cultivate a frigid inelasticity of form, seen in the drawings for the woman on the right of the *Grande Jatte*. What was finally presented to the critics and public at the eighth Impressionist exhibition is a work that was the product of tensions, of decisions forced on Seurat by circumstances, as well as of the artist's long-standing way of seeing.

Flux and Irony

Seurat's work in the suburbs between 1883 and 1885 had consistently involved alteration, adaptation, readjustment of work in progress to assimilate a changing consciousness of his subject. We have seen him develop *Bathing, Asnières* from an apparently proletarian beginning to a reassuringly stable, lower middle-class conclusion. We have seen how the *Grande Jatte* embraced a greater diversity of types, a greater sophistication of allusion, than *Bathing*, as Seurat's acquaintance with this

suburban community grew, as his consciousness of the class mixture of the Grande Jatte's Sunday population developed. But then the very nature of the suburban locality surrounding the island of the Grande Jatte was a fluctuating one. On one side of the island lay proletarian Clichy and Levallois-Perret, comprising factories, workshops, gas-works, and the shanties and tenements of their work force. On the other lay Asnières and Courbevoie, their semirural past as centers for boating now all but gone: they were slipping into a tawdry, middle-class domesticity enlivened, but hardly elevated, by the second-rate demimondaines who settled there. Seurat elected to represent the Grande Jatte on a Sunday, the only day the workers had free, their only opportunity to promenade. Sunday was the occasion for class mixture, and the island of the Grande Jatte an arena for it.[26] Seurat's selection of types clearly indicates his concern to display this mélange—he included bare-headed working girls and bonneted bourgeoises, uniformed wet nurses and chic mamas, top-hatted gentlemen and strolling soldiers. One can argue that he put this cross-section of types within the parentheses of prostitution, between the angler and the *singesse*, because promiscuity and prostitution were bridges across the class divide. In Alphonse Daudet's *Froment Jeune et Risler Aîné* (1874), a naturalistic novel Seurat may well have read, the working-class heroine Sidonie marries well; she and her hus-

Figure 27. Georges Seurat. *Sheet of Studies from the Brest Sketchbook*, 1879/80. Pencil on paper; 15.2 × 24.2 cm. Present location unknown.

196

FIGURE 28. Maurice Chabas (French, 1862–1947). *Family* (study for mural in the Salle des Mariages at the Mairie of the fourteenth arrondissement, Paris), 1889. Oil on canvas; 29 × 64 cm. Paris, Petit Palais.

band buy a smart house on the river at Asnières; she has an affair with his partner; and, "little by little, she reverted to her previous status and even slipped below it. From the comfortable, middle-class status to which her marriage had elevated her, she sunk to the level of a kept woman."[27] Localities such as the Grande Jatte provided women such as those at the left and right of Seurat's painting with short-lived opportunities for the social mobility of the demimonde. The suburban newspaper *Autour de Paris* reported in July 1887 that a well-known *boulevardier* had run off with his wife's maid: "Madame X. surprised them coming back from the Grande Jatte. Great scandal, hurtful words, and screams. The husband made off as quickly as he could; the maid hit her mistress."[28] Class, status, and relationships were all kaleidoscopic in this suburban locality, constantly oscillating between the indeterminate polarities of the middle and lower classes.

Working in oil on canvas, Seurat did not have the narrative means available to the novelist or gossip columnist, enabling the writer progressively to articulate the flux of the suburbs. But he was able to compensate for this in a variety ways. It seems that, in the *Grande Jatte*, he consciously employed a number of different visual languages the better to coincide with the polyglot communities of the suburbs. He used vernacular, emblematic types; he used caricature; he used slang and word-play. One must also stress that he actively made the most of his method's deficiencies and intractabilities. For, in the *Grande Jatte*, drawing did not only serve to compose the picture, it acted to articulate meaning. By petrifying his figures, allowing them no individuality, and restricting them to generic, even caricatural, types, Seurat ironically imposed upon this fluctuating population a discipline that it did not have. Unlike Degas or Forain, unlike even Pissarro or Signac, Seurat allowed his figures no body language, no individuality of pose, no interpersonal exchange. The starchy standardization of the figures is even more salient because they stand alone or in small groups; they form no homogeneous crowd. Here is none of the fraternal equilibrium of the single-class *Bathing* or of the decorations promoting civic virtue that the Third Republic was actively commissioning for suburban town halls (see fig. 28). The *Grande Jatte* ran against all that: it deals with Sunday's temporary *Liberté*, with ersatz, standoffish *Egalité*, with an ironic obverse of *Fraternité*.

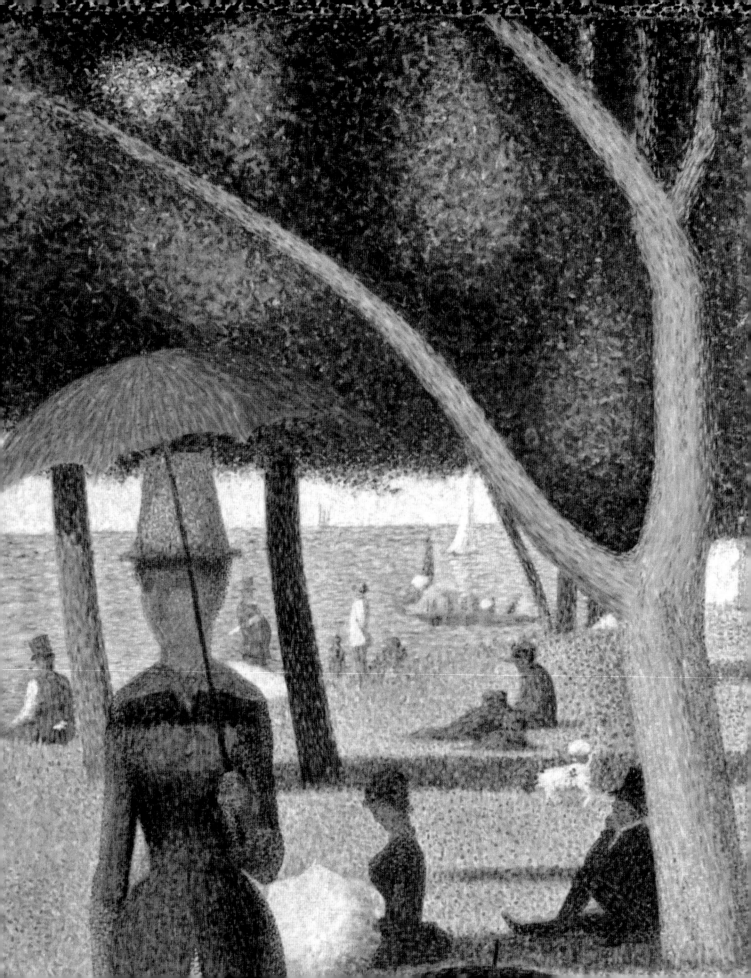

Seurat, Charles Blanc, and Naturalist Art Criticism

MICHAEL F. ZIMMERMANN, *Freie Universität Berlin*

DIRECTOR OF FINE ARTS during the revolutionary year of 1848 and again for three years after the Commune in 1871, founder of the *Gazette des beaux-arts*, the first professor of aesthetics and art history at the Collège de France, Charles Blanc (fig. 2) exerted enormous influence through his writings.[1] That Georges Seurat was influenced to some degree by his *Grammaire des arts du dessin* has long been acknowledged.[2] The evidence of Blanc's importance for the young artist needs only to be cited briefly here. In the oft-quoted letter to his friend the critic Félix Fénéon of June 20, 1890, Seurat wrote that he had read Blanc in the "collège," that is, before he was eighteen years old and prior to his entrance to the Ecole des Beaux-Arts in 1878.[3] The Belgian poet-critic Emile Verhaeren surmised from his conversations with Seurat that "in *La Grammaire des arts plastiques* [*sic*] by Charles Blanc, an entire theory was formulated that, in its fundamental ideas, seems exact. This was his starting point."[4] Another poet-critic, Gustave Kahn, reported that Seurat had an unrivaled knowledge of Blanc's work.[5] Furthermore many of the works that Seurat later studied, not only those of Michel Eugène Chevreul and D. P. G. Humbert de Superville, were mentioned and discussed by Blanc. In 1970 Robert L. Herbert wrote that Seurat's "subsequent readings were either confirmations or scientific extensions of what Blanc says in his eclectic summaries,"[6] a conclusion that has since been widely accepted.

The eclectic nature of Blanc's art theory has also been long recognized, thanks particularly to the work of Misook Song, although much remains to be done on the sources of his particular idealism.[7] However, in linking Blanc with Seurat, the tendency has been to examine the writer's focus on color theory and technique to the exclusion of other influential ideas. It is without doubt important that Blanc consistently interpreted the art of Eugène Delacroix through Chevreul's theories. Seurat not only adopted some of Blanc's views on color mixture, but also deeply penetrated his entire approach, drawing upon the theorist for significant aesthetic judgments. Blanc was probably the last art theorist to reduce the entire historical development of art to a set of trans-

FIGURE 1. Georges Seurat (French, 1859–1891). *Sunday Afternoon on the Island of the Grande Jatte* (detail of pl. 2).

199

fashionable research about the physiology of the nervous system, this switch was merely a new solution for the artist's continuing idealistic search for an aesthetic canon.

Charles Blanc enriched idealistic academic theory through his consideration of nonacademic art and his inclusion of new theories of color and form. His eclectic approach did not alter his academic preferences or his belief in the dogmatic theories on which these were based. That he had an essentially academic mentality can be deduced from the title of his book alone, *Grammaire des arts du dessin*. Like all academics, he regarded painting as an art of drawing. He did not, however, regard drawing as the only mastery which an artist can obtain or against which all others should be seen as less desirable. Chiaroscuro and color were for him equally important, as his enthusiasm for the work of Rembrandt and Delacroix demonstrates. While Blanc repeated the arguments of traditional academic theory in support of the superiority of drawing, he also looked to modern natural science for evidence in support of this belief. According to Blanc, the further along the evolutionary scale a given breed develops, the more it is shaped by drawing and the less by color.

Indeed, wrote Blanc, the richness of color in nature can never be attained by art. He maintained, for this reason, that the artist cannot achieve true beauty through imitation of nature alone, which he dismissed platonically as the mere aping of nature. "Nature is thus superior to art in this inferior region that is color." To the artist, nature appears everywhere in its endless multiplicity: it seems outside the realm of universal concepts. In the success of the naturalists, Blanc saw a decline in French painting: "The painter of style sees the great side, even in little things; the realist imitator sees the small side, even in great things." In comparison with other beings, man alone has the ability to rise above instinctive behavior; where this occurs, there is character. Where finally the individual appears to represent the entirety of humanity, there is beauty, according to Blanc. "Situated between nature and the ideal, between that which is and that which should be, the artist has a vast distance to

historical laws of art, to a grammar. With this attempt, he defended normative aesthetics against the multiplicity of ideals of art produced by art-historical and critical research. Although he believed in eternal laws of art, he differed partly from traditional academic art doctrine in accepting different ideals for different genres of art: he considered Phidias, not Raphael, David, or Ingres, the master of line, Rembrandt the master of light, and Veronese and Delacroix the masters of color.

Seurat's belief in invariable aesthetic laws for the various genres of art originated in Blanc's thinking. When Seurat began to paint in an Impressionistic style, he sought to transform Blanc's still relatively traditional set of laws of art in such a way that it did not contradict the technical and scientific development of contemporary society. But the decisive model for Seurat's search for rules was Blanc's traditional academic idealism and not the natural sciences. Even after 1886, when Seurat transferred his allegiance from Blanc's system of values to Charles Henry's pseudo-scientific theories, based on

traverse in order to go from the reality that he sees to the beauty he divines." The artist should portray a purer image of reality: he should find the ideal that is constituted by the essence, and not merely the surface, of the visible.

What however is to be understood by the "ideal" in art? How can the artist capture it in his works? Blanc believed that the neoplatonic ideal by which man is seen as a perfect microcosm mirroring the macrocosm can be achieved through the study of the human body—the crown of creation, the most complete realization of the divine idea. Since ancient times, the argument against this view has been that there also exist ugly human beings and that they too must be represented in art. Blanc responded to this complaint with a distinctively modern argument: modern science, he said, teaches that the embryo in the mother's body passes through the stages of the evolution of the race in an abbreviated form. Through this process, blemishes may remain that explain the animal-like physiognomy of many humans. Man—the beautiful Adam, the original human body, he who alone corresponded to the ideal of the microcosmic body, an "abridgment of the universe"—has been lost forever. For Blanc the search for this original image constitutes style, and he called the search for style the duty of the artist. "Art is charged with discovering it, hidden at the center of the interior image, feeble and obscured, but still present in the human soul."[8] In this context, Blanc paraphrased Humbert de Superville, who derived the "absolute signs in art" from the human body, and especially from physiognomy.[9]

Naturally Blanc considered the model for his theories the Antique, which he felt most completely realized style in art. For him the Antique meant Greece, which produced one artist par excellence: Phidias. "Phidias created form equal to his idea. He rendered the one as beautiful as the other was great . . . he captured the ideal in the essence of reality, of purified reality, transfigured, as if he had for an instant lifted the veil concealing the perfect example, issued from the hands of God. . . . Phidias overcame the distance that separated Greek art from perfection."[10] Elsewhere Blanc wrote: "You inhale the essence of truth, which is beauty, you experience growing admiration, which will be hereafter without reservation and without return." According to Blanc, it was impossible even for one of the nineteenth-century's champions of the Antique, J. A. D. Ingres, to reach this level: modern individualism leads to a tense and exagger-

ated style. About Ingres's *Angelica* (São Paolo, Museu de Arte), which Seurat probably copied while he was a student in Henri Lehmann's atelier,[11] Blanc remarked: "His aversion to the trivial often pushed him to a counterproductive excess, that is to say to bizarre exaggeration, in a mannered style." Only the more collective art of Antiquity could express general ideas and forms.

Blanc completely dismissed Ingres's exclusive preference for drawing. "To say that drawing is everything says a great deal; it replaces the very definition of painting with one that is much more appropriate to sculpture. . . ."[12] Parallel to the pure principles of art completely realized by Phidias were Blanc's pure principles of painting. Christianity, according to the theorist, tumbled man from his pedestal; as a result, he now found himself in the midst of nature. Correspondingly, painting superceded sculpture as the most important of the arts; the naked, beautiful, human figure was no longer the ideal, but rather the clothed, chaste, emotional human. As a two-dimensional art, painting retained the essential spiritual inwardness of sculpture and could achieve a full corporeality. In this way, Blanc managed to venerate artists such as Rembrandt and Delacroix alongside of Phidias and Ingres.

Not surprisingly, Blanc's relation to Delacroix was contradictory. On the one hand, he reproached him: "The human body is creation's masterpiece: It is a poem whose text is sacred. Each may translate it into his language, but only on condition that he respect general laws and not disturb the body's harmonious mechanism or distort its movements, as Delacroix so often does." On the other hand, he recognized that Delacroix "was protesting against sculptural painting, which is almost as dangerous as pictorial sculpture." In the end, Blanc admired Delacroix because the artist took into consideration specific laws of art and applied them to color, bringing this particular aspect of painting to its fullest realization. He interpreted the artist's oeuvre thoroughly from the perspective of Chevreul's color theory, which he integrated into his canon of art. "People believe that color is a pure gift from heaven and that it possesses incommunicable mysteries, but this is an error; color is learned like music."[13] Blanc concluded: "It is because he understood these laws, studying them thoroughly after having sensed them intuitively, that Eugène Delacroix was one of the greatest colorists of modern times, one might say the greatest."[14] It is striking that Blanc like Seurat was interested only in the colorist in Delacroix,

while he practically ignored Delacroix the Romantic; indeed he expressly warned against this side of the great painter.[15] Blanc emphasized the harmony rather than the expressiveness of colors in Delacroix's paintings. "Delacroix himself always retained the piquant in the harmonious: He pursued unity in the mutual penetration of opposites."[16] Blanc also established general rules for the formation of light and dark tones, guidelines that Seurat followed in most of his drawings: a painting should never have two bright or two dark masses of the same intensity. Half-tones should occupy about half of the surface; the other half should be parcelled out into equal areas of light and dark. "Nothing less than the genius of Rembrandt can change these relationships, limiting [as he did] the field of light to about one-eighth of the space."[17]

In his 1880 book *L'Oeuvre de Rembrandt*, Blanc described the classicists' criticism of Rembrandt—that he was a poor draftsman—as a heresy of the orthodox. He praised the Dutch artist for the qualities that could not be achieved by the correct and elegant style of the classical school: "In Rembrandt's drawing are essential qualities that he possesses to the highest degree: expression and perspective. Regarding expression, which results from the movement and pose of the figure, it would be difficult for this quality to be more simple, stronger, or more penetrating than it is in Rembrandt."[18] But it was not his ability to render the lively movements of figures that made Rembrandt, in Blanc's view, one of the great paradigmatic artists, but rather his masterly construction of pictorial space by means of chiaroscuro.

Blanc's principles for the handling of color, light, and shadow were complemented by the ideas of the painter and influential teacher Thomas Couture, as expressed in his most important text, *Méthode et entretiens d'atelier*. Couture distinguished two ways in which painters treat color. The first, used by a group he called the *coloristes*, strives for the harmony of colors with natural tones. The second, employed by the *luminaristes*, sacrifices the exact tones of nature to the magic of light. Couture considered Rembrandt the supreme *luminariste* and Veronese the greatest *coloriste*.[19] The similarities between Couture's and Blanc's ideas are probably explained by a mutual influence. Blanc distinguished between artists of color and artists of chiaroscuro. He did not like Delacroix's lithographs, and conversely he preferred Rembrandt's etchings to his paintings. In the letter Seurat

wrote to Fénéon cited above, the artist stated that he relied upon "the precepts of Couture on the fineness of tones." He saw a retrospective exhibition of Couture's works and probably read his essay. His reference to the "fineness of tones" probably refers to Couture's section on "Les Coloristes et les luminaristes."[20]

Seurat's dependence on the theories of Blanc and Couture can help explain the great stylistic difference between his early drawings and his early oil sketches. As Herbert has clearly established, Seurat developed his mature drawing style probably near the end of 1881, certainly by 1882.[21] At this time, he switched from an early academic drawing style that gives primacy to line over light and dark to an opposite method in which contours are formed by means of masses of light and shadow. This change cannot be explained, as scholars have attempted to do, simply by the fact that he had left the academic environment of the Ecole des Beaux-Arts and had joined the Impressionist movement. It is also incorrect to think that Seurat was preoccupied almost exclusively at this time with the problem of light and shadow, for which drawing provided an excellent and simple solution.[22] Certainly Rembrandt was the most important source for this development in Seurat's drawing technique, due to the influence on the young artist of the writings of Blanc.[23]

While it is not contested here that Seurat first achieved maturity in drawing before he created finished works in oil, we can no longer assume that the difference between the drawings and oil studies can be explained by sequential development. Granted, in the year 1882, Seurat devoted most of his attention to drawing. In a period during which drawings became for him works of art in their own right, he learned to control light and dark. Developing a soft, but nonetheless monumental, style with conté crayon, he must already have been concerned with color. Thus many of the early oil sketches surely date from the same period. For example, one of the few paintings that has been assigned to 1880 represents gold-red flowers in a cylindrical vase (fig. 3). This charming painting already reflects the color theories of Blanc and Chevreul.[24] It also displays traits characteristic of Seurat's painting style. As in Paul Cézanne's work, space is no longer indicated by a central perspective construction. All lines are inserted into a geometrical framework whose rhythm repeats the rectangular parameters of the canvas. The simple modeling, however, creates an effect

202

FIGURE 3. Georges Seurat. *Vase of Flowers*, c. 1880. Oil on canvas; 46.4 × 38.5 cm. Cambridge, Mass., The Harvard University Art Museums.

of three-dimensionality. On the other hand, the basic stylistic conception of a drawing of roses in a vase (fig. 4) contrasts strongly with the early oil paintings. The round form of the vase, filled with well-defined, white blossoms, is set off against a dark background. Although this sheet, which has been dated 1883,[25] is related to the still life discussed above, through its powerful spatial effect and clear pictorial structure, the effect in each is achieved by totally different means. If one were to see in these two works a stylistic development, one would have to reverse the generally accepted dating.

The stylistic difference between the drawings and the oil sketches is better explained by Seurat's varying intentions in the two media. Following Blanc's recommendation, he constructed drawings according to principles of light and shadow and paintings according to principles of color. Consequently he considered the Barbizon School artists, whom he apparently saw as *luminaristes*, to be better models for his drawings than for his paintings. It is therefore hardly surprising that Seurat's drawings are related to the style of Jean François Millet and Théodore Rousseau, whereas his early attempts in oil, executed simultaneously with drawings, are oriented toward a more Impressionistic style.

Blanc's theories were not the only and perhaps not even the most powerful impulse for Seurat in his attempt to reconstruct Impressionism on a solid, theoretical foundation and as an ambitious approach to painting, based like academic art on careful, studied methods. The idea, however, that this more accomplished form of painting had to choose man as its most important subject did stem from Blanc. If, at the time of his interest in Impressionism, the artist paid attention to contemporary art criticism, he must have seen the movement from a critical distance. In the 1870s, critics such as Emile Zola

FIGURE 4. Georges Seurat. *Roses in a Vase*, c. 1881–83. Conté crayon on paper; 30 × 23.5. Photo: Hauke 1961, vol. 2, no. 572.

FIGURE 5. Etienne Carjat (French, 1828–1906). *Charles Baudelaire* (1821–1867), 1878. Woodbury type; Rochester, New York, International Museum of Photography at George Eastman House.

'modernity'; for I know of no better word to express the idea I have in mind. He makes it his business to extract from fashion whatever element it may contain of poetry within history, to distill the eternal from the transitory."[28]

Like these and other critics, such as Fénéon, Seurat apparently considered naturalism to be the style of the future, a style suited to the new, liberal, or even radically liberal, society. Zola's famous definition of what he regarded as the essence of art, presented in an article he wrote in 1865 in opposition to Pierre Joseph Proudhon's evaluation of Courbet as a socialist painter, already expresses a liberal attitude that becomes clear if we reinsert this well-known remark into the context of the refutation of Proudhon: "I totally relinquish humanity to the artist. My definition of a work of art would be, if I were

FIGURE 6. Etienne Carjat. *Emile Zola* (1840–1902), c. 1876–84. Woodbury type; 23.9 × 18.5 cm. The Art Institute of Chicago, Photo Gallery Restricted Fund (1961.770).

(fig. 6) were writing about Impressionism not merely as the newest phase in the general development of painting, but rather as the most modern expression of naturalism or even Realism, founded by Courbet, Millet, and the Barbizon School, and dominating the art world since 1850.[26] It was in 1878, in the midst of the most productive period of Impressionism, that the writer Théodore Duret grandiosely declared: "The Impressionists descend from the naturalists and have for fathers Corot, Courbet, and Manet."[27] The defense by Charles Baudelaire (fig. 5) of modern subjects in painting is one of the earlier expressions of a tradition which sees the same aim in naturalism and Impressionism. Some of the poet's famous words on the artist Constantin Guys can be quoted here in relation to the *Grande Jatte* because they seem to fit it better than any other painting: "He is looking for that quality which you must allow me to call

to formulate it: 'A work of art is a corner of creation seen through a temperament.' " Zola continued, addressing Proudhon directly: "Thus you have not understood that art is the free expression of a heart and an intelligence, and that the more personal it is the greater it is."[29] Seurat accepted some aspects of this thinking. On a sheet of paper where he had copied excerpts from Delacroix's writings, he noted: "It is the strictest application of scientific principles seen through a personality."[30] Despite his anarchistic convictions, Seurat's friend Paul Signac would still agree in 1894 with Zola's arguments against Proudhon: "It was a trap into which even the best-intentioned revolutionaries like Proudhon too often fell, of insisting upon a precise socialist direction in works of art, whereas, in fact, this tendency is encountered much more strongly among the pure aesthetes, revolutionaries by temperament."[31] Signac's and Fénéon's anarchism, and probably also Seurat's moderate form of anarchism, could be regarded as a more radical continuation of the liberal tradition in the criticism of Zola, Duret, Duranty, and others.

In 1876 Edmond Duranty defended the sketchy character of Impressionist painting with a burst of liberal rhetoric: "Let it be, let it pass. Do you not see in these attempts the anxious and irresistible need to escape the conventional, the banal, the traditional, to reclaim the self, to run far from the entirely regulated, bureaucratic spirit that weighs upon us in this country . . . ?"[32] But Duranty himself and other critics—especially Zola, Duret, and J. K. Huysmans—no longer accepted its unfinished character. They awaited a more perfect, a more fully studied form of art and concluded that Manet, Renoir, Monet, Caillebotte, and Sisley were the forerunners of a great, naturalist painting style of the future, which would express the liberal spirit of its time in finished masterworks.

Even in the article quoted above, Duranty wrote: "I would have thought that a painter who had captured this immense spectacle [of modern life] would have finished by attaining a firmness, a calm, a sureness, and a breadth of vision that perhaps no one at present can claim, and by acquiring a mastery of execution and feeling."[33] Zola announced his break with Impressionism in the June 22, 1880, issue of Le Voltaire. Here he not only turned against Claude Monet, whom the writer believed to be too easily satisfied and too prolific, but also against the principle of painting executed exclusively in natural light. "In my opinion, it is necessary to capture nature in

the impression of a minute: only, this minute must be fixed forever on canvas by a deeply knowledgeable brushwork." While Zola still accepted the basic innovations of Impressionism, he did not believe that its current practitioners had fulfilled its potential: "The formula is there, infinitely divided: but nowhere, in none of them, does one find it applied by a master. They are all precursors, the man of genius is not yet born."[34] In the same year, Huysmans, referring to the psychological experiments of Jean Martin Charcot, famed director of the mental hospital at La Salpêtrière, diagnosed the Impressionists as suffering from atrophy of the retinal nerves. Many paintings "could confirm the experiences of Doctor Charcot with the changes in the perception of colors that he noted in a number of the hysterics at La Salpêtrière and in a number of people afflicted with illnesses of the nervous system."[35]

We can only speculate as to the causes of this shift of opinion.[36] All of the critics discussed here were fervent supporters of a French republic, which was realized only in 1879, when Comte Marie Edmé de MacMahon was forced to retire as president. It was only after that date that the many attempts to re-establish the monarchy after 1873 finally were doomed to failure. Since the fall of the government of Thiers, the French Republic had been ruled mostly by anti-republican politicians; only as the result of a series of elections toward the end of the decade was the constitution increasingly supported by solid republican majorities.[37] According to Hippolyte Taine's very influential sociology of art, the nature of art depends strictly on its geographical and political environment. Taine saw an ideal political and social situation such as the democracy in Athens at the time of Solon as forming the basis of great art like that of Phidias.[38] Following this logic then, the most prominent advocates of the long-awaited true republic would have expected it to produce an art that, if not equal to that of Phidias, at least reflected a similar mastery and completeness.

From the very beginning, Seurat appears to have striven for the qualities of the great artist these critics were waiting for. He therefore applied his originally academic theories to naturalistic subjects. He did not merely attach himself to Impressionism, but rather sought to work his way through naturalism from its beginnings. This goal explains Seurat's reaching back to the art of Millet, Courbet, the Barbizon School, and finally also to the suburban scenes of Jean François

Raffaëlli.[39] Instead of continuing the development of Impressionism as expressed in the most progressive works by Monet and his friends, Seurat tried to establish his own style on the basis of naturalism.

Seurat finally succeeded in synthesizing his early drawn and painted work in *Sunday Afternoon on the Island of the Grande Jatte* (pl. 2). In his earlier *Bathing, Asnières* (pl. 1), he had put aside, for the most part, the styles of both his early drawings and oil sketches. Instead, he oriented himself toward models with which he had been engaged only relatively recently. The landscape

FIGURE 7. Georges Seurat. *The White Coat*, c. 1883. Conté crayon on paper; 31 × 23 cm. Photo: Hauke 1961, vol. 2, no. 570.

is Impressionistic; the way figures are placed in the setting relates to the art of Pierre Puvis de Chavannes. With the *Grande Jatte*, however, Seurat looked back to his earlier drawing style, for example, to that of his representations of stylishly dressed women in the streets (see fig. 7). He also returned to his earlier oil paintings; the oil sketches for the *Grande Jatte* display a style different from that of the *croquetons* for *Bathing*. From the beginning, Seurat followed a method that diverged from his technique for the elaboration of composition in *Bathing*. Even the first oil studies for the Chicago painting are less Impressionistic in effect; in them Seurat was far less concerned with a natural representation of the landscape he had chosen as a stage for his figures. In fact after only minimal preparatory study, he appears to have resolved the issue of the landscape background.

The formation of the landscape did not evolve primarily from *plein-air* studies. Its resolution can be seen in three extant drawings. The first (fig. 8) shows a few trees on the river bank; their surface appearance does not resemble that in the final painting. A great, intricate tree represented in the foreground is the model for the large tree to the right of center in the painting. The painter added the missing branch to the painting. At the left of the drawing, two V-shaped trees are placed close together. They also appear, on a smaller scale, in the finished picture (see fig. 1), where the dark tree to the far left is retained, but doubled, so that both frame the pictorial center marked by the woman with a red umbrella. Finally the tightly grouped trees appear in the right background of the *Grande Jatte*, which had been reshaped more clearly in another of the drawings (fig. 9). The tree in the left foreground is taken from the drawing *Tree and Man* (fig. 10).

From these three sheets and Puvis de Chavannes's *Sacred Grove* (p. 138, fig. 6), Seurat quickly developed the final rhythm of the landscape space. In Puvis's work, the landscape is organized in a very similar configuration.[40] The spatial intervals that structure the *Grande Jatte* imitate the composition of the trees in Puvis's painting. This structure is repeated in all of the oil sketches. Into the finished landscape, Seurat inserted figures painted in a style which corresponds closely to that of the drawings. In *Bathing* Seurat, clearly employing an academic method, had used models he had partially drawn as nudes in his studio. For the *Grande Jatte*, he appears to have studied figures on the site. His main compositional problem was clearly the spatial arrangement of the fig-

FIGURE 8. Georges Seurat. *Landscape with Trees: Study for the "Grande Jatte,"* 1884. Conté crayon on white laid paper; 61.9 × 47 cm. The Art Institute of Chicago, Helen Regenstein Collection (1966.184).

FIGURE 9. Georges Seurat. *Landscape with Trees: Study for the "Grande Jatte,"* 1884. Conté crayon on white laid paper; 47.3 × 61.1 cm. The Art Institute of Chicago, Helen Regenstein Collection (1987.184).

△ FIGURE 10. Georges Seurat. *Tree and Man: Study for the "Grande Jatte,"* 1884. Conté crayon on paper; 61 × 46 cm. Wuppertal, Stadtische Museum.

FIGURE 11. Georges Seurat. *Woman Fishing: Study for the "Grande Jatte,"* 1884. Conté crayon on Ingres paper; 30.7 × 23.7 cm. The Metropolitan Museum of Art, Joseph Pulitzer Bequest, from The Museum of Modern Art, Lizzie P. Bliss Collection (55.21.4).

the contrast of the halos around the figures is somewhat clearer than in the grass. Consequently, Seurat retained this method for example in the drawing of the fisherwoman on the far left (fig. 11). He was now forced to obtain the desired clarity of the pictorial structure through another means. His peculiar, naïvely graceful avoidance of overlappings replaces the *auréoles*. For example, the tip of the sitting woman's umbrella abuts exactly the skirt of the mother at the center of the composition; the umbrella of the older individual next to the nursemaid abuts the trumpeter's leg.

The sculptural feeling of the painting, which the Cubists would praise, derives from the light-dark pattern first articulated in the drawings and then captured in the painting. This synthesis indicates a desire to create a higher style, a legitimate historical image, a Panathenaic frieze of contemporary society, according to Seurat's famous dictum, recorded by Gustave Kahn.[42] Seurat wanted to find the contemporary ideal of art, as Phidias, according to Blanc, had found the eternal ideal of art.

As everything Seurat did was intentional, the synthesis of the *Grande Jatte* did not result simply from a stylistic tendancy toward a kind of modern classicism. Just as Blanc considered the ideal of classicism a problem in the work of Ingres, so Seurat probably considered this ideal a problem in his own work. Consequently the artist did not use any of the approved academic techniques to attain classical appearances, even though he tried to establish a modern approach to painting analogous to academic procedures. His methods of creating a rational pictorial language in the painting are astonishing in their simplicity and frankness. Seurat sought geometric correspondences not only to fulfill the academic demand for a classical composition, that is to say, a strongly geometricized structure of figures. Granted, he read a sequence of articles by David Sutter, a teacher of aesthetics at the Ecole des Beaux-Arts from 1865 to 1870, who insisted on the construction of figures according to various geometric schemes.[43] But the figures in the *Grande Jatte* are not exactly bound by a geometrical structure

ures and the simultaneous expression of perspectival depth and relieflike monumentality. For Seurat this problem was new; while it does not occur in the earlier, independent drawings, it is clearly visible in the preparatory drawings for the *Grande Jatte*. Apparently they were executed later than any of the *croquetons* for the painting.[41]

It has often been remarked that, with these drawings, Seurat renounced Chevreul's laws for the careful lighting and shading of the background, thus heralding a new stylistic phase. However, there is a simple reason for this apparent style change: in the earlier drawings for *Bathing*, Seurat had seen that his method of lightening or darkening the background in order to surround a value by its opposite, creating halos or *auréoles*, was only practicable in the water reflections. In the painting, it was not possible to form the entire background in clear or shadowy, gray or colored masses, which would have clarified the figures. Therefore Seurat refrained from using this method in the drawings as well. In the water,

regulating and harmonizing their position and scale, as recommended by Sutter. Nor is the perspective strict: the space in the painting is not preconstructed or box-like; and, as Meyer Schapiro noted, despite the friezelike arrangement of figures across the picture plane, the perspectival center of the painting is at the right of the composition. Paradoxically, even in the foreground and background planes parallel to the picture plane, there is a diminution in scale from right to left.[44]

Before Seurat elaborated the composition, he seems to have decided on the style of the figures. According to John House, their rigid appearance and forced movements result from a desire to express a mood in opposition to the picture's depiction of radiant weather, and thus "the form of the *Grande Jatte* is an essential part of its meaning."[45] Their style does not just reflect the formal motives of the artist but also his desire to express what he saw, to feel the scene the way the people he depicted saw it. The *Grande Jatte* mirrors the world of the middle-class people strolling on the island. The rigidity of the forms and the naïve avoidance of overlapping inevitably reminds one of the holistic world of educational children's books, where everything has its place and order. But Seurat maintained a critical distance from the world he pictured. Visible in the *Grande Jatte* is a certain ironic treatment of subject not apparent in *Bathing*. This irony was to be characteristic of all of Seurat's late figure paintings. If, as House has argued, *Bathing* and the *Grande Jatte* were originally planned as counterparts, irony can be seen in the opposition of strong, life-sized men and young boys in *Bathing* and the tightly corseted men and women in the *Grande Jatte*. The confrontation is comical. Style and meaning have become one.

The *Grande Jatte* obviously inspired a moving and deeply bitter prose poem by Georges Michel. A librarian at the Bibliothèque Nationale in Paris from 1886 on, he published poems and poetical prose texts under the pseudonym Ephraïm Mikhaël. The little-known text, entitled "The Toy Shop," reads:

I no longer remember the time, or the place, or if it was a dream. . . . Men and women were coming and going along a long, sad promenade; I moved in and out of the crowd, a wealthy crowd, giving off the aromas of women's perfume. And despite the soft splendor of the furs and velvets that brushed against me, despite the red smiles of cool lips seen through fine veils, I began to experience a vague sense of anxiety as I gazed at the strollers marching slowly and monotonously to my right and to my left.

On a bench, a man was watching the crowd with strange eyes and, as I approached him, I heard him sob. I asked him what distressed him so and, raising his great, fevered eyes toward me, the weeping man replied: "I am sad, you see, because for days I have been shut up here in this toy shop. For days and for years, I've seen nothing but puppets, and I am sick of being the only one alive. They are made of wood, but so marvelously fashioned that they move and speak like me. Yet I know that they can only make the same movements, utter the same words, always.

"These beautiful dolls, dressed in velvet and fur, who leave, trailing in the air behind them, an enticing odor of iris, are even more exquisitely articulated. Their mechanisms are even more delicate than the others, and when you know how to work them, they give the illusion of life. . . ."[46]

Like the Parthenon frieze, the *Grande Jatte* is a classical vision of its time—apparently, however, without much sympathy for the ambitions of the society it represents. Phidias's ideal was, for Seurat as it was for Blanc, no longer obtainable. The irony in the *Grande Jatte* seems to be a consequence of the sense of contemporary classicism expressed by Baudelaire: "Since all centuries and all nations have their beauty, we inevitably have our own. This is as it should be. . . . Every beauty contains something eternal and something transitory. . . . The circumstantial element of each beauty is to be derived from the passions, and as we have our particular passions, we have our beauty."[47] A classical vision that does not flee into a timeless arcadia nor borrows from the methods of an outmoded art of painting must inevitably be ironic.

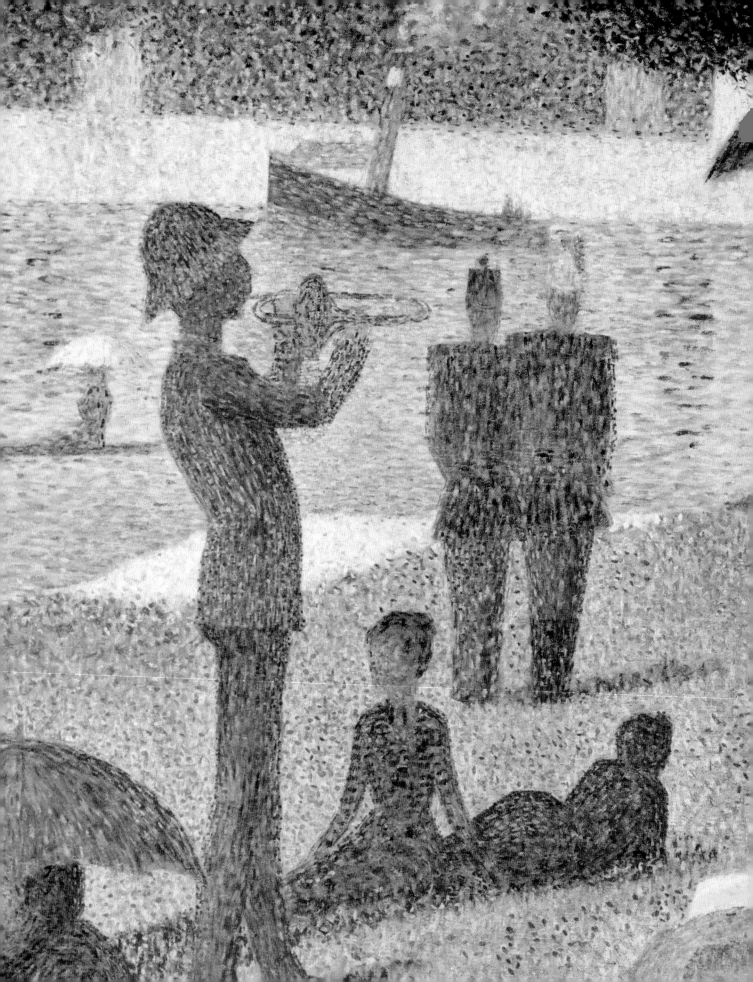

Seeing Seurat Politically

STEPHEN F. EISENMAN, *Occidental College*

WITH THE exception of Gustave Courbet, the political opinions of no major nineteenth-century artist have been more frequently explored in the critical and art-historical literature than those of Georges Seurat (fig. 2). Like Courbet, Seurat is most often linked to anarchist socialism; unlike Courbet, Seurat did not record his political views in writing, and contemporary testimony is meager. The evidence that does exist is nevertheless explicit and revealing. In 1891, the year of Seurat's death, artist Paul Signac (fig. 3) defended the radicalism of his fellow Neo-Impressionist painters in an article in the anarchist journal *La Révolte*: "By the synthetic representation of the pleasures of decadence—balls, *chahuts* (cancans), circuses, such as those done by the painter Seurat who had such a vivid perception of the degeneration of our transitional era—they will bear witness to the great social trial that is taking place between workers and Capital."[1] In the same year, in an obituary in *L'Art moderne*, the Symbolist poet and critic Gustave Kahn said of Seurat's painting *Le Chahut* (p. 150, fig.

FIGURE 1. Georges Seurat (French, 1859–1891). *Sunday Afternoon on the Island of the Grande Jatte* (detail of pl. 2).

22): "If you are looking at all costs for a 'symbol,' you will find it in the contrast between the beauty of the dancer, an elegant and modest sprite, and the ugliness of her admirer; between the hieratic structure of the canvas and its subject, a contemporary ignominy."[2] By claiming that Seurat's works were socially conscious renderings of degrading entertainments, these writers linked Neo-Impressionism to the aesthetics of the best-known and most widely read anarchist of the period, Peter Kropotkin, whose plea for revolutionary solidarity among artists and intellectuals, "An Appeal to the Young," had been published in *Le Révolté* (precursor of *La Révolte*) in 1880:

You poets, painters, sculptors, musicians, if you understand your true mission and the very interests of art itself, come with us. Place your pen, your pencil, your chisel, your ideas at the service of the revolution. Figure forth to us, in your elegant style, or your impressive pictures, the heroic struggles of the people against their oppressors, fire the hearts of our youth with that glamorous revolutionary enthusiasm which inflamed the souls of our ancestors. . . . Show the people how hideous is their actual life, and place your hands on the causes of its ugliness. Tell us what a rational life would be, if it did not encounter at every step the follies and ignominies of our present social order.[3]

211

FIGURE 2. Ernst Laurent (French, 1859–1929). *Georges Seurat* (study for *Scene by the Brook*), 1883. Black chalk on paper; 39 × 29 cm. Paris, Musée d'Orsay. Photo: Thomson 1985, p. 77.

FIGURE 3. Georges Seurat. *Paul Signac*, 1889–90. Conté crayon on paper; 34.5 × 28 cm. Private collection. Photo: Herbert 1962, p. 160.

Yet this social-realist stance was only adopted by Seurat's Neo-Impressionist colleagues—Signac, Maximilien Luce, Camille and Lucien Pissarro, and Théo van Rysselberghe—when they made agitational posters and illustrations for the anarchist press (see fig. 4), not when they made ambitious easel paintings. In fact these artists were far more comfortable with an aestheticist position, a belief that works of beauty are their own justification and that artists' only responsibility is to their talent. Indeed in the very article in *La Révolte* in which he discussed Seurat's focus upon degrading mass entertainments, Signac claimed that artists no longer needed to paint such subjects because stylistically innovative art, by its very freedom from convention, was necessarily revolutionizing. Rejecting overtly political subject matter as well as traditional naturalism, Signac wrote:

It was a trap into which even the best intentioned revolutionaries . . . too often fell, of insisting upon a precise socialist direction in works of art whereas, in fact, this tendency is encountered much more strongly among the pure aesthetes, revolutionaries by temperament, who, striking off the beaten path, paint what they see, as they feel it, and very often unconsciously supply a solid axe-blow to the creaking social edifice.[4]

By 1895 Lucien Pissarro did not see any reason for an anarchist to represent proletarian subject matter, claiming: "Every production which is truly a work of art is socialist (whether or not the creator wishes it), because he who has produced it makes his fellow men share the most passionate and purest emotions which he has felt before the sights of nature. . . . This work of pure beauty will enlarge the people's aesthetic conceptions."[5]

The great attraction of this position for artists like the Neo-Impressionists was the artistic latitude it offered; yet this very openness tended to weaken the political significance of the art. Indeed, throughout the twentieth century, the cause of pure art would be championed by avant-gardes of varied political persuasion, thus prompting renewed calls by radicals for a social-realist art of unambiguous political utility. The origin of this form/content or modernist/realist debate in the very avant-garde circles in which Seurat worked has made it particularly difficult for historians to move beyond this sterile opposition and develop a nuanced account of Seurat's politics.[6] Thus, despite the obvious and extraordinary scale of Seurat's ambition and commitment, most recent

FIGURE 4. Paul Signac (French, 1863–1935). *Les Démolisseurs*, 1896. Lithograph; 51.8 × 35.8 cm. Berne, private collection. Photo: Kornfeld and Wick 1974, n.p.

examinations of the artist and what one contemporary
called his "manifesto painting,"[7] *Sunday Afternoon on
the Island of the Grande Jatte* (pl. 2), have sharply dis-
tinguished the political from the poetic or formal con-
cerns of the artist.

The question of Seurat's politics is not answered sim-
ply by considering the working-class content or the in-
novative form of his pictures. Neither is it merely a mat-
ter of determining the artist's attitude toward his society
and its political organization. Rather the question is
whether a given work by Seurat initiates a political and
aesthetic dialogue with its spectators, thereby encourag-
ing them to realize their capacities for critical thought
and aesthetic pleasure, a goal advocated by nineteenth-
century anarchists and socialists, including Charles
Fourier, Karl Marx, and Kropotkin. I shall argue that,
by its contradictory mixture of idealism and mate-
rialism, epic and comic, classic and contemporary, the
Grande Jatte ironizes aesthetic and social convention. In
addition its Chromo-luminarism demands the collabora-
tion of its audience, thereby positing the revolutionary
ideal of overcoming the alienation of artistic producers
from consumers within capitalist society. The political
significance of Seurat's *Grande Jatte*, it is proposed, does
not merely lie in its representation of alienated social
types—prostitute, *flâneur*, rower, clerk, soldier, and
nurse—but in its attempt to *affirm these very types as
legitimate spectators for painting*. In the face of a con-
temporary French political regime that stressed the ulti-
mate economic and moral utility of a disciplined aes-
thetic education, Seurat asserted the universal human
right to aesthetic pleasure, which he called "harmony."[8]

Symbolism and Materialism in the *Grande Jatte*

From its first appearance, critics were unsure what to
make of the *Grande Jatte*, at times seeing it as Symbolist
or idealist, at others as Realist or naturalist. Writing in

1887 for the Belgian avant-garde journal *L'Art moderne*,
Seurat's friend the critic Félix Fénéon (fig. 5) said of the
Neo-Impressionist painters, including Seurat: "Among
the throng of mechanical copyists of externals, these
four or five artists produce the very effect of life: this is
because for them objective reality is simply a theme for
the creation of a superior, sublimated reality in which
their personality is transformed."[9] Fénéon's words
echoed the famous Symbolist literary manifesto written
by Jean Moréas and published only the preceding year in
Figaro littéraire: "Enemy of instruction, declamation,
false sensibility, and objective description, Symbolist
poetry seeks to clothe the idea in a sensible form which,
nevertheless, would not be an end in itself, but would
remain subordinated to the Idea while serving to express
it."[10] By 1889 Fénéon had gone so far as to claim that

even Seurat's vocabulary of line, shading, and color should now be understood in Symbolist terms: "Monsieur Seurat will understand that a line, independent of a descriptive role, possesses a measurable abstract value."[11] Seurat's career after 1886, especially his growing knowledge and use of the French physicist and aesthetician Charles Henry's theories about the emotive properties of line and color—that certain directions and hues are by themselves conducive to happiness or sadness—would seem to demonstrate Fénéon's perspicacity.[12]

Indeed there can be little doubt that much about the appearance and reception of Seurat's *Grande Jatte* supports its association with a contemporaneous Symbolist aesthetic. The mat, chalky, and thinly painted surface of this very large picture and its uniformity of tonal value conjure a tradition of fresco painting or decorative mural cycles admired by the Symbolist theorist G. Albert Aurier, who claimed in 1891: "Painting can be created only *to decorate* with thoughts, dreams, and ideas the banal walls of human edifices."[13] Seurat's achievement of "broad and ideal decoration," hailed by the Belgian Symbolist poet Emile Verhaeren in the same year,[14] was also enhanced by his success in breaking down any sense of distance between spectators and painted figures. The prostitute (*cocotte*) and *flâneur* (*boulevardier*) in the right foreground are fully life-sized and made to seem even bigger by their juxtaposition with the unnaturally diminutive pug dog and monkey. The mother and child in the exact center of the canvas are seen frontally, thus emphasizing their conformity with the picture surface, while the flattened silhouettes of the three seated or reclining figures in the left foreground similarly stress planarity and proximity. Seurat's inversion of color "temperatures" in the painting, with warm, advancing hues in the background and cool, receding colors in the foreground, as well as his juxtaposition of complementaries across the boundaries of figure and ground, also tends to diminish the perception of space and volume, creating a flattened, patterned surface.

Other aspects too of the *Grande Jatte* conform to Symbolist precepts. The frigidity of posture and emotion in the picture, so often commented upon, recalls the Nabis painter Maurice Denis's disdain for trompe l'oeil and the literary in art: "What is great art if not the disguise of natural objects with their vulgar sensations by icons that are sacred, magical, and commanding?"[15] In addition Seurat's pictorial references to ancient and Quattrocento masterpieces—most notably to the Pan-athenaic frieze of the Parthenon and to the Arezzo frescoes by Piero della Francesca—conform to a classicism and hieraticism celebrated by such Symbolists as Denis and the Swiss painter Ferdinand Hodler. By creating decorative, classicizing, non-naturalistic painting in which, as art historian Reinhold Heller has recently written, "an aura of surface cohesion . . . is accented in antagonism to the illusion,"[16] Seurat was believed by Symbolist writers to have rejected the materiality of the earthly realm and embraced a perfected world of "Idea."

Several reviews of the *Grande Jatte* at its debut in the eighth Impressionist exhibition also seem to highlight the Symbolist aspects of the painting. Jean Ajalbert, a critic marvelously attuned to the variety of costume, posture, and social class on view in the work, nevertheless concluded his review by claiming that Seurat's real achievement was one of abstraction and symbol: "Yes, this is truly a synthetic work achieved by combining opposites; the approximate result is a unification through drawing and color of people and things different only in detail; this is a synthetic work which disdains those facile subterfuges of an enumerative art in order to give life to an abstract contour." Maurice Hermel, in his review for *La France libre*, was equally certain that the myriad occupations and social types in the *Grande Jatte* were unified in a "perfect synthesis of the suburban stroller," thus constituting a "modern symbolism." Another critic, the pseudonymous "X" of *La Liberté*, found nothing to admire in Seurat's work, but nevertheless described it as a Symbolist fantasy: "His *Sunday on the Grande Jatte* is a great blow struck on behalf of his ideas about art. Alas this great blow sounds totally hollow. This large canvas is a fantasmagoria drowned in green and yellow, where the figures, resembling marionettes, seem mechanically riveted to their background."[17]

Yet equally noteworthy in the criticism of Seurat's *Grande Jatte* was the recognition of its unmistakable contemporaneity, sensuality, and even vulgarity in opposition to its apparent timelessness, spirituality, and asceticism. The syntax of this criticism—with its long, often contradictory enumerations of character, class, and natural effects—is significant for an appreciation of the anti-Symbolist elements in the *Grande Jatte*. Henry Fèvre, writing in May 1886 for the *Revue de demain*, commented, "Little by little, one understands the intention of the painter; the dazzle and blindness lift and one becomes familiar with, divines, sees, and admires the

great yellow patch of grass eaten away by the sun, the clouds of golden dust in the treetops, the details that the retina, dazzled by light, cannot make out; then one understands the stiltedness of the Parisian promenade, stiff and distorted; even its recreation is affected. . . . It is a materialist Puvis de Chavannes, a coarse summary of nature, savagely colored."[18] The postures of Seurat's figures struck Fèvre as stiff and posed; his relationship to the more academic art of Puvis seemed to the critic to be that of a parodist, even though the representation of light and atmosphere is subtly naturalistic. Another critic, Alfred Paulet, wrote: "The painter has given his figures the automatic gestures of lead soldiers, moving about on regimented squares. Maids, clerks, and soldiers all move around with a similar slow, banal, identical step. . . . Apart from giving only a general idea of things from a single point of view, this general idea is underlined in an exaggerated way."[19] Here again the writer discovered not a timeless and idealized sociability, but a degrading and caricatural torpor.

Seurat's friend, the critic Jules Christophe, was most insistent of all about the social and class diversity of the people on the Grande Jatte: "Monsieur Georges Seurat . . . has planted . . . fifty people, life-sized, on the bank of the Seine at the Grande Jatte, one Sunday in the year 1884, and has attempted to capture the diverse attitudes of the epoch, of sex, and of social class: elegant men and women, soldiers, nannies, bourgeois, workers. It is a brave effort."[20] Paul Adam's review is the most favorable and incisive in its description of the artist's curious blending of real and ideal, contingent and timeless, comic and tragic:

Everything appears clear and clean, and without obscuring or evading the difficult parts, in an extraordinary scale of tones. Some silk roses on the dress of a baby are visible near some woolen roses on the dress of her mother; every distinction is carefully registered. And even the stiffness of the figures and their punched-out forms contribute to the note of modernity, reminding us of our badly cut clothes which cling to our bodies and our reserved gestures, the British cant imitated everywhere. We strike poses like those of the figures of Memling. Monsieur Seurat has seen this perfectly, has understood, conceived, and translated it with the pure drawing of the primitives. In conclusion this exhibition initiates a new art, remarkable particularly for the scientific bases of its procedures, the return to primitive forms, and the philosophic concern for rendering pure perception.[21]

Where Fèvre saw dust clouds and blinding light, Adam saw perfect clarity and cleanliness; where Paulet saw only exaggeration and a "general idea of things from a single point of view," Adam saw a scientific attitude and "carefully registered" distinctions. Some of the formal devices used by Seurat to emphasize a Symbolist flatness and ideality—especially scale, figural frontality, and avoidance of rigorous perspective—also served to increase the spectators' sense of their own physical presence among the throng on the island. (This perception is unavoidable when confronting the actual painting, as opposed to its reproduction.) If Seurat's Grande Jatte then is a Symbolist work, it is one in which, judging both by these mixed and frequently contradictory reviews, and by the experience of the painting itself, there is surprisingly little of the simplicity, reductiveness, and idealism that one finds in paintings by such bona fide Symbolists as Gauguin, Denis, Munch, and Hodler. Indeed, Seurat's directness in confronting nature and the physical body, deformed by class and costume into an odd, mechanical silhouette, suggests that Symbolism alone is not an adequate aesthetic framework with which to approach the Grande Jatte.[22]

Far from an image of iconic stability that disdains modern history, the Grande Jatte is a picture of contingency and contemporaneity; far from a painting of modern life that rejects idealism, Seurat's work is monumental and classic. At once contemporary and timeless, epic and ironic, visionary and realist, the Grande Jatte advances no specific political or aesthetic doctrines. Indeed its odd melding of genres, sources, and points of view suggests a purposeful evasiveness, an intention to occlude critical interpretation. Such a strategy recalls the earlier efforts of Impressionists—Claude Monet, Auguste Renoir, and Camille Pissarro—to create and exhibit paintings that elided the comforting antinomies of the Third Republic, especially those concerned with work and leisure, city and country, through an art that was abstract and monumental, radical and bourgeois. The result both of intense group practice and of heroic individual invention, Impressionism could be taken to exemplify either the radical democratic ideals of the 1871 Commune or the liberal individualism sanctioned by the new Republic.[23] Critics of Impressionism were therefore unable for a time to determine the ideological bases of this art or to establish its implied audience. Precisely such ideological indeterminacy appears to have accompanied Seurat's Grande Jatte during its initial weeks and

months of exhibition. As a result, Seurat's work temporarily achieved something like aesthetic autonomy. Only by simultaneously putting forward and then undercutting interpretive clues can the artist obviate political and aesthetic verities and assert the autonomy, independence, and non-subservience to doctrine of the work of art. The *Grande Jatte* in short assumes an ironic posture toward its subject; while such a stance advances no specific politics, it would nevertheless be wrong to consider Seurat and his art apolitical. For it is precisely the rejection of convention, the ironizing of all organized political systems, and the celebration of personal autonomy (including the capacity for pure aesthetic pleasure) that characterizes much fin-de-siècle anarchism. In 1902 Signac refined his position on the revolutionary character of pure art by acknowledging the people's need for aesthetic training:

The anarchist painter is not one who will show anarchist paintings, but one who, without regard for lucre, without desire for reward, will struggle with all his individuality, with personal effort, against bourgeois and official conventions. . . . The subject is nothing, or at least only one part of the work of art . . . when the eye is educated, the people will see something other than the subject in pictures. When the society we dream of exists, the workers freed from the exploiters who brutalize them, we will have time to think and to learn. They will appreciate the different qualities of the work of art.[24]

In a post-revolutionary society, Signac claimed, a society without exploitation or repressive cultural institutions, the natural human capacity for aesthetic pleasure will become liberated. Seurat appears to have shared this anarchist goal: his *Grande Jatte* stands opposed to conventions of either art or politics; his Chromo-luminarism, as shall be demonstrated here, is an attempt to make his audience collaborate in the artistic process and thereby liberate their aesthetic senses.

Seeing Seurat's *Grande Jatte*

In the introductory chapter of his book of 1879, *Color: A Textbook of Modern Chromatics*, the American physicist Ogden Rood described the process whereby a set of lenses in the human eye project pictures of the external world onto the surface of the retina. He concluded: "These retinal pictures are, as it were, mosaics, made up of an infinite number of points of light; they vanish with

the objects producing them." Rood's book also includes the well-known passage in which he explained the advantages to painters of the use of an optical mixture of colors: "We refer to the custom of placing a quantity of small dots of two colors very near each other, and allowing them to be blended by the eye placed at the proper distance. . . . This method is almost the only practical one at the disposal of the artist whereby he can actually mix, not pigments, but masses of colored light."[25] Seurat apparently believed he painted the *Grande Jatte* in conformity with Rood's theses concerning the greater luminosity of optical versus material mixtures of color, when he informed Fénéon of his methods in 1886. The latter described them in the same year:

These colors, isolated on the canvas, recombine on the retina: we have, therefore, not a mixture of material colors (pigments), but a mixture of differently colored rays of light. Need we recall that even when the colors are the same, mixed pigments and mixed rays of light do not necessarily produce the same results? It is also generally understood that the luminosity of optical mixtures is always superior to that of material mixture, as the many equations worked out by M. Rood demonstrate.[26]

However, as John Gage and Alan Lee have recently shown, both Seurat and Fénéon profoundly misunderstood Rood.[27] They wrongly believed that the American physicist claimed that *every* material mixture was deficient in luminosity when compared to color achieved by optical mix. This misunderstanding resulted in colors in the *Grande Jatte* that Emile Hennequin, as early as 1886, correctly perceived to be "dusty or lusterless" and "almost entirely lacking in luminosity," especially in those areas, such as the trousers of the reclining man in the left foreground or the dress of the woman with the fishing pole, where complementary dots or strokes of paint have been intermingled.[28] Nevertheless, Seurat continued in his pursuit of a scientific aesthetic and, by the end of his life, was convinced that he had indeed discovered, "scientifically, with the experience of art . . . the law of pictorial color." In a letter to his friend Maurice Beaubourg, the artist described his aesthetic:

Art is Harmony.

Harmony is the analogy between opposites and the analogy between elements similar in *tonal value*, *color*, and *line*,

A 803 $2.50

Harmonian Man
Selected Writings of Charles Fourier

Edited with
an Introduction
by Mark Poster

FIGURE 6. Jean-Francois Gigoux (French, 1806–1894). *Portrait of Charles Fourier*, n. d. Paris, Réunion des Musées Nationaux. Photo: Mark Poster, ed., *Harmonian Man: Selected Writings of Charles Fourier* (New York, 1971), cover.

considered in terms of the dominant, and under the influence of lighting, in gay, calm or sad combinations . . .

Given the phenomena of the duration of a light impression on the retina, synthesis is the unavoidable result. The means of expression is the optical mixture of tonal values and colors (both local color and the color of the light source, be it sun, oil lamp, gas, etc.), that is to say, the optical mixture of lights and of their reactions (shadows) in accordance with the laws of *contrast*, gradation and irradiation.

The harmony of the frame contrasts with that of the tonal values, colors and lines of the picture.[29]

The basis of Seurat's Chromo-luminarist technique was color conflict, or "contrast," and its resolution, harmony, or "synthesis"; his motto "art is harmony" was thus a proclamation that beauty arises from a continuous process of competition between contrasting colors, values, and lines. This conflictual relationship moreover extends even beyond the limits of the canvas to the frame itself, which in turn presumably exists in tension with the world beyond.

"Harmony" for Seurat, it is argued here, was not merely a formal ideal, as it had been for previous color theorists such as Eugène Chevreul, Charles Blanc, and Rood; rather it was a complex expression of utopian faith, a gentle assertion that, even in the absence of a revolution to depose what Marx called the "sense of having" from its reigning position among the human senses, artists could paint pictures that would gratify the visual senses of their audience and thereby induce feelings of harmony.[30] The social and political dimensions of Seurat's concept of harmony become apparent when compared with the ideas of such utopian socialists as the Count of Saint-Simon and especially Charles Fourier (fig. 6), who claimed that the "harmonies of the universe" offered the model for a "harmony of the passions" on earth. Just as the order and harmony of the cosmos is assured by the gravitational attraction between bodies, so the "harmony and unity" of society could be assured by the creation of communes, or what he called "phalansteries," based upon emotional and sexual attraction between humans: "Such will be the effect of association . . .; it will secure the happiness of the people by offering them the means of wealth and pleasure in productive employment—in agricultural and manufacturing labors, which it will render as attractive as any known

pleasures now are, and which in this order will be made so enticing as to allure to them even the rich and great."[31]

Fourier's theories, in which the word "harmony" recurs at every turn, remained important for French socialism in the late nineteenth century because of his focus on the development of working-class associations and cooperative societies, and for his reformist assertion that "the educational system of Harmony will serve to spread good taste even among the lower class."[32] Fourierist ideas moreover were propagated during the decade of the 1880s through three significant journals published in Paris and by the continued example of an actual commune created by Jean Baptiste Godin near his factory at Guise.[33]

The contention that Seurat's concept of harmony had a social dimension finds support in the writings of Charles Henry, which we know were closely studied by Seurat. Henry appears to have been particularly influenced by Fourierism when he claimed as his goal "the creation of universal harmony."[34] The purpose of a scientific aesthetic, he wrote, was:

to spread pleasure within us and without, and from this point of view, its social function is immense in these times of oppression and muted collisions. It must spare the artist useless hesitations and attempts in pointing out the path by which he can find richer and richer aesthetic elements. It must furnish the critics with rapid means of discerning ugliness, which is sensed but often inexpressible.[35]

Signac, Henry's friend and sometime collaborator (see fig. 7), was equally excited about the utopian potential of a scientific aesthetic. In April 1889, he wrote to Vincent van Gogh:

I seize the opportunity . . . to carry out the blocks for a work commissioned from me, in collaboration with M. Charles Henry, by the Librairie de l'Art (perhaps you have read a number of articles by my collaborator in the *Revue indépendante*). It is a book on the aesthetics of forms, for which an instrument—the aesthetic protractor constructed by Charles Henry—permits one to study the measurements and the angles. In this way one can see whether a form is harmonious or not. This will be of great social importance, especially with reference to industrial art. We are going to teach the workmen, apprentices, etc., to see the correctness and beauty of things, for 'till now they have only received aesthetic education by means of empirical formulas couched in misleading or fatuous advice.[36]

A year later, Henry attempted to put Signac's ideas into practice by offering instruction in Neo-Impressionist color theory to the furniture workers of the radical Faubourg Saint-Antoine in Paris. This pedagogical experiment was apparently short-lived, but, by insisting that "universal harmony" has an objective physiological basis, Henry and Signac echoed Fourier's claim to have discovered an analogy between the "harmonies of the universe" and the "harmony of the passions." At the same time, they rejected the vague utopianism of Fourier by asserting that Neo-Impressionism had a practical role to play in educating the senses of the working class. This aesthetic education moreover would be far removed from the "fatuous advice" preached by the state cultural organs.

Successive republican regimes since 1876 had stressed the usefulness of art education, especially accurate, mimetic drawing, as a way of raising the moral standards and economic productivity of the working class. Art education under the ministry of Jules Ferry (1883–85) and his successors encouraged the precise reproduction of figural or geometrical models and discouraged experimentation and any departure from naturalism. The intent of such a program was to demonstrate that moral, political, and formal beauty consist of a judicious balance of elements and a respect for distinctions, not of a utopian erasure of differences. Ferry described the moral lessons essential for the maintenance of the republic in 1883 in an address to the Chamber of Deputies: "The conditions in which humanity moves are not indefinitely or arbitrarily modifiable. We can only touch them if we take into account that which constitutes the nature of things . . . [that is we can only do so if] we recognize that the earth . . . where we live is not the domain of the absolute; but it is the principle of the relative which is sovereign here."[37] Thus, where official art instruction was intended to aid in the development of a factory system and improve worker productivity, Neo-Impressionist art education stressed the "artistic" element in manufacturing, the preservation of workers' traditional skills, and ultimately the complete emancipation of human creative potential.[38] Where official art instruction had the maintenance of a bourgeois status quo as its ultimate goal, Neo-Impressionist art education had the creation of revolutionary "harmony" as its final aim.

Unlike Henry and Signac, Seurat never formulated, as far as we know, a revolutionary pedagogy, but like them

FIGURE 7. Paul Signac. *Advertisement for "Cercle Chromatique"* (theater program for the Theatre Libre), 1889. Color lithograph; 15.5 × 18 cm. Boston, Museum of Fine Arts.

he sought to break down the distinctions between artist and worker, fine and industrial art. (It is well known that when asked by his friend the critic Octave Maus the selling price of *The Models* (see pl. 5), Seurat computed its value like a day laborer would figure his wages: "one year at 7 francs a day."[39]) Indeed Seurat's *Grande Jatte* was a pioneering effort to bridge the gap between art and life, between aesthetic object and perceiving subject, and as such remains a profound meditation upon the cultural potential of a post-revolutionary society.

Seurat's island has often been described as a sacred grove or island of Cythera (we might add Cnidos, famed for its ancient cult of Venus and site of Fourier's harmo-

nious *New Amorous World*).[40] The ostentatiously illicit couple in the foreground with the symbolic monkey and pug (the dog of choice among prostitutes), the curious mixture of uncoupled men and women, the hint of romantic trysts in the woods at the right, and the general light and heat all suggest a kind of hothouse phalanstery, a place where "pleasure was marketed" and desire mediated.[41] The painting's spectators are explicitly invited into sensual dialogue with the work by virtue of its subject matter, its physical immediacy, and most of all, its Chromo-luminarism, a technique designed to achieve an absolute identity or complete transparency between artistic intention and aesthetic effect. Seurat's principle of harmony was democratic: since its laws were universal, spectators needed no prior training in the history of art; since its application could be learned by worker and artist alike, the creation of beauty need no longer be the vocation of aesthetic specialists but could become the avocation of all.

A final reckoning with the politics of Seurat's picture must acknowledge the obvious: that the island of the Grande Jatte was never fabled Cythera, that the undermining of aesthetic convention never posed a serious threat to the ideological status quo, and that Chromo-luminarism was little more than a will-o'-the-wisp. Seeing Seurat politically does not mean making exalted claims for the social efficacy of the artist's work or imputing to the artist a political sophistication he likely lacked. Rather it means engaging the political questions raised by the work, which include those of ideology, social class, and the alienation of humans from their own senses. The latter question, highlighted by Seurat's Chromo-luminarist technique, has seemed to me paramount in understanding the politics of Seurat's *Grande Jatte*. For an artist concerned, more than any other of his time, with pure visibility, it thus remains an inescapable irony that seeing Seurat at all must mean seeing him politically.

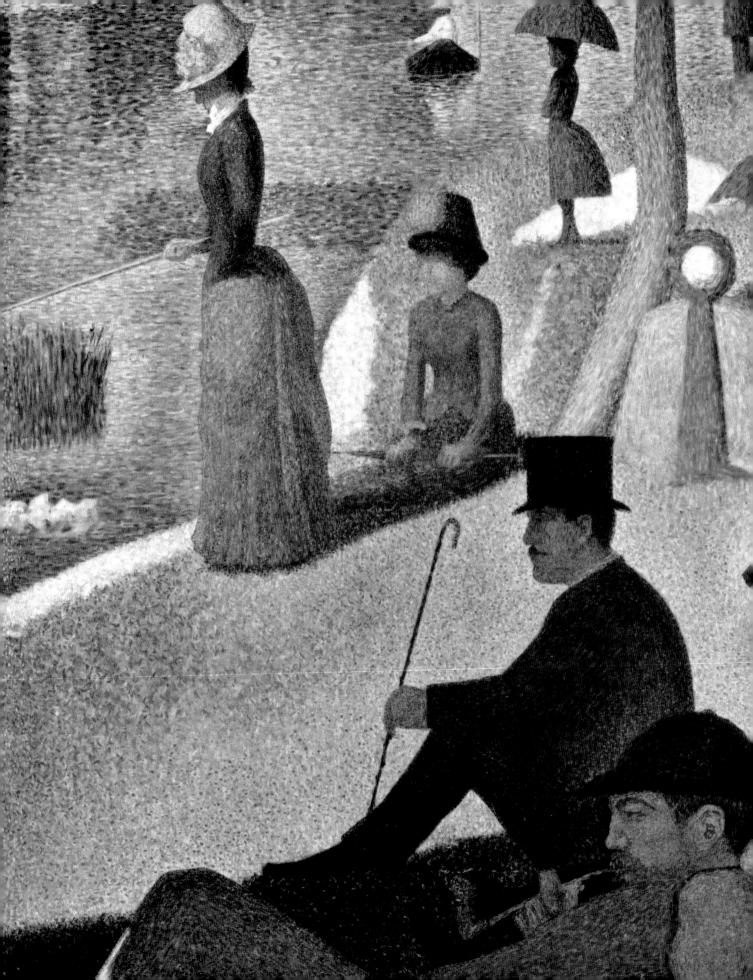

The *Grande Jatte* as the Icon of a New Religion: A Psycho-Iconographic Interpretation

MARY MATHEWS GEDO, *Chicago*

"The Grande Jatte *is one of those great paintings in which every generation finds the meaning best suited to it."*
JOHN RUSSELL[1]

ART CRITICISM has entered a post-formalist era, and the strict stylistic analyses of works that prevailed in the past have been replaced by symbolic interpretations of content. The enigmatic nature of Georges Seurat's *Sunday Afternoon on the Island of the Grande Jatte* (pl. 2) has made it a special favorite with art historians imbued with this new methodology. It is perhaps an ironic commentary on our age of affluence that many of these evaluations of the *Grande Jatte* emphasize Marxist politico-economic readings of the painting, now perceived as filled with references to struggles between the bourgeoisie and working classes.[2]

Erwin Panofsky long ago pointed out that the construction of valid depth interpretations of paintings requires that the scholar possess a profound understanding not only of the history of culture, but of human psychology. In short, art historians undertaking this type of depth analysis must be able to recognize and evaluate the

significant role that the personality, character, and experiences of an artist inevitably play in shaping his or her oeuvre, as well as being aware of their own psychological response to the work—and to the artist.[3]

Marxist critics have generally ignored Panofsky's warning, preferring to read the *Grande Jatte* without considering any extant evidence concerning Seurat's cast of mind and personal motives that might challenge the validity of their analyses. Despite their cavalier disregard of the fact, the readings of the *Grande Jatte* provided by the Marxists and their allies depend just as completely on their internalized vision of Seurat as does the overtly psychological interpretation contained in this essay. Without exception these politico-economic readings are all predicated on an implicit internal vision of Seurat as a person who actively interested himself in the social problems of his day, empathized with those whose class and privilege levels differed radically from his own, and determined to use his great picture as a painted manifesto to publicize such issues.

Nothing we know about Seurat's history, neither his own statements, the eye-witness accounts of acquaintances, nor the writings of contemporary critics who

FIGURE 1. Georges Seurat (French, 1859–1891). *Sunday Afternoon on the Island of the Grande Jatte* (detail of pl. 2).

223

knew him, supports such a thesis.[4] If it is true that we possess precious little information about Seurat from which to construct a psychological profile of him (especially as compared with the abundant primary data available about such leading contemporaries as Claude Monet and Paul Gauguin), what we do know about his personality seems internally quite consistent and congruent with the interpretation of the *Grande Jatte* presented here.

Seurat's Character and Personal History

The relevance of the details of Seurat's personal history and character for the formal and iconographic nature assumed by the *Grande Jatte* requires the following review of biographical details, with which the reader may already be familiar.

Without exception, acquaintances and friends portrayed Seurat (see fig. 2) as a secretive, solitary, eccentric personality. When asked to characterize the artist physically, friends likened him to a figure from an ancient Assyrian relief, a Renaissance painting, or even to Donatello's statue of Saint George—in short, to images from other times and places, associations suggestive of the artist's unusual character and attitudes.[5] To the observant, and maliciously witty, Edgar Degas, Seurat seemed more like a notary than a rare creature from the past, what with his pedantic manner and somber, correct clothing.[6] But Degas's mockery focused on another aspect of Seurat fully as central to his character as his other-worldliness: his pronounced compulsivity and extreme degree of organization. It was probably these characteristics that prompted his colleague Edmond Aman-Jean to peg the artist as "the perfect model of the bourgeois," adding, "Seurat's mother, whom I saw only once, was of the same type."[7] Seurat's background was, indeed, solidly bourgeois and, unlike most of his artistic peers, he never had to depend for survival on the sale of his work. Instead his father supplied Georges—the third of his four children—with a regular, though by no means princely, allowance. It permitted the artist to live modestly but securely, to maintain an independent studio, and eventually even to support a mistress and infant son (about whom his family knew nothing until one day in 1891 when the dying artist arrived at his mother's doorstep with his little family in tow).

Seurat's father, a bailiff and property owner, seems also to have been a truly eccentric individual whose odd behavior and secretive ways were certainly strongly imprinted on Georges, whether by heredity or example. At least by the time most of Seurat's friends knew the family, the artist's father lived apart from his wife and children for the most part in a country retreat at Le Raincy or in a separate apartment he maintained at La Villette (a poor district of Paris), the center of his bailiff's work. He faithfully returned to the family domicile only on Tuesdays—a weekly reunion from which Seurat never dared absent himself.[8] We do not know when the father effectively separated from his family; perhaps this occurred

FIGURE 2. Georges Seurat. Photograph. Photo: Dorra and Rewald, p. xxxi, fig. 3.

soon after the death of Seurat's younger sibling, a brother who was born in 1863 and died in 1868. (Seurat, born on December 2, 1859, was therefore between three and four years that child's senior.) Whether or not this tragedy precipitated the father's departure, it must have profoundly affected the entire family, including Georges, by then a boy of eight or nine.[9]

Seurat's two surviving siblings, his brother, Emile, and sister, Marie Berthe, were respectively twelve and thirteen years older than the future artist, who consequently lived much of his childhood alone with a doting mother whose tenderness toward him was probably accentuated by the loss of her youngest child. Throughout his brief life, Seurat remained very attached to his mother. Although the artist spent most of his waking hours in his separate studio, he continued to live at home until his death in 1891; impeccably clad, he dined with his mother every night, even after he had established the liaison with his mistress, Madeleine Knobloch, who would bear him a son. Unlike her husband and older son, Madame Seurat was very supportive of Georges's artistic ambitions. In view of his extreme attachment to his mother, it is perhaps not so surprising that Seurat chose as his mistress a girl whose social status and character were as far removed from that of his mother as possible.[10]

No matter how much or little time the elder Seurat spent with his family, there can be no doubt that he exerted a profound effect on Georges's character, for the son grew up to share his father's precise, methodical approach to life. Surely only the son of a most painstaking man could have invented Pointillism! From his father too the artist probably inherited his unusual visual-motor skills; although Seurat senior had lost a hand in an accident, he was so dexterous in managing his prosthesis that he could neatly carve and distribute a roast, slice by slice, impaled on his hook.[11] The fact that the father, so stern and rigid, possessed this dangerous-looking appendage must have added to young Georges's awe of him; small wonder that acquaintances noticed Seurat's seeming timidity and gentleness (though they all recognized his underlying, extreme stubbornness and determination).[12] Seurat's father was an extreme religious fanatic who engaged in heterodox religious rituals. Fond of enacting the role of a priest, he rigged up a chapel at his country villa, where he "said" Mass for as many of the local peasants as he could corral to play the congregation, while his gardener enacted the role of assisting deacon.[13] He also owned an enormous collection of popular religious prints and used many of them to decorate the walls of his villa. The artist's own interest in popular broadsides—a large number of such *images populaires* were discovered in his studio following his death—probably grew out of his identification with his father's unusual propensity for collecting cheap holy pictures.[14] As one might expect from someone who had grown up in such peculiar circumstances, Seurat showed meager social skills and had little empathy for others. Acquaintances all described him as quiet and withdrawn in social situations, except when discussing art, especially his own theories and projects, when he would become animated and involved. (The critic Téodor de Wyzewa noted that Seurat had planned out his projects thirty years into the future and never tired of explaining in detail, to anyone he could buttonhole, his researches, the sequences he planned to use, and the number of years he expected to spend on each project.)[15] Quite insistent on receiving due credit for the originality of his ideas, Seurat was eternally apprehensive (like the equally suspicious Paul Cézanne) that his artistic peers would steal, simplify, and cheapen his innovations. These suspicions led him, on more than one occasion, to make cruel accusations of plagiarism. So sensitive was the kindly Camille Pissarro to Seurat's quasi-paranoid fearfulness that the older artist constantly found himself reassuring the world—not to mention Seurat himself—about the primacy of the latter's artistic ideas.[16]

No one quotes a single remark of Seurat's that documents any humanitarian interests on his part. Nor do we possess any proof that the imagery of the *Grande Jatte* contained veiled political messages actually comprehended, but deliberately ignored, by friendly critics of the period. T. J. Clark may argue that Félix Fénéon, the critic closest to Seurat, purposefully downplayed the *Grande Jatte*'s daring social implications, but it seems much more logical to infer that reviewers did not comment about such issues because they were neither uppermost in Seurat's mind when he created the picture nor in those of his contemporaries who viewed it.[17] Had any of the numerous critics then unreceptive to the glories of the *Grande Jatte* discerned such underlying themes in it, they surely would not have missed the opportunity to use such observations to ridicule the painter and his creation still more savagely.

Although Seurat obviously intended that his great painting appear totally modern and up-to-the-minute, he simultaneously realized that he was creating the

Grande Jatte for the ages. Well aware, like Michelangelo before him, that the specific problems of his era would matter very little to the average viewer a thousand years in the future, Seurat designed his figures to merit comparison with those depicted on the Parthenon frieze, not to document the transient social problems of his period.[18]

The Creation of the *Grande Jatte*

The elder Seurat's usurpation of the rights and rites of the priesthood dramatically demonstrated to his artist son that one need not await ordination by a bishop to assume holy orders. But if his father's unconventional behavior encouraged Georges in his own daring ambitions, it also reinforced in his mind the central importance of the methodical approach to every endeavor. Although Seurat's father aspired to offer Mass, he was neither qualified nor entitled to do so, and he could only play act the role of priest, pretending to himself and his "congregation" that he could effect the miracle of the Eucharist. Both aspects of the paternal lesson played a part in the evolution of the *Grande Jatte*. Seurat initiated his artistic career with a lengthy, self-imposed apprenticeship initially devoted solely to the creation of drawings; gradually he added small panel paintings and oils on canvas to his repertory. Then in 1883 the young artist suddenly and boldly made the quantum leap from painting modest-sized pictures to creating a mural-sized canvas, *Bathing, Asnières* (pl. 1). That a young man in his early twenties should have undertaken a project of this scope (at a time when far fewer artists dared to work on such a scale than is the case today) reflects a level of self-confidence that one might label hubris, had not Seurat's belief in his genius been so well justified. By the spring of 1884, he had completed *Bathing*, and he immediately set to work on the *Grande Jatte*, a composition that he must have had in mind for some time. From the moment he first conceived of this project, Seurat surely realized that it would play a unique role in his career, and in the history of art as well. From the start, the *Grande Jatte* became Seurat's magnificent obsession. Never again would the creation of a single canvas involve so many preparatory drawings and preliminary painted sketches on his part, culminating in the definitive oil study (p. 195, fig. 26).

That Seurat intended to create a revolution with the *Grande Jatte* seems certain enough. The question remains: What kings of modernism did he hope to dethrone when he unveiled the *Grande Jatte* to the Parisian public? Edouard Manet and Claude Monet, the foremost avant-garde painters then active in France, immediately come to mind. Seurat spoke admiringly of Manet and his importance in the evolution of modernism, but complained about Monet's "coldness" (an interesting reaction from a man who could scarcely be described as warm and spontaneous himself) and apparently downplayed the importance of Monet's example in his own artistic development.[19] Significantly, among Seurat's contemporaries, only Manet and Monet had executed paintings that might be described as direct ancestors of the *Grande Jatte*, not only in their related subject matter, but in their revolutionary intent: each had created a large composition on the theme of a "luncheon on the grass." Though both pictures had been created twenty years or more before Seurat initiated the *Grande Jatte*, events of early 1884 again focused the attention of the Parisian art world on these pictures. The great memorial exhibition honoring Manet, who had died the previous April, opened in January 1884, at the Ecole des Beaux-Arts.[20] Seurat surely attended this major artistic event (perhaps many times), where he would have had the opportunity not only to view the *Luncheon*, but Manet's final masterpiece, *The Bar at the Folies-Bergère* (1881–82; London, Courtauld Institute), a canvas whose implications would not have been lost on the younger artist either. But it must have been the *Luncheon* (fig. 3) that spoke to Seurat most directly as he prepared to paint his own interpretation of Parisians enjoying a summer outing beside the water.

In the early spring of 1884, Monet enlisted the help of his dealer, Paul Durand-Ruel, in a determined effort to reclaim his enormous version of the *Luncheon*, which he had been forced to abandon when he moved from Argenteuil to Vétheuil in 1878.[21] He soon succeeded in repossessing the canvas, only to discover that large sections had been destroyed by mildew during its years in storage. He salvaged two intact portions, which he retained in his own collection throughout his lifetime. As an elderly man, he kept the major central remnant on exhibition in one of his studios (fig. 4) and proudly posed for his photograph before the painting. It seems logical to assume that he showed it off to artist friends like Pissarro and Auguste Renoir as soon as he had it in

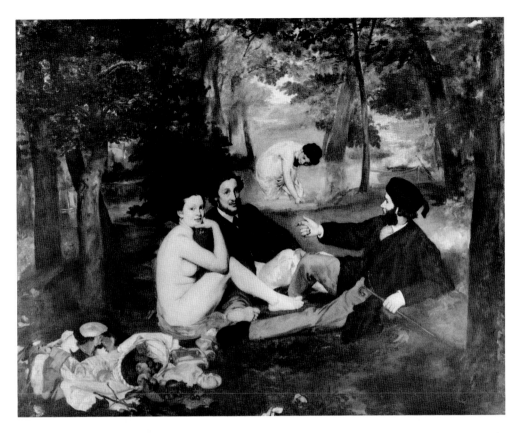

FIGURE 3. Edouard Manet (French, 1832–1883). *Luncheon on the Grass,* 1863. Oil on canvas; 208 × 264 cm. Paris, Musée d'Orsay. Photo: Paris, Réunion des Musées Nationaux.

FIGURE 4. Claude Monet (French, 1840–1926). *Luncheon on the Grass* (central fragment), 1865–66. Oil on canvas; 248 × 217 cm. Paris, Musée d'Orsay. Photo: Paris, Réunion des Musées Nationaux.

227

hand again. Seurat could have learned about this rescue operation and the appearance of the surviving fragment through his many shared artistic contacts with Monet.

If Seurat's knowledge of these two versions of the "luncheon" theme helped to inspire his own, new undertaking, the history of both pictures also conveyed implicit cautionary tales that must have reinforced his determination to follow the most careful procedures in executing his own great figurative landscape. Manet's *Luncheon* had apparently been a studio production, painted indoors from start to finish, a fact reflected in the character of the landscape, which looks a bit as though the artist had rolled a painted backdrop down behind his sitters, then reproduced it in his picture. The young Monet, no mean competitor himself, apparently determined to outdo Manet by painting his composition outdoors, so he executed the large-scale final study, at least in part, in the forest of Fontainebleau, planning to enlarge it to its definitive scale (fifteen by twenty feet) in his studio.[22] This ambitious project proved to exceed both his artistic and financial means, and Monet was finally forced to abandon the canvas unfinished.

Seurat intended to avoid similar problems by basing his painting on elements elaborated independently in nu-

FIGURE 5. Auguste Renoir (French, 1841–1919). *Luncheon of the Boating Party*, 1881. Oil on canvas; 129.5 × 172.7 cm. Washington, D.C., The Phillips Collection.

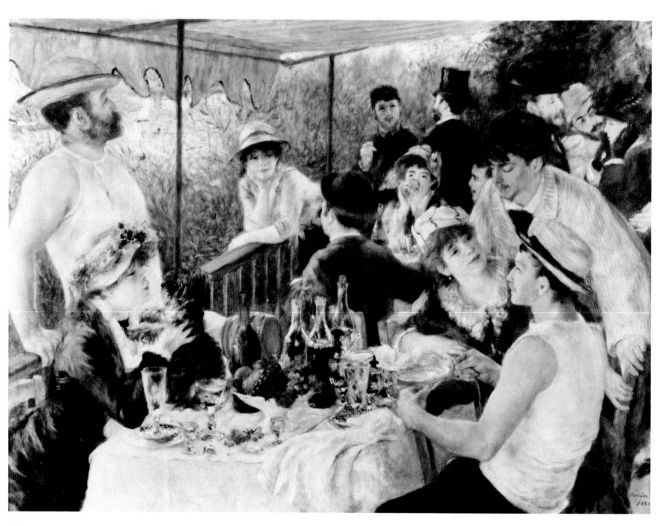

merous careful drawings and panel paintings made on the site, then assembled in the studio into a single composition, organized according to the mathematical proportions of the Golden Section. He also applied the most up-to-date scientific information about the laws of color mixture and perception to his painting process, and the consistency of light depicted in the *Grande Jatte* certainly helps to unify this composition, which its creator envisioned as a work that would wed science to art in a permanent, royal union.[23]

The Impressionist exhibitions held in Paris in 1881 and 1882 provided additional fertile sources of inspiration for Seurat, who religiously attended these events.[24] At the 1882 show, he would have seen Renoir's delightful picture *Luncheon of the Boating Party* (fig. 5), depicting a group of the artist's friends dining at an outdoor restaurant on the Seine, whose sparkling waters are visible in the background. If the similarities between Renoir's canvas and the *Grande Jatte* seem more generic than specific, the same cannot be said of Federico Zandomeneghi's *Place d'Anvers* (fig. 6), included in the sixth Impressionist exhibition, which opened in Paris on April 1, 1881. Zandomeneghi's canvas shows startling formal and iconographic relationships with Seurat's picture. In view of the latter's quasi-paranoid resentment over the alleged appropriation of his inventions by con-

temporaries, his free incorporation of so many of Zandomeneghi's seems startling—proving perhaps the validity of the adage that good artists borrow, but great artists steal.

But Seurat by no means limited himself to ideas gleaned from more or less contemporary works (including those of Pierre Puvis de Chavannes, another important model for the younger artist). Rather he turned to the great works of the past as major sources of inspiration for a composition that he obviously intended should be timeless, as well as absolutely contemporary. Can it be accidental that Seurat's selection of works from the past concentrated so heavily on great religious decorations? It seems likely that this choice was both conscious and deliberate, reflecting the fact that, from the start, he conceived of the *Grande Jatte* as a modern icon, the secular equivalent of a great religious altarpiece. In this regard, it seems relevant that, in a commentary written later about the *Grande Jatte*, Seurat specifically linked its inception to a religious holiday, emphasizing that he began the studies *and* the painting proper on Ascension Thursday 1884.[25] In another statement, alluded to above, he described his artistic goal as that of depicting modern people moving about as they do on the frieze of the Parthenon, which portrays the annual sacred procession honoring the goddess Athena. This

229

greatest of Greek temples must have often been in Seurat's mind when he initiated his project; as Robert Herbert observed, the artist's treatment of the grove of trees on the *Grande Jatte* rendered in a beautiful drawing recently acquired by the Art Institute (p. 207, fig. 9), recalls the columns of the Parthenon, reminding us of the fact that, in the earliest Greek temples, such columns were actually created from tree trunks.[26]

The similarities between the protagonists of the *Grande Jatte* and those depicted by Piero della Francesca in his frescoes at Arezzo have been widely recognized. However, the fact that Piero's paintings depict a deeply religious subject—the finding of the True Cross by the Empress Helena, mother of Constantine—is usually glossed over in favor of emphasizing the abstracting, geometricizing tendencies and mathematical concerns shared by the two artists.[27]

Seurat's interest in the wonderful collection of Egyptian artifacts in the Musée du Louvre, Paris, also played an important role in the evolution of the *Grande Jatte*, whose figures have seemed to many observers virtually as hieratic as those found in Egyptian art. One might also note that the discrepancies in scale evident in Seurat's canvas recall the proportions of Egyptian art, where the pharaoh is invariably rendered as much larger than anyone else, while other individuals are graduated in size according to their rank and relationship to the ruler.[28] The fact that many of those paintings and reliefs depict personages on the shores of the Nile probably made such fragments doubly appealing to Seurat, engrossed as he was in portraying contemporary Parisians on the banks of the Seine. But the fact that virtually all of Egyptian art was deeply religious in character, designed to embellish temples and tombs, may also have played a major role in directing Seurat's attention to this rich source.[29]

Although critics have not usually compared Seurat's personages to those depicted in Byzantine mosaics, similarities seem apparent. The way Seurat flattened bodies and reduced drapery folds to flat, linear details, rendered in stitchlike strokes, recalls corresponding characteristics in the treatment of figures at important Byzantine religious sites, such as Ravenna.[30]

Despite the vast scope of his *Grande Jatte* project, Seurat completed the big painting in less than a year. He had it ready by March 1885 when it was scheduled to be included in the exhibition of the Indépendants, which was cancelled. After a summer on the sea coast, he re-turned to his studio and to the *Grande Jatte*, which he reworked extensively between October 1885 and May 1886, when it was shown in the eighth, and final, Impressionist exhibition. During that winter and spring, he significantly modified several of the major figures (most notably the woman with the monkey and the woman fishing, whose bustles he updated according to styles depicted in the latest fashion broadsheets) and added the extensive veil of Pointillist dots that now covers much of the painting's surface.

Seurat's obsession with the *Grande Jatte* did not end with this second painting campaign; several years later, perhaps as late as 1890, he returned to the picture again, restretching the canvas to expose its virginal margins, on which he painted Pointillist borders in pigments different from those used in the original composition. Before making the latter changes, he evidently tried out his new idea on the final study (p. 195, fig. 26). This canvas too bears evidence of being restretched after its completion to provide space for a painted border similar to that enclosing the definitive version. Even more surprising, Seurat also later retouched at least one other preliminary study for the *Grande Jatte*.[31]

Between 1886 and 1888, the artist returned to the *Grande Jatte* in a more indirect manner, reproducing a large segment of the lower right quadrant of the picture in two versions of *The Models*, painted in 1886–87 (Philadelphia, Barnes Collection) and 1888 (pl. 5). The emotional investment in *The Models* that led him to create a second version correcting defects he perceived in the first of these compositions may have had its inception in a desire to disprove critical charges that the Pointillist technique could not be adapted to painting the nude. After the fact, Seurat apparently concluded that the Pointillist brushstrokes employed in the first version of *The Models* seemed too minute, and he created the second smaller, more luminous revision. His motivations for including the *Grande Jatte* in his representation of the models remains more mysterious. However, this gambit did provide Seurat with an opportunity to "correct" a problem that developed soon after he completed his second campaign on the *Grande Jatte*: the myriad orange and green dots he added to the painting at that time soon changed color and faded. The resulting imbalances destroyed Seurat's cherished ambition of providing viewers with unique sensations of optical luster.[32] Reproducing that portion of the *Grande Jatte* in his next major picture permitted him to correct those

defects. In the exquisite final revision of *The Models*, the segment from the *Grande Jatte* appears as a shimmering mirage, less substantial than in its original conception, but far more luminous.[33] Seurat's continued preoccupation with the *Grande Jatte*, an obsession that seemingly prevailed throughout the remainder of his lifetime, reinforces the hypothesis that this picture—above and beyond all his other canvases—played a unique role, both in his artistic evolution and in his mental life.

The Iconography of the *Grande Jatte*

To be truly convincing, any symbolic interpretation of the *Grande Jatte* must account for its enduring broad appeal, the fact that it speaks with equal forcefulness to the general public and art professionals alike. Repeated informal observations and conversations with visitors to The Art Institute of Chicago admiring the picture suggest that many people relate to this painting on a deeply personal level, perhaps one with unconscious roots or ramifications. This conviction received additional confirmation a few years ago, when interviews with leading Chicago painters about the role the *Grande Jatte* had played in their careers revealed that a number of them associated the canvas with tender reminiscences of their personal past or family history.[34] Such associations must be evoked by qualities in this composition far removed from the arcane politico-economic and socio-iconographic readings of the *Grande Jatte* comprehended only by a small group of scholars.[35] Like valid scientific theories, convincing iconographic interpretations of masterpieces should possess a certain beauty, echoing, however dimly, the radiant character of the works they seek to explicate. Seurat's great painting elevates the responsive viewer to a reflective, contemplative—even spiritualized—state, far removed from concerns about the struggles of the proletariat in nineteenth-century France.

Apart from their seemingly forced character, these revisionist interpretations of the *Grande Jatte* typically require endowing certain protagonists in the painting with specific identifications or imputed characteristics. The complete absence of any secure documentation that might prove or disprove such contentions has resulted in insoluble scholarly squabbles involving selected key figures in the painting. Evidence implicit in other avant-garde pictures contemporary with the *Grande Jatte* suggests that these supposed identifications are far less definitive than their inventors would have us believe. To illustrate this point, two examples have been selected here: the prominent reclining male figure, the so-called *canotier*, or rower, in the left foreground, as a member of the working class; and that of the fashionably dressed fisherwoman in the left center as a prostitute (fig. 1). Proponents of the lower-class status for the rower point to his sleeveless garb and sprawling position, which contrast so markedly with the formal clothing and hieratic poses assumed by most of the island's other inhabitants. But in Renoir's *Luncheon of the Boating Party* (fig. 5), modeled on a group of his friends, he represented the male figures in costumes ranging from the strict attire of the standing gentleman in the background, shown in black top hat and suit, to the utter informality of the two young men lounging in the foreground, whose sleeveless jersey shirts mirror their more casual poses. These two men—usually identified as Gustave Caillebotte (straddling the chair), the well-to-do engineer, amateur painter, and patron of the Impressionists, and Alphonse Fornaise, Jr., the son of the proprietor of the restaurant where the luncheon took place—both belonged to the middle class. Indeed it is probably no exaggeration to describe Caillebotte as a member of the *haute bourgeoisie*.[36] The pictorial evidence supplied by Renoir's painting suggests that assigning class identifications to Seurat's personae on the basis of costumes or poses presents serious difficulties. Canoeing had become so popular in late-nineteenth-century France that both bourgeois and working-class men spent their leisure time in that sport, for which they all dressed with appropriate casualness.

Richard Thomson has identified the prominent woman shown fishing at the lower center of the *Grande Jatte* as a prostitute, citing as evidence numerous contemporary caricatures representing tarts as women who "fished" for men (a visual pun based on the similarity between the French terms for the verbs to fish, *pêcher*, and to sin, *pécher*).[37] In *The Pond at Montgeron* (fig. 7), one of four large canvases that Claude Monet painted in 1876 on commission from his patron Ernest Hoschedé, the artist included the sketchy figure of a woman who fishes in a pool, while children lounge nearby. Daniel Wildenstein suggested that she probably represents Alice Hoschedé, the wife of Monet's patron.[38] It is simply inconceivable that the artist would have portrayed a person of this status—a woman, moreover, with whom he

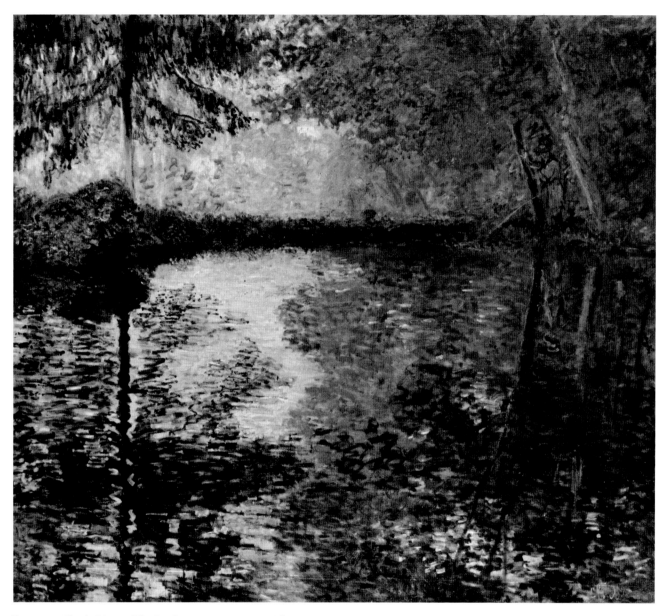

FIGURE 7. Claude Monet. *The Pond at Montgeron*, 1876. Oil on canvas; 17.2 × 19.3 cm. Leningrad, The Hermitage.

was rapidly becoming deeply emotionally involved himself—as a hooker. Clearly not all representations of fisherwomen from this period should be regarded as references to whores!

In her symposium presentation, Hollis Clayson offered a socio-political reading of the *Grande Jatte* as a painted representation of the "deconstruction" of family life in late nineteenth-century France.[39] She cited as evidence the predominant number, scale, and location of unaccompanied women and children depicted in the picture, as contrasted with the smaller size and secondary roles accorded many of the male protagonists. She also

232

pointed out that Seurat represented only one complete nuclear family in the canvas, the relatively tiny group of mother, father, and baby portrayed in the distant center of the picture. This argument ignores evidence suggesting that Seurat's decision to emphasize female figures in the *Grande Jatte* may originally have been conceived primarily for artistic purposes. *Bathing, Asnières*, Seurat's first large-scale painting, completed just prior to the *Grande Jatte*, also shows contemporary Parisians enjoying themselves along the Seine. The fact that both canvases were once the same size (until the artist enlarged the *Grande Jatte* to add its painted border) and that their settings depict the same point on opposite banks of the river has led many critics to postulate that they originally shared a thematic program that subsequently lost importance as the *Grande Jatte* evolved (and acquired more and more personal meanings?).[40] If the two pictures once shared such a programmatic link, Seurat's decision to feature women and girls so prominently in the *Grande Jatte* becomes more understandable, because *Bathing* depicts only male figures, primarily adolescent boys, and the contrast would have provided artistic variety.

In her summary of Seurat's biography, Clayson did not mention the fact that the artist himself came from a broken family, for his father deserted his family physically and emotionally, if not financially, leaving the future artist to be raised in effect by his mother as a single parent. Her interpretation also ignored the fact that Seurat never represented intact family groups anywhere else in his oeuvre, except for the single instance in the *Grande Jatte*. Perhaps this omission reflected neither his sociological nor his political commitment, but the impact of those childhood experiences which deeply colored his adult artistic vision.[41]

Although this essay challenges the notion that Seurat intended to subvert his masterpiece into a painted polemic depicting either class struggles or family problems in late nineteenth-century France, it seems clear enough that he wanted the personae of the *Grande Jatte* to represent a broad range of contemporary Parisian types.[42] However, the degree of abstraction, regulation, and idealization that he imposed upon his protagonists transcends their personal identities, setting them forever apart from mundane considerations of role or status. At its deepest level, the *Grande Jatte* represents the triumph of order over chaos, the re-emergence of a classical golden age in modern Paris, with people in contemporary garb replacing the Greek characters portrayed in

the seventeenth century by Nicolas Poussin and by Puvis de Chavannes in the nineteenth.[43]

The artist evolved his idealized vision through a long series of preparatory drawings and paintings. Two splendid examples of this type in the Art Institute, a drawing and a little oil on panel, probably both executed on site, illustrate how the actual realities of the island and its visitors differed from Seurat's inner vision. A comparison of the early conté-crayon study of a tree on the island (p. 207, fig. 8) with the comparable detail in the final painting (pl. 2), shows how Seurat transformed the twisted tree he actually observed into a comely specimen, smoothing its cleft trunk and magically restoring its former symmetry by replacing a large missing limb recorded in the sketch only as a gaping wound. A vivid little oil sketch, formerly in the Block Collection (pl. 3), reflects the ambiance of the island on a particular day, with its unprepossessing populace spread willy-nilly about the terrain, like so many pebbles cast.

By contrast, in Seurat's definitive vision, all the protagonists appear glorified and carefully positioned, cocooned in the special, individual spaces the artist reserved for them in his painting. Except for the tiny family group with the baby portrayed in the distant center of the picture, no person interacts with another. Even those few figures who touch one another seem mutually oblivious. Nor do the characters engage the spectator; only two figures face us, the central woman and child, and they both have veiled features and indistinct glances. In his masterpiece, Seurat chose to avoid the confrontational atmosphere created by Manet in his *Luncheon*, in which the nude model stares us down; he abjured too the convivial hospitality of Monet's luncheon scene, in which the central female figure symbolically invites the viewer to join the party. Nor did Seurat choose to depict the kind of camaraderie and high spirits conveyed by Renoir's jolly group of rowers. Instead Seurat's protagonists seem lost in contemplation. Many of them gaze raptly toward the Seine, that watery artery pulsing through the heart of Paris. Like members of a devout congregation attending an outdoor mass, they seem caught up in a pantheistic homage to nature, paying silent tribute to the beauties of Paris and the delights of a perfect summer afternoon. Their meditation is characterized by a certain tempo, a silent music, supplied by the regular repetition of poses and shapes, curves, lines, and angles, presented in continually varied contexts that suggest analogies to the construction of symphonic music, with its recurring patterns of theme and variations.[44]

Concluding Speculations and Summary

Like a god, Georges Seurat created his painted progeny in his own image. The isolated, meditative character of the personae of the *Grande Jatte* mirrors the artist's own withdrawn personality, just as their pantheistic homage to nature parallels his monotheistic worship of art. However, the psychological isolation of the figures in this picture can be found in paintings by Seurat from the beginning of his career. Even in those early oils on panel showing peasants working the fields side by side, the men never interact, apparently as unaware of one another as the fishermen represented in other panels casting their lines in unison but otherwise ignoring one another. Small wonder that in the only picture by Seurat

widely regarded as a self-portrait, *The Painter at Work* (fig. 8), the artist represented himself on a ladder (perhaps as he painted the *Grande Jatte*), with his back turned to the spectator.

In creating the numerous preparatory studies for the *Grande Jatte*, Seurat seemingly focused only on individuals who were actually unengaged with other island visitors at the time he captured them, or were at least represented by him in such a state of aloneness. A sole possible exception might be *The Snack* (fig. 9), a small panel painting that may or may not be a preparatory study for the *Grande Jatte*. It shows three little boys picnicking together, but even here the children, although physically close, really do not engage one another.

The psychological isolation that characterizes the personae of the *Grande Jatte* becomes even more marked in the canvases Seurat created subsequently. Although critics frequently contrast the stiffness of the populace of the *Grande Jatte* with the more tender, natural demeanor of the nudes represented in *The Models*, the isolation expressed here is no less strong, since the nudes are really the same model in three different poses (all based on great art of the past), and she does not interact with anyone, except the painted image of the woman with the monkey, reproduced from the *Grande Jatte*.[45]

Seurat's treatment of his protagonists in other late works reflects the increasing emotional withdrawal that clouded his final years. As his artistic ideas and achievements gained currency among the small circle of avant-garde artists active in Paris and Brussels, he became ever more fearful that others would steal and cheapen the inventions that he regarded as his alone. As his paranoia congealed, he removed himself ever more from his peers, a distancing reflected in the marked physical and psychological isolation of the figures in *The Bridge and Quays at Port-en-Bessin* (1888; the Minneapolis Institute of Arts) and *Bridge at Courbevoie* (fig. 11). The elegiac twilight mood of *Bridge at Courbevoie* permeates several of Seurat's other late landscape paintings, recalling the similar feeling apparent in the final canvases of another short-lived artist, Caravaggio, a coincidence that makes one wonder whether both men might have experienced premonitions of their coming deaths.

FIGURE 8. Georges Seurat. *The Painter at Work*, c. 1884. Conté crayon on paper; 30.7 × 22.9 cm. The Philadelphia Museum of Art.

234

FIGURE 9. Georges Seurat. *The Snack*, c. 1885. Oil on panel; 15.5 × 24.7 cm. Great Britain, private collection. Photo: Hauke 1961, vol. 1, p. 97.

FIGURE 10. Claude Monet. *Monet's House at Argenteuil*, 1873. Oil on canvas; 60.2 × 73.3 cm. The Art Institute of Chicago, Mr. and Mrs. Martin A. Ryerson Collection (1933.1153).

235

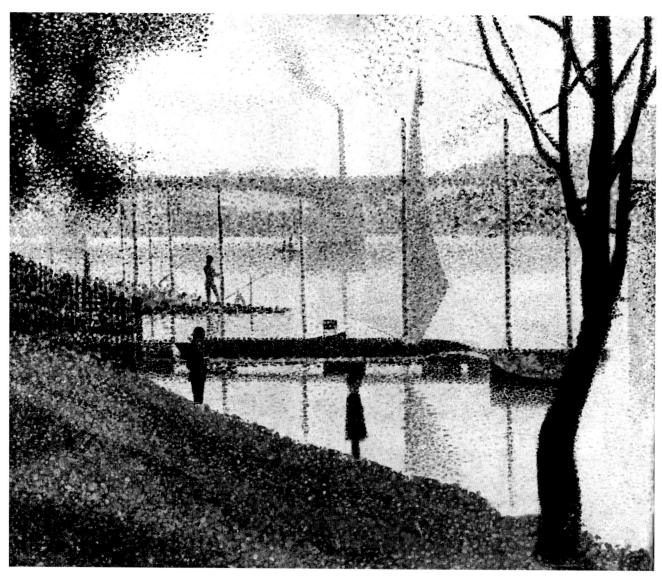

FIGURE 11. Georges Seurat. *Bridge
at Courbevoie*, 1886–87. Oil on
canvas; 46.4 × 55.3 cm. London,
Courtauld Institute.

If the personae Seurat invented for the *Grande Jatte*
collectively represent his emotional isolation, various in-
dividual figures from the ensemble refer more specifi-
cally to aspects of their creator's emotional life. Indeed,
it seems likely that, as his work on the painting pro-
gressed, each of his characters—perhaps originally con-
ceived in a spirit of greater neutrality—gradually ac-
quired a unique personal significance for him that the
fragmentary data available about his life permit us to
reconstruct only in equally fragmentary ways. The

unique character of the little family group—the mother,
father, and baby depicted interacting with one another in
the remote center of the canvas—suggests that they
probably possessed such meaning, perhaps recalling the
distant days of the artist's own infancy, a halcyon period
predating his father's quasi-psychotic withdrawal from
his family. The images of the two cadets, based on a
popular print depicting toy soldiers, may likewise refer
to happy moments of early childhood.[46] The equation of
the figure of the aged woman accompanied by the nurse
with the artist's mother offered in the Sondheim musical
interpretation of Seurat's life seems quite perceptive.[47]
Does this grouping of the old lady and nurse convey his
apprehension that he was destined to devote much of his

236

adult life to the care of a lonely, aging mother? (In this connection, it should be noted that the figure of the female nurse is widely believed to derive from the statues of male scribes so prevalent in Egyptian art.) Perhaps the child in white, shown at the exact center of the canvas, memorializes the little brother who died in early childhood. Had this child lived, he could have shared with Georges the burden of caring for his mother (represented here with the child as the more youthful figure she would have been at the time). The fact that the child wears a dress does not mean that the figure represents a girl; boys of that period wore dresses until they reached school age. A painting by Monet in the Art Institute, *Monet's House at Argenteuil* (fig. 10), shows his son, Jean, then about six years of age, wearing a white dress and hat remarkably similar to those of the central child in the *Grande Jatte*. One last speculation concerns the celebrated rower. Whomever else he may represent, perhaps he also symbolizes the artist's own, idealized alterego, the unrealized dream of a man who could never permit himself the relaxed, unconventional behavior of the painted figure shown taking his ease on the banks of the Seine.

If the protagonists of the *Grande Jatte* encode various highly personalized symbolic meanings, the formal aspects of the picture conceal messages just as personal. Art historians are accustomed to separating analysis of the formal structural elements of a painting from symbolic interpretations of its content. Within the oeuvre of a single artist, such distinctions do not exist; form and content contribute equally to the indissoluble whole that constitutes a personal iconography, and both are equally revealing of the private person, as well as the public artist. If the content of the *Grande Jatte* speaks to us of Seurat's personal relationships, past and present, its formal characteristics reveal his competitive ambitions, his dreams of artistic glory. The formal innovations of the *Grande Jatte* introduced an entirely new style of painting, refining and redefining Impressionism, reconciling

it with traditional picture making, while simultaneously transforming the academic approach by re-examining the entire issue of the relationship of the sketch to the finished painting.

With the creation of the *Grande Jatte*, the artist scored a resounding triumph over the Impressionists, especially over Monet, surely his foremost artistic competitor. But Seurat simultaneously achieved a still more definitive victory over his tyrannical father, a man whose example, as we have seen, imbued his son with an awareness of the importance of a methodical approach to life, while simultaneously serving as a constant reminder of the necessity for grounding one's dreams of achievement in vigorous preparation. Ever mindful of this example, the future artist prepared for his public career by undertaking a rigorous, self-designed apprenticeship before making his public debut as a painter. He extended the same careful procedures to the creation of the *Grande Jatte*, which evolved into its definitive form with the aid of dozens of preparatory drawings and sketches.

The fact that the picture indirectly alludes to so many great religious works of the past suggests that, from the beginning, it assumed special spiritual connotations in the mind of its creator. The religious aspects of the composition became increasingly important as the picture progressed, and by the time Seurat applied the topmost layer of Pointillist dots to the painting, each stroke had assumed the character of a ritualistic gesture imbued with a holy quality. This underlying spirituality of the *Grande Jatte*, however, did not translate itself into overt religious imagery; rather it is reflected in the meditative nature of the canvas and the hieratic, processional character of its protagonists. In creating this great painting, the artist replaced his father's sterile religious enactments with creative new rites that elevated the process of picture making to the level of sacred ritual and the role of the artist himself to that of the high priest of a new religion.[48]

Afterword

JOHN RUSSELL, *New York City*

THIRTY YEARS ago, when I was as green as grass, I was asked by Thames and Hudson, Inc., in London to write a short book on Seurat for a broad general public. Ever ready at that time to jump at a commission, no matter how giddy, I said that much could be done with Seurat in a plain, stout format. Whether the book that eventually resulted is good or bad is not for me to say, but it is still in print.

The first of its uses was that, for the first time in a modest format, it really did present an overview of Seurat's work in all its variety. This was owed not to any researches of my own, but to the generosity of César de Hauke, compiler of the two-volume catalogue raisonné of Seurat's paintings and drawings that was to be published in Paris in 1962.

Seurat at that time had not the prestige that he now enjoys. French connoisseurs were touched, almost without exception, when they identified a genuine English enthusiasm for his work. It was a matter of legend in the 1950s that, when Benedict Nicolson, future editor of the *Burlington Magazine*, went to pay his respects to Félix Fénéon, Seurat's first and most inspired elucidator, Fénéon insisted on giving him an original drawing by Seurat as a souvenir of their encounter.

Fénéon in such matters was all fire and air. As much as anyone in the last one hundred years, he reinvented the language of art criticism. And he was the first and last master of the two- or three-line review that puts the poets out of business. But he also had quite another side to him. "Fénéon can be depended upon," said France's Minister of War at a time when Fénéon was a junior official on his staff. What he meant was that, in all the things that mattered, Fénéon was both firefly and Euclid, long-distance planner and master of the verbal *entrechat dix*.

And the thing about César de Hauke was that he too could be depended upon. He had neither the brilliance nor the versatility of Fénéon. Where art, music, and literature were concerned, he had none of the 360-degree vision that caused Fénéon to single out Rimbaud, Proust, Apollinaire, Debussy, and Vuillard at a time when few would have recognized them as among the most gifted people of their day.

He could, on the contrary, be wonderfully, decisively, and irremediably narrow in his judgments. On one occasion, I passed through Paris during the run of a major exhibition of the work of Paul Signac. As Signac had been close to Seurat in their early days, I ventured to ask what de Hauke had thought of the show. "I have not been," he said, "and I have no intention of going. Signac bores me—to DISTRACTION!"

Formidable was the effect of this anathema, when delivered at close quarters through lips turned temporarily

green with horror and scorn. César de Hauke in such matters was completely himself, just as he was unmistakably himself, and without affectation, when he brought the traffic to a halt in St. James's Street in London by stumping across the road in a suit of green and purple Irish tweed, most villainously cut upon the bias.

He did not in general look upon the world lightly. Its shortcomings rarely escaped him. Over every last page-proof of his forthcoming Seurat catalogue, he would stand and stare like Sherlock Holmes, struck to the spot by new evidence of human frailty. "How many works do you hope to reproduce in your book?" he asked me, shuddering perceptibly from head to foot as I mentioned a number that would now be described as "in the low three figures." As if seized anew by the vanity of human hopes, he fell silent for what seemed like a very long time. "If you truly intend to persist," he said at last, "my own photographic collection has just returned from the printers. Please consider yourself free to make whatever use of it may seem to you appropriate."

"And the fee?" I asked. "The fee?" said de Hauke, as if the word were one that he had never heard before. "If you insist, a check for . . . francs would be acceptable." As to the figure in question, I will say only that I doubt that so small a check had ever before been written out to his professional account.

So César de Hauke, like Félix Fénéon, could be depended upon. He did not, however, have what might be called a point of view in relation to Seurat's activity. He knew good from bad, and right from wrong, and year from year. Beyond that he allowed the great paintings and the great drawings to lead their own life. "This is what Seurat did," he seemed to say. "Make of it what you can."

It is a challenge to which every generation will respond in the way that is closest to its own fantasies, ambitions, and cravings for order. Wary and secretive in life, Seurat in his work gave freely, openly, and with both hands. He reinvented, day after day, the potential of both painting and drawing. At twenty-five, when he did *Sunday Afternoon on the Island of the Grande Jatte* (pl. 2), he was already one of the greatest of all picture-architects; yet, in the Giorgionesque life-span that was allotted to him, he also asserted himself in drawing after drawing as the one of the great poets of instantaneity. Experience in his work comes to us coded and recoded in so many ways that no one generation, no one ob-server, no one polemic will ever exhaust him.

We can trace these shifts of belief almost year by year. In 1926 Roger Fry saw in the *Grande Jatte* "a world from which life and movement are banished and all is fixed forever in the rigid frame of its geometry." Five years later, Robert Rey saw the life of the painting as slowed, not stilled, as if the slow-motion film were playing a part in it. Some observers continued to believe that there was some kind of demonic formula in Seurat's use of the dot, but Meyer Schapiro put that to rights when he said that "I cannot believe that an observer who finds Seurat's touch mechanical has looked closely at the pictures."

That Seurat was a great moralist can never have been in doubt. But he was neither censor nor teacher, but rather an instinctive mathematician who could do very complicated sums in his head and finds ways of showing us, without a word spoken or written, which modes of action were worthy of a human being, and which others were not.

It was E. M. Forster in 1949 who came close to a certain idea of Seurat when he said that "Art is the one orderly product which our muddling race has produced. . . . It is the lighthouse that cannot be hidden: *c'est le meilleur témoignage que nous puissions donner de notre dignité.* 'Antigone' for 'Antigone's' sake, 'Macbeth' for 'Macbeth's,' 'La Grande Jatte' for 'La Grande Jatte's.' "

But forty years later, broad general statements of that sort do not go down too well. Other, stricter, more scientific, and more tightly documented and argued points of view proliferate. The *Grande Jatte* as a portrait of an industrial society in transition turns up here, there, and everywhere and in many a language that is remote from that of Félix Fénéon.

This particular reader read with an attention that bordered on bemusement the contributions to this number of *The Art Institute of Chicago Museum Studies*, in which disciplines unborn in Seurat's day are matched against the great and indestructible painting. I came. If I was not always conquered, it is because I still think of Seurat as a supreme master of the poetic imagination who went his own way—secret, wary, competitive in the extreme—and hewed to no one discipline, no one set of beliefs, no one view of the world. No more than the Titian/Giorgione *Concert Champêtre* in the Musée du Louvre is the *Grande Jatte* swing wide open to a single set of keys. That is why this particular reader hopes to be around in twenty-five years' time, when the *Grande Jatte* will be interpreted all over again.

NOTES

Rossen. "Foreword," pp. 112–13.

1. Alfred H. Barr, Jr., "Research and Publications in Art Museums," paper delivered at a conference, "The Future of Art Museums as an Educational Institution," held at The Art Institute of Chicago (cosponsored with the University of Chicago), May 24–25, 1944. Published in *Museum News* 23, 13 (Jan. 1, 1946), p. 8. Reprinted in *Defining Modern Art—Selected Writings of Alfred H. Barr, Jr.* Ed. by Irving Sandler and Amy Newman, intro. by Irving Sandler. New York, 1988. p. 209.

2. Rich 1935, p. 6.

3. Schapiro 1935, p. 16.

House, "Reading the *Grande Jatte*," pp. 115–31.

Many colleagues and friends helped me as I developed the ideas of this article, though they may not agree with my conclusions; I should like particularly to acknowledge Kathleen Adler, Tamar Garb, and Paul Smith, in addition to the recent studies by T. J. Clark, Martha Ward, and Richard Thomson, cited in note 6 below.

1. Signac, cited in Rewald 1949, p. 107.

2. Paul Signac, "Les Besoins individuels et la peinture," in *Encyclopédie française*, ed. by A. de Monzie (Paris, 1935), vol. 16, pp. 7–10, reprinted in Signac 1964, p. 154.

3. Fénéon 1886, reprinted in Fénéon 1966, pp. 66–67; Adam 1886, cited in Clark 1984, p. 316 n. 14.

4. Rich 1935, p. 23.

5. Schapiro 1935; Meyer Schapiro, "New Light on Seurat," *Art News* 57, 2 (Apr. 1958), p. 44, reprinted in Schapiro 1978, pp. 103–104.

6. Herbert 1962, 1968, 1970; Clark 1984; Thomson 1985; and Ward 1986.

7. See Inge Fiedler, "A Technical Evaluation of the *Grande Jatte*," in the present issue, pp. 173–79.

8. On the place, see also Thomson 1985, pp. 116–19.

9. For discussion of the reference to Sunday, see Clark 1984, pp. 261–63; Thomson 1985, pp. 119–20; and S. Hollis Clayson, "The Family and the Father: The *Grande Jatte* and its Absences," in the present issue, pp. 160–64. On the inclusion of the date 1884 in the original title of the picture, see House 1980, p. 346.

10. The town-hall decorations have been published in an important exhibition catalogue: Paris, Musée du Petit Palais, *La Triomphe des mairies* (Paris, 1986).

11. The only visible nuclear family is the small standing group in the right background of the picture, to the right of the sunlit tree. See Clayson (note 9), pp. 157–58.

12. See Richard Thomson, "'Les Quat' Pattes: the image of the dog in late nineteenth-century French art," *Art History* 5, 3 (Sept. 1980), pp. 323–37; on the possible association between pugs and courtesans, see p. 337 n. 76.

13. For discussions of prostitution in Paris, see Alain Corbin, *Les Filles de noce* (Paris, 1978); and S. Hollis Clayson, "The Representation of Prostitution in Paris during the Early Years of the Third Republic," Ph.D. diss., University of California, Los Angeles, 1984.

14. Richard Sennett, *The Fall of Public Man*, 2d ed. (London, 1986), pp. 161–74.

15. Octave Uzanne, *The Modern Parisienne* (first published in Paris in 1894; English ed.: London, 1912), pp. 199–200; *Journal de Marie Bashkirtseff* (Paris, 1890), vol. 2, pp. 105–106. I owe the last reference to Tamar Garb.

16. See Thomson 1985, p. 123; and idem, "The *Grande Jatte*: Notes on Drawing and Meaning," in the present issue, pp. 186–87. For a differing view, see Mary Gedo, "The *Grande Jatte* as the Icon of a New Religion: A Psycho-Iconographic Interpretation," in the present issue, pp. 231–32.

17. See Ward 1986, pp. 434–35; the figure was identified as a *canotier* by Fénéon 1886 and by Christophe 1890.

18. On the imagery of the wet nurse, see Fanny Faÿ-Sallois, *Les Nourrices à Paris au XIXe siècle* (Paris, 1980), pp. 230–34; Thomson 1985, pp. 122–23; and Linda Nochlin, "Seurat's *Grande Jatte*: An Anti-Utopian Allegory," in the present issue, pp. 145–47, 242n. 24. For a differing interpretation of the nurse in the *Grande Jatte*, see Gedo (note 16), pp. 236–37, 251 n. 47.

19. For the moral status of this group, see Clark 1984, pp. 265–67; Thomson 1985, pp. 121–24; and Ward 1986, pp. 434–36.

20. Moore 1886, cited in Ward 1986, p. 434. Christophe 1890 described the couple on the right side as "hieratic and scandalous."

21. Another reference to the demimonde, the image of the man in the foreground smoking in public, has been drained of its habitual associations with sexual licence: the total lack of interchange between him and the woman beside him thwarts any anecdotal reading.

22. Thomson 1985, pp. 124–25.

23. Clark 1984, pp. 265–67.

24. Ward 1986, pp. 434–36.

25. Thomson 1985 (p. 122) identified the hatless girls as working class, but their trim, simple dresses seem to link them with the urban *petite bourgeoisie*.

26. Ajalbert 1886, cited in Clark 1984, p. 316 n. 12.

27. See House 1980, p. 348; and Clark 1984, pp. 261–66, 315.

28. Clayson (note 9), pp. 160–64.

29. Extracts from this text will give a flavor of the type of interpretation that pictures such as Jourdain's invited: "Here is one of the *canotiers* returning from the boat triumphantly carrying two bottles of champagne. . . . What joy at this news, and how happy she is, the gay *canotière* who raises her arms, with her mouth open and her eyes lit up, ready, armed with her knife and fork. Her companion seems less enthusiastic; all her thoughts are for her neighbor whose tender gaze reproaches her culpable indifference; perhaps the sparkling liquid will restore her spirits; but it may only make the tears flow!" See *L'Illustration*, no. 1842 (June 15, 1878), p. 390.

30. For arguments that the two are closely linked, see House 1980, pp. 346–49.

31. Paul Smith, in lectures given at the Courtauld Institute, London,

from material in his forthcoming doctoral thesis on Seurat for the Courtauld.

32. The picture's title, *Bathing, Asnières*, does not suggest a Sunday; indeed the smoking chimney may indicate a weekday. See Clayson (note 9), p. 162.

33. For a contrary argument, that *Bathing* is a "rather conservative" canvas and that they are not related, see Thomson 1985, pp. 79–90, 125–26.

34. After its exhibition at the 1882 Salon, Gervex's canvas was installed as a decoration in the town hall of the nineteenth arrondissement in Paris.

35. See House 1980, pp. 346–49.

36. Fèvre 1886, p. 149, and Paulet 1886, both cited in Dorra and Rewald 1959, p. 160; Hermel 1886 and Adam 1886, p. 550, both cited in Clark 1984, p. 316 nn. 14, 17.

37. The theme of models posing in the artist's studio was frequent in the Salon during the 1880s; for further discussion of Seurat's picture, see House 1980, pp. 349–51.

38. Hermel 1886 and Paulet 1886.

39. Smith's forthcoming thesis (see note 31) will examine these links at length; I am indebted to him for his discussion of these issues with me. See also Paul Smith, "Paul Adam, *Soi* et les 'Peintres impressionnistes': La Genèse d'un discours moderniste," *Revue de l'Art* 82 (1988), pp. 39–50.

40. Théophile Thoré, in *L'Indépendance belge* (June 29, 1868), reprinted in idem, *Salons de W. Bürger, 1861 à 1868* (Paris, 1870), vol. 2, pp. 531–32; Stéphane Mallarmé, "The Impressionists and Edouard Manet," in *Art Monthly Review and Photographic Portfolio* 1, 9 (Sept. 30, 1876), pp. 117–22, reprinted in San Francisco 1986, pp. 27–37, esp. 33–34; for further discussion of Manet in these terms, see House, "Manet's Naïveté," in "The Hidden Face of Manet," *Burlington Magazine* 128, 997 (Apr. 1986), pp. 1–19.

41. Fénéon 1886, reprinted in Fénéon 1966, p. 66.

42. Signac, cited in Rewald 1949, and Signac 1891, p. 4, both cited in Thomas Crow, "Modernism and Mass Culture," in *Modernism and Modernity*, ed. by Benjamin H. D. Buchloh et al., (Halifax, Nova Scotia, 1983), p. 218.

43. Crow's article (note 42) is of fundamental importance for any examination of art and radical politics in this period.

44. For discussions of Seurat's political views, see House 1980, pp. 349ff.; Thomson 1985, pp. 94–95, 192–93; and Stephen F. Eisenman, "Seeing Seurat Politically," in the present issue, pp. 211–21.

45. I would now disavow the assumptions that lay behind my 1980 article and its title "Meaning in Seurat's Figure Paintings"; it is misleading to suggest that a picture has a single meaning, and that meaning is inherent in the work itself.

Nochlin, "Seurat's *Grande Jatte*, an Anti-Utopian Allegory," pp. 133–53.

This article is derived from a lecture delivered at The Art Institute of Chicago on October 5, 1988, initiating the Norma U. Lifton Memorial Lecture Series for the School of the Art Institute. A member of the art-history faculty at the school, Norma Lifton died in January 1988. I prefaced my talk as follows: "I would like to think of this lecture as a kind of homage to Norma Lifton, a woman I never actually knew but somehow feel as though I had known, thanks to the words of her friends and admirers. One of them described her as having 'a sharp mind, a good ear, and a wonderful instinct for quality in all she saw and did'; I cannot think of higher or more honest praise."

1. The standard translation is Ernst Bloch, *The Principle of Hope*, trans. by Neville Plaice, Stephen Plaice, and Paul Knight (Cambridge, Mass., 1986), vol. 2, p. 814. Used here is the translation in Franz and Growe 1983, pp. 82–83. Bloch was associated with the Frankfurt School, an influential group of Marxist theoreticians of social and aesthetic issues in Germany before World War II, and, after the war, in the United States.

2. The concepts of "spectacle" and "spectacular society" were developed in the 1960s as part of the theoretical work of a group in France called the Situationist International and especially by Guy Debord. For further information, see Clark 1984, pp. 9–10.

3. Bloch (note 1), pp. 813–14. The translation here is by Plaice, Plaice, and Knight.

4. The satiric exaggeration of structure itself constitutes an anti-utopian strategy, allegorizing the failure of formal harmony in more traditional paintings of the time and calling into question, like the so-called social harmony it refers to, the whole idea of a "paradise on earth."

5. Seurat did not simply remove the process of pictorial construction from painting, neutralizing handiwork into nonexistent smoothness and universality, as did a Neoclassical artist such as J. A. D. Ingres. The facture is unremittingly present. It has simply been mechanized, positively depersonalized, and made anti-expressive.

6. Schapiro 1935, pp. 14–15.

7. Fourierism was an influential utopian socialist movement founded by Charles Fourier (1772–1837). On Papety see Nancy Finlay, "Fourierist Art Criticism and the *Rêve de Bonheur* of Dominique Papety," *Art History* 2, 3 (Sept. 1979), pp. 327–38. Finlay referred to the *Dream of Happiness* as having "its message of Fourierist utopia conveyed by standard classical formulas in a classicizing style . . ." (p. 330).

8. Ibid., p. 331.

9. Ibid., p. 334.

10. Théophile Gautier, in *Moniteur universel* (June 3, 1867), cited in Claudine Mitchell, "Time and the Ideal of Patriarchy in the Pastorals of Puvis de Chavannes," *Art History* 10, 2 (June 1987), p. 189.

11. Signac 1891, p. 4, cited in Thomson 1985, pp. 207, 233 n. 82.

12. Indeed, looking at the criticism of the time, it becomes clear that it is the expressive formal structure of the whole rather than the social differences marking the picture's cast of characters—or more exactly the unprecedented juxtaposition of working and middle-class figures so emphasized by T. J. Clark in his recent account of the work (Clark 1984, pp. 265–67)—that made the most forceful impression on articulate viewers of the 1880s and made them read the *Grande Jatte* as pointed social critique. As Ward 1986 pointed out, contemporary critics "acknowledged diversity but did not attend to its implications. Most were far more concerned to explain why

all of the figures appeared to be rigid, stiff, expressionless, and posed . . ." (p. 435).

13. Ward 1986, p. 435.

14. Fèvre 1886, p. 149, cited in Ward 1986, pp. 435, 442 n. 80.

15. Adam 1886, p. 550, cited in Ward 1986, pp. 435, 442 n. 81.

16. Paulet 1886, cited in Thomson 1985, pp. 115 n. 31, 229, 230 n. 33.

17. Fénéon 1886, trans. in Nochlin 1966, p. 110.

18. Rich 1935, p. 2.

19. One need only think of the famous diagrams of Cézanne's paintings in Erle Loran, *Cézanne's Compositions* (Berkeley, Los Angeles, London, 1943), which were recycled by Pop artist Roy Lichtenstein in such works as *Portrait of Madame Cézanne* of 1962 (see Pasadena Art Museum, *Roy Lichtenstein*, exh. cat. by John Coplans [1967], fig. 11).

20. Schapiro 1935, pp. 11–13.

21. For the most recent verdict on Seurat's "scientific" color theories, see Lee 1987, pp. 203–26. Lee concluded unequivocally: "Far from being scientifically well founded, his 'chromo-luminarist' method was pseudo-science: it was specious in its theoretical formulation, and was applied with an indifference to any critical appraisal of its empirical validity" (p. 203).

22. Broude 1978, p. 173.

23. Ward 1986, pp. 434–35.

24. From the front, a wet nurse can be understood to be any nursing woman; from the rear, because of the presence of the circular cap and the signifying ribbon and cloak, the figure can only be seen as a wet nurse. Thus the back view reduces ambiguity of signification along with human relationship. For a full-scale analysis of Morisot's *Nursing*, see Linda Nochlin, "Morisot's *Wet Nurse*: The Construction of Work and Leisure in Impressionist Painting," in idem, *Women, Art, and Power and Other Essays* (New York, 1988), pp. 37–56. For a differing interpretation of the nurse, see Mary Gedo, "The *Grande Jatte* as an Icon of a New Religion: A Psycho-Iconographic Interpretation," in the present issue, pp. 236–37, 251 n. 47.

25. Herbert 1962, reprinted in Broude 1978, p. 129.

26. Fry 1926, cited in Russell 1965, p. 157.

27. The animal freedom of the dog, a chattel by definition, cannot signify social freedom the way the girl does. And indeed his position, a parodic version of the capriole, one of the advanced positions of equestrian dressage, signifies artificed constriction itself.

28. For this notion, as well as the relation of the transcient and fragmentary to the utopian function of art, see Bloch, "The Conscious and Known Activity Within the Not-Yet-Conscious, The Utopian Function," in *The Utopian Function of Art and Literature*, trans. by J. Zipes and F. Mecklenburg (Cambridge, Mass., 1988), pp. 103–40, esp. p. 139.

29. For the negative contradiction of Courbet's figuration of hope in the *Studio*, in the form of the Irish beggar woman, see Linda Nochlin, "Courbet's Real Allegory: Rereading 'The Painter's Studio,'" in The Brooklyn Museum, *Courbet Reconsidered*, exh. cat. by Sarah Faunce and Linda Nochlin (1988), pp. 26–29.

30. Fénéon 1886, cited in Halperin 1988, p. 83.

Clayson, "The Family and the Father: The *Grande Jatte* and its Absences," pp. 155–64.

The conversations I have had with Richard R. Brettell (former Searle Curator of European Painting at the Art Institute) in front of the *Grande Jatte* launched the line of thinking that became this essay. I have benefitted as well from the comments of Ann Adams, Carol Duncan, and Carol Zemel on this material, and from Martha Ward's vast knowledge of Neo-Impressionism. Nancy Ring's remarks were decisive for the completion of this article. I am grateful for their help.

1. Although this is the title that is most widely used today for the painting, Seurat gave it a slightly different one whenever he exhibited it. He called it *Un Dimanche à la Grande-Jatte (1884) (A Sunday on the Grande Jatte [1884])*. The year 1884 was invariably appended to the title in order to mark the date of its inception rather than 1886, the year of its completion.

2. In a letter to Félix Fénéon, dated June 20, 1890, Seurat claimed that he began all aspects of the project on Ascension Day. See Dorra and Rewald 1959, p. 157. By giving one date of birth to the entire enterprise, Seurat wished to assert that he worked on the huge canvas and the smaller pieces simultaneously. But the completion of some of the small-scale works preceded the conclusion of the large canvas: nine of the sketches and one study for example were shown in the first Société des Artistes Indépendants exhibition, in 1884.

3. See Richard R. Brettell's summary of the second campaign in his *French Impressionists, The Art Institute of Chicago* (Chicago and New York, 1985), p. 89; also see Inge Fielder, "A Technical Evaluation of the *Grande Jatte*," in the present issue, pp. 173–79.

4. Schapiro 1935, p. 14.

5. House 1980, esp. pp. 346–49; and idem, "Reading the *Grande Jatte*," in the present issue, pp. 115–31.

6. Clark 1984, chaps. 3 and 4; see esp. pp. 155, 204.

7. House 1980, p. 348.

8. Griselda Pollock and Fred Orton, "Les Données Bretonnantes: La Prairie de representation," *Art History* 3, 3 (Sept. 1980), p. 331.

9. Thomson 1985, pp. 122–26; and idem, "The *Grande Jatte*: Notes on Drawing and Meaning," in the present issue, p. 185.

10. Clark 1984, p. 265.

11. See Patrick H. Hutton, ed., *Historical Dictionary of the Third French Republic 1870–1940* (New York and Westport, Conn., 1986), pp. 701–702. See also Heinz Gerhard Haupt, "The Petite Bourgeoisie in France, 1850–1914: In Search of *Juste Milieu*," in Geoffrey Grossick and Heinz Gerhard Haupt, eds., *Shopkeepers and Master Artisans in 19th Century Europe* (London, 1984), pp. 95–119.

12. Christopher Prendergast, "Blurred Identities: The Painting of Modern Life," *French Studies* 40, 4 (Oct. 1986), p. 404. In his review of Clark 1984, Prendergast presented and summarized Clark's argument better than anyone else has to date.

13. Ibid.

14. Clark 1984 came down particularly hard on Claude Monet: "I cannot see, for example, that Monet's two pictures of *Le Boulevard des Capucines* in 1873 do more than provide that kind of touristic entertainment, fleshed out with some low-level demonstrations of painterliness" (pp. 70–72).

15. An original analysis of the critical reaction to Seurat's *Grande Jatte* in 1886 can be found in Ward 1986. Ward observed that critics did not generally remark upon the social diversity of the population of Seurat's *Grande Jatte* for two reasons: because by 1886 critics were becoming more interested in aesthetic than in social issues, and because the painting's population is not diversified. On these points, she disagreed with Clark and Thomson.

Although Clark and Thomson for example agreed on the presence of social difference in the picture, they parted company on its significance and its precise signifiers. Thomson 1985 wrote: "The simplified visual language of popular imagery, a refined range of specific types, the punning invocation of argot, and the associations of animal imagery. These were the means that enabled Seurat . . . to come to terms with the complex modernity of the suburbs" (p. 126). Evaluating the picture from an entirely different standpoint, Clark 1984 stated that he was making "the following claims for [Seurat's *Grande Jatte*]: that it attempts to find form for the appearance of class in capitalist society, especially the look of the 'nouvelles couches sociales' [see note 40 below]; that the forms it discovers are in some sense more truthful than most others produced at the time; and that it suggest ways in which class might still be painted" (p. 261).

16. I have drawn an imaginary line laterally across the painting's middleground, connecting the horn player at the left to the running girl at the right. I have included these two figures and all the figures in front of them in my inventory.

17. I am counting the following pairs as mothers and children: 1) the seated female pair on the edge of the large foreground shadow—the girl (the daughter) is admiring a nosegay, while the mother, protected by her red hat and red parasol, surveys the island; 2) the redheaded, hatless woman at far right, seated near the baby carriage and encircling the child (daughter) alongside her with an arm; 3) the seated woman in a straw hat at the farthest right edge of the picture, who appears to await the child (daughter) in red running in her direction.

18. On what the island of the Grande Jatte was like at the time, see House 1980, p. 347; Clark 1984, p. 261; and Thomson 1985, pp. 116–19.

19. *The White Dog* (study for the *Grande Jatte*), 1884. Oil on panel; 15.5 × 25 cm. United States, private collection.

20. Russell 1965 believed that Seurat did not study the island on Sundays: "Seurat's tendency was to give the Ile de la Grande Jatte its Monday face; later, when getting on to the big picture, he would people the island as he pleased" (p. 146). Russell was surely correct in warning his readers away from the trap of assuming that Seurat only painted what he saw.

21. E. Levasseur, *Questions ouvrières et industrielles en France sous la Troisième République* (Paris, 1907), p. 448.

22. Lafargue encouraged workers to claim what the bourgeoisie claimed: leisure and intellectual life. I learned of Lafargue's "Droit à la paresse" from an excellent lecture given by Kristin Ross (titled "The Right to Laziness") at the Colloquium in Nineteenth-Century French Studies (13th Annual Meeting), Northwestern University, 1987. See also idem, "Rimbaud and the Resistance to Work," *Representations* 19 (Summer 1987), pp. 62–86.

23. Levasseur (note 21), p. 448.

24. Michelle Perrot, *Les Ouvriers en grève: France 1871–1890* (Paris and the Hague, 1974), vol. I, p. 260.

25. Levasseur (note 21), pp. 448–49.

26. Perrot (note 24), p. 227, reported that by 1893 ninety-three percent of French workers benefitted from Sunday off.

27. Philippe Meyer, *The Child and the State: The Intervention of the State in Family Life* (Cambridge, 1983), pp. 33–34.

28. Joseph Lefort, "Du Repos hebdomadaire," cited in Meyer (note 27), p. 125 n. 20.

29. Levasseur (note 21), p. 449.

30. See Meyer (note 27), chaps. 1–3; Jacques Donzelot, *The Policing of Families* (New York, 1979); and E. P. Thompson, "Time, Work-Discipline, and Industrial Capitalism," *Past and Present* 38 (Dec. 1967), pp. 56–97.

31. The classic study is Philippe Ariès, *Centuries of Childhood: A Social History of Family Life* (New York, 1962). A good, short overview of the shift to the modern family ideal appears in the series of articles by Christopher Lasch in *The New York Review of Books*: "The Family and History" (Nov. 13, 1975), pp. 33–38; "The Emotions of Family Life" (Nov. 27, 1975), pp. 37–42; and "What the Doctor Ordered" (Dec., 11, 1975). An excellent feminist critique of recent family history is Rayna Rapp, Ellen Ross, and Renate Bridenthal, "Examining Family History," in *Sex and Class in Women's History*, ed. by J. L. Newton, M. P. Ryan, and J. R. Walkowitz (London, 1983), pp. 232–58.

32. See Thompson (note 30), pp. 73ff.; Perrot (note 24), pp. 225–27; and Georges Duveau, *La Vie ouvrière en France sous le Second Empire* (Paris, 1946), pp. 243ff.

33. Edward Young, *Labor in Europe and America; a special report on the rates of wages, the cost of subsistence (etc.)* (Philadelphia, 1875), p. 674. Young was chief of the U. S. Bureau of Statistics.

34. Joan W. Scott and Louise A. Tilly, "Women's Work and the Family in Nineteenth-Century Europe," in Charles E. Rosenberg, ed., *The Family in History* (Philadelphia, 1975), pp. 145–78.

35. John House would disagree with my interpretation of *Bathing* as a depiction of Monday. In comparing the two works, he wrote: "The contrast of staffage is clearly a question of class: working-class leisure [in *Bathing*] opposed to the fashionable classes on display [in the *Grande Jatte*]." See House 1980, p. 347. But, even though House reproduced Roger Jourdain's *Sunday* and *Monday* (prints after lost paintings that hung in the Salon of 1878; see p. 126, figs. 13, 14) to support his observation of class differences between Seurat's canvases, he did not conclude that they are Sunday and Monday pictures like Jourdain's. Nor would Clark (whose book also reproduces the above-mentioned engravings of Jourdain's *Sunday* and *Monday* in connection with Seurat) share my view; see Clark 1984, pp. 157–58, 201–202, 261–63.

36. Perrot (note 24), p. 226.

37. In Perrot (note 24), p. 226, are the phrases "pas de toilette à faire" ("no dressing up to do") and "il rêve d'échapper à la blouse et d'être mis en bourgeois" ("he dreams of escaping from his smock in order to wear bourgeois clothes").

38. Ibid., pp. 225–26.

39. Thomson 1985, p. 125.

40. By the mid-1870s, Léon Gambetta (1838–1882) was the leading republican politician in France. To recognize the greater differentiation within the middle class toward the end of the nineteenth century, Gambetta coined the expression "nouvelles couches so-

ciales;" he used it for the first time in a speech in 1872. He imagined this rapidly growing sector of the middle classes as the potential basis of a new political coalition under the Third Republic.

41. Clark 1984, p. 265.

42. "On n'est qu'un ouvrier, mais on sait se tenir aussi bien qu'un bourgeois," Duveau (note 32), p. 366. On this issue, see also Perrot (note 24), pp. 225–28.

43. See Duveau (note 32), pp. 367–68; and Perrot (note 24), pp. 225–28. The sportsman is not however, as Stephen Sondheim interpreted him in his musical *Sunday in the Park with George* (1984), an angry worker looking for a fight.

The identification of this figure has been controversial. (For a cogent discussion of the disputed identity and complete citations for the 1886 criticism, see Ward 1986, pp. 434–36, 495–96.) Fénéon's June 1886 review mentions the presence in the *Grande Jatte* of a *canotier* (rower or canoeist). His September 1886 article on the Eighth Impressionist Exhibition specifically identifies the reclining man as a *canotier*. Jules Christophe's 1886 review enumerated the following social types in the painting: elegant men and women, soldiers, nannies, bourgeois, workers ("élégants, élégantes, soldats, bonnes d'enfants, bourgeois, ouvriers"). Clark 1984 (p. 265) believed that the reclining man in Seurat's picture is the worker on Christophe's list, while House 1980 argued that this figure is Fénéon's *canotier*. House wrote: "Fénéon and other contemporaries identify him as a *canotier*, and *canotage* was a recreation which belonged integrally to this demi-mondaine world" (p. 347). In his review of Clark's 1984 book, House 1986 pointedly expressed his dissent over the identity of the reclining figure: "The man smoking a pipe cannot be confidently identified as a worker; his hat and vest seem rather to be the casual gear of a bourgeois *canotier*" (p. 297). My ideas about the identity and function of this figure do not rely upon a strictly either/or position.

44. See Clark 1984, p. 265.

45. See Thomson 1985, pp. 121–23; and Ward 1986, pp. 434–36. The outlandish monkey confirmed her venal status for most early viewers. The contours of her dress dramatized the size of her bustle so that her fashionable outfit threatened to appear "hyper-fashionable" (an outright exaggeration of current fashion). At the time, female "hyper-fashionability" was usually understood to connote immorality.

46. All of the biographical information comes from Jean Sutter, "Recherches sur la vie de Georges Seurat (1859–1891)," unpubl. ms. (eighty copies circulated "aux Amis de Georges Seurat"), 1964. I thank Martha Ward for bringing this to my attention.

47. To be exact, Antoine Seurat was a minor court official (*huissier*) of the Tribunal of the Département of the Seine at La Villette.

48. Gustave Kahn, "Au Temps du pointillisme," *Mercure de France* (Apr. 1, 1924), p. 13. I am grateful to Martha Ward for the exact reference. See also Russell 1965, p. 23. Ironically, in an 1888 letter to Emile Bernard, Vincent van Gogh used the same term to describe Degas: "[Degas] lives like a little notary . . ." ("Lettre IX," *Lettres de Vincent van Gogh à Emile Bernard* [Paris, 1911], p. 102).

49. The definitive account of the relationship between Neo-Impressionist art and anarchist politics is John G. Hutton, "A Blow of the Pick: Science, Anarchism, and the Neo-Impressionist Movement," Ph.D. diss., Northwestern University, 1987.

50. Perrot (note 24), p. 226.

51. For a psychoanalytical reading of the *Grande Jatte* in which the frequent absence of Seurat's own father is correlated with the iconography of the painting, see Mary Gedo, "The *Grande Jatte* as the Icon of a New Religion: A Psycho-Iconographic Interpretation," in the present issue, pp. 224–25, 233.

52. The best analysis of the coexistence of these opposing qualities in the painting remains Schapiro 1935, pp. 12–13.

Inge Fiedler, "A Technical Evaluation of the *Grande Jatte*," pp. 173–79.

1. The *Grande Jatte* underwent conservation treatment in December 1957 in preparation for the Seurat exhibition at the Art Institute and The Museum of Modern Art, New York, from January to May 1958. Dirt and grime were removed from the painting's surface. Because the edges of the picture were too fragile to safely support the weight of the canvas, the tacking margins were reinforced from the back of the canvas with thin strips of linen fabric infused with a wax adhesive. This weakness was probably the result of the painting having been removed from its stretcher and rolled for transport many times in its history. Otherwise it was considered to be in very good condition. Conservator Louis Pomerantz also noted during his examination that the painting was unvarnished. It was decided not to varnish it, but to continue keeping it under glass. On April 15, while it was at The Museum of Modern Art, a serious fire occurred there; fortunately the *Grande Jatte*, as well as all of Seurat's other paintings in the exhibition, suffered no damage and was safely evacuated. This was the only time the painting ever left the Art Institute since it came to the museum in 1926. See conservation examination and treatment report, Dec. 6, 1957, Conservation Department, and Art Institute Archives. See also Russell Lynes, *Good Old Modern, An Intimate Portrait of The Museum of Modern Art* (New York, 1973), pp. 359–76.

2. See Walter C. McCrone, Lucy B. McCrone, and John G. Delly, *Polarized Light Microscopy* (Ann Arbor, 1978). In addition to the optical microscope, we employed other analytical methods, such as microchemical tests, electron microprobe, x-ray diffraction, and microspectrophotometry, to provide supplementary data on a number of the samples. Microchemical tests use specific chemical reactions on a micro scale to identify substances. The reaction involves either chemically combining specific color changes or the formation of a recognizable compound by chemically combining the unknown pigment with specific known substances in a controlled manner. Electron microprobe is a method of x-ray fluorescense that uses characteristic x-rays to identify the chemical elements present in a few cubic micrometers of a sample. (One micrometer is equal to $\frac{1}{25,400}$ of an inch.) The technique of x-ray diffraction measures the angles through which x-rays are preferentially scattered by a crystal, providing information about the interatomic or intermolecular distances in the crystal. These values are then used for identification of specific compounds. Microspectrophotometry allows the measurement of spectral (or color) absorption curves from small areas of a sample.

3. On Charles Blanc and Seurat, see Michael Zimmermann, "Seurat, Charles Blanc, and Naturalist Art Criticism," in the present issue, pp. 199–209.

4. See Signac 1964, pp. 106–107; and Nochlin 1966, p. 122. See also Rewald 1978, pp. 97–98.

5. During his second campaign, Seurat enlarged many of the forms, with the most significant changes applied to the main figures. These enlargements generally altered their contours into more curved shapes. Examples can be seen in the fisherwoman, (most noticeable in her skirt), the bustle of the woman with the monkey, and in the skirt and both arms of the central woman with the child. In addition to the main figures, some of the foliage and animals were also changed. The brush strokes used by Seurat for these alterations are a combination of dots, dashes, and lines.

6. Anthea Callen, *Techniques of the Impressionists* (Secaucus, N.J., 1986), pp. 58–61.

7. On Seurat's knowledge of color theory, see Homer 1970. See also Michel Eugène Chevreul, *De la Loi du contraste simultané des couleurs et de l'assortiment des objets colorés* (Paris, 1839); English ed.: *The Principles of Harmony and Contrasts of Colours*, trans. by Charles Martel, 3d ed. (London, 1883). See Ogden N. Rood, *Students' Text-Book of Color; or, Modern Chromatics* (New York, 1881); and Hermann von Helmholtz, *Handbuch der physiologishen Optik* (Leipzig, 1867). Seurat knew of the work of physicist James Clerk Maxwell through the writings of Rood. Maxwell's findings were published in two volumes in Cambridge, England, in 1890. See James Clerk Maxwell, *The Scientific Papers of James Clerk Maxwell*, ed. by W. D. Niven (New York, 1965), pp. 243–45, 264–70, 410–44, and 445–50. For current re-evaluation of Seurat's interpretations and applications of color science, see Gage 1987 and Lee 1987.

8. Signac, cited in Rewald 1978, p. 76; and Signac 1964, p. 99.

9. Nochlin 1966, p. 118. See also Herbert 1970, pp. 23–34.

10. Homer 1959, and 1970, pp. 146–53.

11. Félix Fénéon, "Au Pavillon de la ville de Paris," *Le Chat noir* (Apr. 2, 1892), cited in Halperin 1970, vol. 1, pp. 212–13.

12. Zinc yellow ranged during Seurat's time from pale yellow to marigold; which variety he used is unknown. The exact nature of the color change is still being investigated. See Rutherford J. Gettens and George L. Stout, *Painting Materials, A Short Encyclopaedia* (New York, 1966), p. 178; and Robert L. Feller, ed., *Artists' Pigments: A Handbook of their History and Characteristics* (Washington, D.C., 1986), vol. 1, pp. 201–204.

13. Gettens and Stout (note 12), p. 113.

14. Herbert 1968, p. 112.

15. Signac, cited in Rewald 1949, pp. 170–71.

16. Dorra and Rewald 1959, pp. 96, 102–103.

17. See conservation examination and treatment report (note 1).

18. See David Miller, "Conservation of Neo-Impressionist Painting," in Ellen Wardwell Lee, *The Aura of Neo-Impressionism: The W. J. Holliday Collection*, exh. cat. (Indianapolis, 1983), pp. 29–30.

19. In addition to the *Grande Jatte*, the present author sampled three other works by Seurat as historical benchmarks to establish patterns in the use of pigments and the application of paint. Two are small panels in the Art Institute: *Final Study: Bathing, Asnières*, 1883, and the *Oil Sketch for the "Grande Jatte,"* 1884 (pl. 3). Their palettes are similar to the 1884–85 stage, except for the absence of emerald green in *Bathing* and only a minor amount of the pigment in the *Oil Sketch*, possibly added later. See Fiedler 1984. The third painting sampled is *The Island of the Grande Jatte*, 1884, in the collection of Mrs. John Hay Whitney (pl. 4). Like the final painting, the Whitney landscape was executed in three stages and in colors that correspond to the *Grande Jatte*'s three stages, though the landscape lacks zinc yellow and was not as heavily reworked in the Divisionist technique. The author is indebted to Mrs. Whitney for granting permission to sample and analyze her painting. The results have been presented at various professional meetings; a final report, incorporating the research on all four works, is in preparation.

Thomson, "The *Grande Jatte*: Notes on Drawing and Meaning," pp. 181–97.

1. An extended version of this analysis of *Bathing, Asnières* is given in Thomson 1985, pp. 75–90.

2. For Asnières and its environs, see Thomson 1985, pp. 116–19.

3. L. Barron, *Les Environs de Paris* (Paris, 1886), pp. 39–40.

4. Edmé Périer, *Notes sur la ville d'Asnières* (Asnières, 1890), pp. 11, 61–62.

5. Letter from Georges Seurat to Félix Fénéon, June 20, 1890, cited in Thomson 1985, pp. 224–25.

6. Fèvre 1886, p. 149.

7. Joris Karl Huysmans, "Chronique d'art: Les Indépendants," *La Revue indépendante* 2, 2 (Apr. 1887), p. 55.

8. For recent accounts of the criticism of the *Grande Jatte* in 1886, see Clark 1984, pp. 261–67; Thomson 1985, pp. 114–16, 120–22, 124–26; and Ward 1986, pp. 434–38.

9. Paulet 1886, p. 2.

10. Hermel 1886; and Christophe 1886, p. 194.

11. See Richard Thomson, "Jean-Louis Forain's *Place de la Concorde*: a rediscovered painting and its imagery," *The Burlington Magazine* 125, 960 (Mar. 1983), pp. 154, 157–58.

12. See for example Georges Auriol's comments on Degas's milliners in "Huitième exposition," *Le Chat noir* (May 22, 1886), p. 708.

13. L. Rigaud, *Dictionnaire d'argot moderne*, rev. ed. (Paris, 1888), p. 349.

14. For instance see Hermel 1886; and G. Geffroy, "Hors du Salon. Les Impressionnistes," *La Justice*, May 26, 1886, n.p. This is discussed in Thomson, *Degas, The Nudes* (London, 1988), pp. 139, 142.

15. Adam 1886, p. 550.

16. Thomson (note 14), pp. 130–32. However Gary Tinterow has recently pointed out that *Woman Drying Herself* (1884; Leningrad, Hermitage) may have been shown rather than *Woman in the Bath* (c. 1885/86; London, Tate Gallery); see Paris, Réunion des Musées Nationaux; Ottawa, National Gallery of Canada; New York, The Metropolitan Museum of Art, *Degas*, exh. cat. by Jean Sutherland, Douglas W. Druick, Henri Loyrette, Michael Pantazzi, and Gary Tinterow (Paris, Ottawa, and New York, 1988), pp. 385, 386 fig. 195.

17. Octave Mirbeau, "Exposition de peinture. 1, rue Laffitte," *La France*, May 21, 1886; and Auriol (note 12).

18. Mirbeau (note 17).

19. Geffroy (note 14).

20. Among others, Mirbeau (note 17) and a certain Labruyère, "Les Impressionnistes," *Le Cri du peuple*, May 28, 1886, compared Pissarro's work favorably with that of Millet. Paulet 1886 and Mirbeau considered Pissarro's art "robust," and Mirbeau gave special praise to his drawing.

21. Ajalbert 1886, p. 391.

22. Barron (note 3), p. 63.

23. Fèvre 1886, p. 151.

24. For an extended account of the genesis of the *Grande Jatte*, see Thomson 1985, pp. 97–108.

25. Undated letter from Signac to Pissarro (Feb. 1887); see Paris, Hôtel Drouot, *Archives de Camille Pissarro*, sale cat., Nov. 21, 1975, no. 172.

26. On this locality and the visual representation of Sunday, see Thomson 1985, pp. 116–20; and S. Hollis Clayson, "The Family and the Father: the *Grande Jatte* and its Absences," in the present issue, pp. 159–64.

27. A. Daudet, *Froment Jeune et Risler Ainé* (Paris, 1874), in *Oeuvres complètes d'Alphonse Daudet*, vol. 4 (Paris, 1926), pp. 237–38.

28. "Canton de Courbevoie. Asnières," *Autour de Paris*, July 17, 1887.

Zimmermann, "Seurat, Charles Blanc, and Naturalist Art Criticism," pp. 199–209.

I wish to thank Susan F. Rossen. Without her advice, I could not have expressed my ideas in this language which is not mine.

1. On Charles Blanc, see Misook Song, *Art Theories of Charles Blanc 1813–1882* (Ann Arbor, 1984), pp. 10–16; T. J. Clark, *Image of the People. Gustave Courbet and the 1848 Revolution* (London, 1973); idem, *The Absolute Bourgeois: Artists and Politics in France, 1848–51* (London, 1973); P. Vaisse, "La Troisième République et les peintres. Recherches sur les rapports des pouvoirs publiques et de la peinture en France de 1870 à 1914," Thèse d'Etat, University of Paris, 1980, pp. 78–80.

2. Charles Blanc, *Grammaire des arts du dessin. Architecture, sculpture, peinture* (Paris, 1867). It first appeared in the *Gazette des beaux-arts* between 1860 and 1866 in installments.

3. The letter is reproduced in facsimile in Hauke 1961, vol. 1, p. xxi. Several versions of this letter exist. See Herbert 1962, p. 167; and Homer 1970, pp. 17–19, 268–70.

4. Verhaeren 1891, pp. 430–38, reprinted with insignificant variations in Emile Verhaeren, *Sensations* (Paris, 1927) and excerpts reprinted in Broude 1978, pp. 25–30.

5. Kahn 1971, p. 7.

6. Herbert 1970, pp. 23–26.

7. Song (note 1). Song emphasized Blanc's eclecticism, tracing it to the ideas of the nineteenth-century philosopher Victor Cousin. She also explored the connections between Blanc's color theories and Neo-Impressionism. The emphasis in my account of Blanc lies more on his traditional academic idealism. I first studied Charles Blanc (without unfortunately knowing Song's work) for a Ph.D. dissertation on "Seurat and Artistic Theories of His Time," with special reference to the French physicist and aesthetician Charles Henry, for the University of Cologne in 1985.

8. Charles Blanc, *Grammaire des arts du dessin*, 3d ed. (Paris, 1876), vol. 3, pp. 9–10, 20, 25–28, 30, 32. This is the edition that Seurat most probably read.

9. Ibid., p. 32. See D. P. G. Humbert de Superville, *Essai sur les signes inconditionnels dans l'art* (Leyden, 1827); and Barbara M. Stafford, *Symbol and Myth. Humbert de Superville's Essay on Absolute Signs in Art* (Cranbury, N.J., and London, 1979).

10. Blanc (note 8), pp. 445–46.

11. On Lehmann, see S. M. M. Aubrun, *Henri Lehmann 1814–1882. Portraits et décors parisiens*, exh. cat., Paris, Musée Carnavalet (1983).

12. Blanc, *Ingres* (Paris, 1870), pp. 65–66, 213, 225.

13. Blanc, "Eugène Delacroix," in *Les Artistes de mon temps* (Paris, 1876), pp. 38, 40, 43.

14. Blanc (note 8), p. 564.

15. Félix Fénéon, "Notes inédites de Seurat sur Delacroix," *Bulletin de la vie artistique* (Apr. 1922), cited in Broude 1978, pp. 13–15.

16. Blanc (note 13), p. 62.

17. Blanc (note 8), p. 554.

18. Blanc, *L'Oeuvre de Rembrandt* (Paris, 1880), p. xxv.

19. Thomas Couture, *Méthode et entretiens d'atelier* (Paris, 1867), pp. 222–26.

20. Couture's eclecticism has been compared with Seurat's approach by Albert Boime, *Thomas Couture and the Eclectic Vision* (New Haven and London, 1980), pp. 489–92.

21. Herbert 1962, pp. 35–36, 44.

22. The character of the drawings that exhibit both epic and naturalistic qualities is regularly cited as justification for this view. The misconception that Seurat worked exclusively with black and white for many years before turning to color (and that, when he did, his oil sketches became less dark and melancholic in mood) presumably goes back to the comments of critic Gustave Kahn. Kahn, who was not acquainted with the artist before 1886, elaborated this view in his obituary of Seurat. See Kahn 1891, cited in Broude 1978, pp. 22–25.

23. Herbert was the first to consider the possibility of Rembrandt's influence on Seurat. In 1956 he examined a portfolio of popular prints (unfortunately they were subsequently destroyed) in the possession of Seurat's descendants. Among them were several Rembrandt etchings and a few drawings. The reproductions after Rembrandt included some that had been printed in a supplement of *Le Figaro* of Apr. 8, 1882. See Herbert 1962, pp. 60–63. Norma Broude noted that the strong distortion of the Rembrandt originals seen in these reproductions occurred because of the heliogravure technique. As a result, the fine structure of the Rembrandt originals had vanished. See Broude, "The Influence of Rembrandt Reproductions on Seurat's Drawing Style: A Methodological Note," *Gazette des beaux-arts*, ser. 6, 86, 1293 (Oct. 1976), pp. 155–60. According to Herbert, the portfolio included reproductions that clearly did not come from *Le Figaro*. It is possible that they were from Blanc's book on Rembrandt (note 18), which was accompanied by original-sized engravings after Rembrandt by Firmin Delangle. In these the

copyist paid special attention to the reproduction of the light-dark effects and to perspective. The drawing is however quite crude, occasionally to the point of caricature.

24. See Dorra and Rewald 1959, no. 7. The painting is obviously very early, perhaps a bit later than 1880, the date indicated by Dorra and Rewald. Dorra described it as "unmistakably in the Impressionist manner" (p. lxxix). Related to Blanc's theories are the greenish halo above the red flowers; the use of little brushstrokes with different colors, especially in the background (inspired by Blanc's recommendation of "gradation"); and the arrangement of dark and light.

25. Hauke 1961, vol. 2, no. 572. This is probably because of the dissolution of the forms. The dating of the drawings of the years 1881–83 remains highly speculative.

26. Emile Zola, "Salons et études de critique d'art," in *Oeuvres complètes*, ed. by Henri Mitterand (Paris, 1969), vol. 12, pp. 1003, 1034.

27. Théodore Duret, "Les Impressionnistes" (1878), reprinted in *Critique d'avant-garde* (Paris, 1885), pp. 63–64.

28. Charles Baudelaire, *Curiosités artistiques, l'art romantique, et autres oeuvres critiques*, ed. by H. Lemaître (Paris, 1980), p. 466, trans. in idem, *The Painter of Modern Life and Other Essays*, trans. and ed. by Jonathan Mayne (London and New York, 1970), p. 12. In this regard, it is interesting to note that, according to Kahn, Seurat had a drawing by Guys hanging in his studio. See Broude 1978, p. 22.

29. Emile Zola, *Le Bon Combat. De Courbet aux impressionnistes*, ed. by Gaeton Picon (Paris, 1974), pp. 38–39.

30. Herbert 1970, p. 25. These excerpts were taken from [E. Piron], *Eugène Delacroix, sa vie et son oeuvre* (Paris, 1865), cited in Broude 1978, pp. 13–15.

31. Signac 1891, p. 4; trans. in Herbert and Herbert 1960, p. 480. Richard Shiff gave a more detailed account of the concept of artistic freedom in Impressionist art criticism. He discussed the epistemological consequences of Zola's and other related definitions of art and convincingly argued that it can be conceived in a more subjectivist (romantic) and a more objectivist (naturalist) way. But he gave no emphasis to the idea that a vision that takes liberated temperaments as the basis of art can be seen in the ideological context of French republicanism. See Richard Shiff, *Cézanne and the End of Impressionism* (Chicago and London, 1984), pp. 21–38.

32. Edmond Duranty, *La Nouvelle Peinture* (Paris, 1876), p. 33.

33. Ibid., pp. 31–32.

34. Zola (note 26), pp. 1015, 1018. Zola's new stance had been foreshadowed in his review "Lettres de Paris: Deux Expositions d'art au mois de mai," written for Russian readers of *Le Messager de l'Europe* (Jun. 1876); trans. in Zola (note 29), pp. 172–86.

35. J. K. Huysmans, "L'Exposition des indépendants en 1880," *L'Art moderne*, 2d ed. (Paris, 1902), pp. 103–104.

36. A much-disputed question, which cannot be resolved here, is whether this change in the critical climate created a crisis for Impressionism in about 1880. The view that it did is fully presented by Joel Isaacson in the exhibition catalogue *The Crisis of Impressionism 1878–1882* (Ann Arbor, 1980), pp. 1–47. See also Charles S. Moffett, "Disarray and Disappointment," in San Francisco 1986, pp. 293–309.

37. See Odile Rudelle, *La République absolue. Aux Origines de l'instabilité constitutionelle de la France républicaine 1870–1889* (Paris, 1982).

38. Hippolyte Taine, *Philosophie de l'art*, 2d ed. (Paris, 1881), pp. 97–256. Taine discussed (pp. 247–56) the Parthenon frieze in detail, interpreting it as a portrayal of Athenian society at the time. Seurat obviously saw the frieze this way, to judge from comments attributed to Seurat cited by Kahn (see note 42).

39. See Herbert 1962, pp. 63–65, 87–91.

40. The picture was shown in the Salon of 1884. It seems that Seurat's friend Edmond François Aman-Jean helped Puvis transpose it from the preliminary drawing to the large canvas. See Rich 1935, pp. 47–48; Robert Herbert, "Seurat and Puvis de Chavannes," *Yale University Art Gallery Bulletin* (Oct. 1959), pp. 22–29; Benedict Nicholson, "Reflections on Seurat," *The Burlington Magazine* 104, 720 (May 1962), pp. 213–14; and E. F. Aman-Jean, *Souvenir d'Aman-Jean* (Paris, 1970), p. 18.

41. Dorra and Rewald 1959, no. 138b-j; Hauke 1961, vol. 2, nos. 627–35, 644. This issue cannot be discussed here.

42. In an article about Puvis de Chavannes, Kahn quoted "a young Impressionist innovator": " . . . the Panathenaic frieze was a procession. I want to make modern people move about as on these friezes in their most essential characteristics. . . ." See Kahn, "Exposition Puvis de Chavannes," *La Revue indépendante* (Jan. 6, 1888), pp. 142–43, cited in Broude 1978, p. 20. Herbert 1962 was the first to identify this "innovator" as Seurat (pp. 110, 168 n. 35).

43. David Sutter, "Les Phénomènes de la vision," *L'Art* (Jan.-Mar. 1880). See Homer 1970, pp. 18, 270 n. 27; Niels Luning Prak, "Seurat's Surface Pattern and Subject Matter," *The Art Bulletin* 53, 3 (Sept. 1971), pp. 367–78.

44. Schapiro 1935, p. 12, and 1978, p. 106.

45. House 1980, p. 348. According to House, the inclusion of the *Grande Jatte* in the background of *The Models* (pl. 5) is an ironic allusion to stylistic difference. The elegant, relaxed contours of the nudes in the later painting indicates that the stiffness of the figures in the earlier composition was intentional.

46. Ephraïm Mikhaël, *Poésie. Poèmes en prose* (Paris, 1890), pp. 131–33; trans. in Sven Loevgren, *The Genesis of Modernism*, rev. ed. (Bloomington, Ind., and London, 1971), pp. 218–19. The style of the anonymous introduction to the 1890 citation of Michel's poems suggests that it may have been written by Fénéon. This prose poem seems to be historically more directly related to the *Grande Jatte* than the accounts of it and its site by Jules Christophe, Gustave Coquiot, and other critics. Seurat may have met Michel at the regular Monday-night get-togethers of Robert Caze, to which he had been invited since 1884 at the instigation of Albert Dubois-Pillet. See Jean Sutter, ed., *Le Néo-Impressionnisme* (Neuchâtel, 1970), p. 16.

47. Baudelaire (note 28), p. 195.

Eisenman, "Seeing Seurat Politically," pp. 211–21.

1. Signac 1891, p. 4, cited in Herbert and Herbert 1960, p. 480.

2. Kahn 1891, p. 110, cited in Broude 1978, p. 25.

3. *The Essential Kropotkin*, ed. by Emile Capouya and Keitha Tompkins (New York, 1975), p. 23.

4. Signac 1891, p. 4.

5. Lucien Pissarro, letter to the editor, *Les Temps nouveaux* 1, 32 (Dec. 7–13, 1895), p. 1, cited in Ralph E. Shikes and Paula Harper, *Pissarro, His Life and Work* (New York, 1980), p. 238.

6. Alone among recent scholars, Clark 1984 has treated the matter of politics as central and not peripheral to Seurat's work, arguing that *Sunday Afternoon on the Island of the Grande Jatte* provocatively represents the conflicted, contradictory, and even comic appearance of different social classes intermingling at a popular recreational spot on the outskirts of Paris (p. 261). For Clark Seurat's radicalism chiefly lay in his assertion that the dominating Impressionist view of social class—that it existed only at the elusive and shifting borders of modern urban life, and that it was visible only through sidelong glances, bird's-eye views, or atmospheric haze—was a deception useful to the bourgeoisie in their efforts to erect a stable relationship between city and country. Such an ideological construction was essential in the contest to win the allegiance to capitalist hegemony of newly formed and politically unsecured "nouvelles couches sociales," namely, the lower middle class. (For a discussion of this term, see S. Hollis Clayson, "The Family and the Father: The *Grande Jatte* and Its Absences," in the present issue, pp. 243–44 n. 40.) Seurat's *Grande Jatte*, according to Clark, thus "attempts to find form for the appearance of class in capitalist society, especially the look of the 'nouvelles couches sociales'; [and] the forms it discovers are in some sense more truthful than most others produced at the time. . . ."

7. Hermel 1886.

8. Seurat as cited in Broude 1978, p. 22.

9. Félix Fénéon, "Le Néo-Impressionnisme," *L'Art moderne* (May 1, 1887), p. 139, reprinted in Broude 1978, p. 41.

10. Jean Moréas, "Le Symbolisme," *Figaro littéraire* (Sept. 18, 1886), cited in Robert Goldwater, *Symbolism* (New York, 1979), p. 145.

11. Fénéon as cited in Goldwater (note 10), p. 146.

12. See Charles Henry, *Cercle chromatique* (Paris, 1888), p. 9. On Henry see José A. Argüelles, *Charles Henry and the Formation of a Psychophysical Aesthetic* (Chicago and London, 1972); Henri Dorra, "Charles Henry's 'Scientific' Aesthetic," *Gazette des beaux-arts*, ser. 6, 74, 1211 (Oct. 1969), pp. 345–56; and Robert L. Herbert, "'Parade de Cirque' de Seurat et l'esthétique scientifique de Charles Henry," *Revue de l'art* 50 (1980), pp. 9–23.

13. G. Albert Aurier, "Le Symbolisme en peinture," in *Mercure de France* 2, 15 (1891), trans. in Herschel B. Chipp, *Theories of Modern Art: A Source Book by Artists and Critics* (Berkeley, Los Angeles, and London, 1973), p. 92.

14. Verhaeren 1891, p. 438, reprinted in Broude 1978, p. 30.

15. Maurice Denis, *Théories: 1890–1910* (Paris, 1920), p. 13, cited in Chipp (note 13), p. 100.

16. Reinhold Heller, "Concerning Symbolism and the Structure of Surface," *Art Journal* 45, 2 (Summer 1985), p. 150.

17. Ajalbert 1886, pp. 392–93; Hermel 1886; and X [Pseud.], "Les Artistes indépendants," *La Liberté* (May 18, 1886), n. p.

18. Fèvre 1886, p. 149.

19. Paulet 1886.

20. Christophe 1886, p. 194.

21. Adam 1886, p. 550.

22. As Erich Franz (Franz and Growe 1983) concluded: "Each figure [in the *Grande Jatte*] demands to be seen for itself; the figures' shared pictorial context is precisely one of diversity, which accentuates the idiosyncrasies of form. The unity of the image is really a product of the spectator's imagination, a mental reaction to its confounding multiplicity and to the isolated existence of every piece of formal information it provides, which is the true common denominator of the scene" (p. 82).

23. See Stephen F. Eisenman, "The Intransigent Artist *or* How the Impressionists Got their Name," in San Francisco 1986, pp. 50–59.

24. Signac, cited in Herbert and Herbert 1960, p. 479.

25. Ogden N. Rood, *Color: A Textbook of Modern Chromatics*, 4th ed. (London, 1904), pp. 10, 140.

26. Fénéon 1886, p. 261, reprinted in Broude 1978, p. 37.

27. Gage 1987 and Lee 1987.

28. Emile Hennequin, "Notes d'art: Exposition des artistes indépendants," *La Vie moderne* (Sept. 11, 1886), p. 581, reprinted in Broude 1978, p. 42.

29. Seurat, cited in Broude 1978, pp. 22, 18–19.

30. Karl Marx, "Economic and Philosophic Manuscripts of 1844," *The Marx-Engels Reader*, ed. by Robert C. Tucker (New York, 1978), p. 87.

31. Charles Fourier, *Harmonian Man: Selected Writings of Charles Fourier*, ed. by Mark Poster, trans. by Susan Hanson (New York, 1971), p. 61.

32. As cited in Fourier, *The Utopian Vision of Charles Fourier*, ed. and trans. by Jonathon Beecher and Richard Bienvenue (Boston, 1971), p. 264.

33. See *Devoir: revue des questions sociales*, *Revue du mouvement social et economique*, and *Rénovation: organe de la conciliation sociale et des doctrines d'association*. On Godin see A. Brauman, *Le Familistère de Guise ou les équivalents de la richesse* (Brussels, 1976); and T. G. Beddall, "Godin's Familistère," *Architectural Design* 46 (July 1976), pp. 423–27.

34. Henry, *Rapporteur esthétique* (Paris, 1888), p. 15, cited in Homer 1970, p. 199.

35. Henry, "Introduction à une esthétique scientifique," in *La Revue contemporaine, littéraire, politique et philosophique* (Aug. 1885), p. 441, cited in Homer 1970, pp. 190–91.

36. Vincent van Gogh, *Complete Letters of Vincent Van Gogh*, (Greenwich, Conn., 1948), vol. 3, no. 584a p. 153, cited in Homer 1970, p. 299.

37. Cited in Miriam R. Levin, *Republican Art and Ideology in Late Nineteenth-Century France* (Ann Arbor, 1986), p. 81. Also see ibid., chap. 4, "The Establishment of Modern Liberal Democracy through Art Education," pp. 77–113.

38. On the degradation of labor under the Third Republic, see Lenard R. Berlanstein, *The Working People of Paris, 1871–1914* (Baltimore and London, 1984); and Roger Magraw, *France, 1815–1914: The Bourgeois Century* (New York and Oxford, 1986), pp. 296–305.

39. Seurat, cited in Broude 1978, p. 15.

40. Fourier, *Le Nouveau Monde amoureux*, ed. by S. Debout-Oleszkiewicz (Paris, 1957).

41. Anthony Vidler, *The Writings of the Walls: Architectural Theory in the Late Enlightenment* (Princeton, 1987), p. 112, which includes a discussion of Fourier's utopia.

Gedo, "The *Grande Jatte* as the Icon of a New Religion: A Psycho-Iconographic Interpretation," pp. 223–37.

My understanding of the *Grande Jatte* has been deepened by long discussions with leading Chicago painters, especially William Conger, Barbara Rossi, and Robert Skaggs. Conversations with Eva Masur, who shared her deep knowledge of the French language and culture with me, also informed this essay. John Larson, Museum Archivist at the Oriental Institute of the University of Chicago, also graciously answered my many questions about specific images in ancient Egyptian art related to those in the *Grande Jatte*.

It should be noted that references to the ideas of Hollis Clayson and Richard Thomson contained in this essay are based on the papers they presented at the symposium, "Seurat and *La Grande Jatte*: The New Scholarship," May 15–16, 1987, The Art Institute of Chicago. To compare the versions cited here with the definitive essays, the reader should consult the relevant footnotes for page citations to this issue of *Museum Studies*.

1. Russell 1965, p. 156.

2. For the quintessential Marxist interpretation, see Clark 1984, pp. 260–67.

3. Erwin Panofsky, *Studies in Iconology: Humanistic Themes in the Art of the Renaissance* (New York, 1962), pp. 11–16.

4. Dorra and Rewald 1959 included important critical writings about the artist, most notably all the relevant material from the publications of Félix Fénéon. See "*Félix Fénéon: Ecrits sur Georges Seurat*," pps. xi–xxxi. See also pp. 139–64 for excerpts from critical comments dealing specifically with the *Grande Jatte*.

See also Ward 1986, pp. 414–38. She reviewed the critical responses to the *Grande Jatte* at the time of its initial exhibition, as part of an attempt to evaluate Clark's interpretation of the painting. She commented: "Clark's own reading of the image in these terms [i.e., that the populace Seurat depicted in the painting showed the nature of class distinctions in contemporary France, as embodied in the transient population of the *Grande Jatte*] is compelling and convincing, but his claim for the criticism in 1886 is puzzling. For what seems hard to grasp is why critics, with the exception of Christophe [the only critic who claimed that Seurat intended 'to seize the diverse attitudes of age, sex, and social class: elegant men and women, soldiers, nannies, bourgeois, workers' and called it 'a brave effort'], were not attentive to the blatant juxtapositions in Seurat's painting. At best, reviewers scanned the population and took note of the various types, disregarding the order of their placement in the image" (p. 435). Ward also pointed out that, in a later (1890) publication, Christophe altered his comments about the *Grande Jatte*, omitting the catalogue of types mentioned in his review of 1886 (p. 434).

5. See Broude 1978 for many contemporary descriptions of the artist's appearance and behavior, especially Broude's selection of "Witness Accounts (Including Reported Statements by Seurat)," pp. 20–35. For another, much briefer selection of similar comments, see Courthion 1968, pp. 9–10.

6. Degas's witticism has been widely quoted; see Gustave Kahn's comments about it in Kahn 1971, pp. 8–9.

7. Reprinted in Broude 1978, p. 34.

8. Herbert 1962, pp. 7–11, provided details about Seurat's life not mentioned by other sources. See also Russell 1965, pp. 9–14.

9. Minervino 1972, p. 85, listed the birth and death years for the artist's parents and siblings, but neither this text nor that of Dorra and Rewald 1959, p. lxxxvii, gives the exact month and day of the brother's death; Rewald stated that the boy died when he was five and a half, so Seurat, born at the end of 1859, was probably not yet nine at the time.

10. The fragmentary information we possess concerning Madeleine Knobloch suggests that she was of lower-class origin. After Seurat's death, she tried to establish herself in Brussels as a milliner, but no one knows whether she had actually practiced this trade earlier. Although Seurat's mother must have been deeply shocked by her son's inappropriate choice of a mistress, she and other members of the artist's family behaved with the utmost generosity toward the girl and gave her half of Seurat's oeuvre. For an account of her subsequent behavior, see Rewald 1978, pp. 394–96 and nn. 83, 84. This description suggests that Knobloch either possessed a particularly vicious character, or was extremely disturbed, or both. Shortly after the artist's death, she traveled to Brussels to present works to Belgian colleagues whom Seurat's family had designated to receive these artistic mementos. In Brussels "she was able to obtain money from [the critic Gustave] Kahn to whom she said that the painter's friends were conniving to 'despoil' her of his works; she accused [Paul] Signac of having but one design, that of 'burying his rival,' Seurat, and [Maximilien] Luce of having finished Seurat's *Cirque* [*The Circus*, the artist's final picture, left incomplete at his death]." Knobloch soon returned to Paris, where she continued to spread untrue rumors and cause trouble. Signac deplored her "idle talk and lies, like those of a crazy concierge . . ." (all quotations from Rewald 1978, p. 396).

11. See Russell 1965, p. 23; and Herbert 1962, p. 9. Russell stated that the father lost his right hand, but Herbert identified it as the left.

12. Arsène Alexandre for example described Seurat as possessing "the gentleness of a girl," as being peaceable, but stubborn and determined. See Courthion 1968, p. 9.

13. Descriptions of Seurat senior's behavior suggest that he probably suffered from an encapsulated psychosis, perhaps of a well-defended paranoid type. People with such a disorder may seem perfectly rational or logical in dealing with day-to-day situations that do not involve their delusional systems. The elder Seurat was apparently a shrewd and successful businessman, whose bizarre thought and behavior patterns became really apparent only when he discussed religion and carried out his bizarre rituals and practices. His attempts to assume the rights and rites of the priesthood would certainly have been considered sacrilegious by the Roman Catholic church and would seem to reflect his underlying grandiose paranoid ideas. In this regard, it might be noted that Herbert reported that he always insisted upon being addressed by the pretentious title "Monsieur l'Officier Ministériel." See Herbert 1962, p. 9.

14. See ibid., pp. 110–13, for Herbert's excellent discussion of the influence of "primitive" art on Seurat's style. He mentioned correla-

tions between the artist's collection of popular broadsides and the appearance of certain figures in the *Grande Jatte*.

15. Cited in Broude 1978, p. 31.

16. See John Rewald's "Artists' Quarrels (including letters by Pissarro, Signac, Seurat, and Hayet, 1887–1890)," in Broude 1978, pp. 103–107. This material, originally published in Rewald 1943, appears in English for the first time in Broude 1978. See also Rewald 1978, who wrote: "Feeling either continually crushed by Seurat's superiority and his insistence upon it, or else being dissatisfied with his theories, several of his associates now began to abandon his group. Seurat may actually have welcomed some of these defections . . ." (p. 388). In a personal letter to Rewald, dated Jan. 17, 1950, the artist-architect Henry van de Velde related that he eventually became so disillusioned by the artist's "distrustfulness and meanness" that he came to doubt the rightness of Seurat's artistic views (pp. 388, 404 n. 69). In light of Seurat's attitudes, it seems likely that the false rumors and outright lies spread by Madeleine Knobloch following his death represented her ill-digested version of the artist's own misperceptions of the behavior of his colleagues.

17. Clark 1984, pp. 263, 315 n. 9. In Ward's discussion of these issues (Ward 1986), she commented that Clark's assertion is "undoubtedly true, and yet it is also important to emphasize that Seurat himself, from all reports, talked obsessively about his artistic theories, virtually to the exclusion of all other issues" (p. 436). Since the evidence Ward brought to bear consistently fails to support Clark's thesis, one cannot help but wonder why she kept politely insisting that it must be valid. For an argument in favor of Seurat as an anarchist, see Herbert and Herbert 1960, esp. p. 480. For an effective counter argument, see House 1980, esp. pp. 345–50. Reviewing the few recorded comments by Signac, Fénéon, and Kahn that impute anarchist motives to Seurat, House noted: "Since Seurat's friends had lost a leader through his death, it is understandable that they tended to assimilate his views, whatever they had been, with their own in support of their own causes. The surviving evidence is certainly not enough to justify an anarchist reading of the *Baignade* [*Bathing*] and the *Grande Jatte* . . ." (p. 349).

18. See Herbert 1962, p. 168 n. 35, regarding the history of Seurat's remark about the Parthenon frieze.

19. Rich 1935 correctly decried the tendency of "certain students of modern art . . . to underrate Seurat's debt to Monet. Though he did not know the painting of Monet, or that of Renoir, Sisley, and Pissarro until after 1882, it is significant that the moment he comes into contact with their art his own deepens and grows more positive" (p. 43).

20. For a complete listing of the 179 paintings shown, see Paris, Ecole Nationale des Beaux-Arts, *Exposition des oeuvres d'Edouard Manet*, pref. by Emile Zola (Paris, 1884).

21. See Joel Isaacson, *Monet: Le Déjeuner sur l'herbe* (New York, 1972), p. 95 n. 2. Monet left the canvas with his landlord, Alexandre Flament, at Argenteuil in January 1878, in lieu of payments for rental of a home previously occupied by the artist.

22. Whether Monet executed the sketch for the *Luncheon* primarily outdoors remains a complex, unresolved question, too tangential to the concerns of this essay to air here. Nor does this essay address the question of Manet's intentions in introducing the ambiguities in figure-ground integration and the depiction of depth and aerial perspective apparent in his version of the *Luncheon*. Whether these features reflect Manet's conscious plan is irrelevant here. More to the point is the fact that Manet evidently regarded them as defects which his more realistic depiction would "correct."

23. The most thorough discussion of the scientific basis of Seurat's painting can be found in Homer 1970, esp. pp. 112–54. Gage 1987 presented a dissenting view. The Golden Section, or Golden Number, provides a way to compose pictures according to mathematical formulae, used to determine axes about which the artist can locate the figures in his compositions. For a detailed account of Seurat's use of the Golden Section, see Dorra and Rewald 1959, pp. lxxix–cvi, esp. lxxvi–vii. See also Roger Herz-Fishler, "Examination of Claims Concerning Seurat and 'The Golden Number,'" *Gazette des beaux-arts*, ser. 6, 101, 1370 (Mar. 1983), pp. 109–12.

24. Kahn 1971 stated that Seurat "was a student at the peripatetic museum—the exhibitions of the Impressionist painters . . ." (p. 5). Writing about Paul Gauguin's 1880 statuette *Woman on a Stroll* (*The Little Parisienne*), Charles Stuckey suggested that the rigid poses adopted by Gauguin in this sculpture and by Edgar Degas in his similar wax figurine *The Schoolgirl*, dated c. 1880, "surely influenced Seurat, whose own drawings of archaically columnar figures from modern life are generally dated around 1882." See Paris, Réunion des Musées Nationaux, Washington, D. C., National Gallery of Art, and The Art Institute of Chicago, *Gauguin*, exh. cat. by Richard Brettell, Francoise Cachin, Claire Frèches-Thory, Charles F. Stuckey, and Peter Zeghers (Washington, D. C., 1988), no. 6 p. 21. Gauguin's statuette was exhibited in the Impressionist group show of 1881.

25. See Seurat's letter to Fénéon of June 20, 1890, cited in Dorra and Rewald 1959, p. xxvii n. 34.

26. Herbert 1962, p. 110.

27. Good copies of Piero's Arezzo frescos were readily available to Seurat. Created by Charles Lazeux in 1872–73, they were installed in the chapel of the Ecole des Beaux-Arts, Paris, by the time Seurat enrolled there in 1878–79. See Albert Boime, "Seurat and Piero della Francesca," *The Art Bulletin* 47 (June 1965), pp. 265–71, abridged and reprinted in Broude 1978, pp. 156–62; Boime did not mention the religious connotations of the paintings.

28. For a very different interpretation of the origin of these discrepancies, see Richard Thomson, "The *Grande Jatte*: Notes on Drawing and Meaning," in the present issue, p. 188.

29. It should be noted that simians appear in genre scenes as well as religious representations in ancient Egyptian art. In the latter depictions, monkeys are shown in offering and funereal scenes, typically nibbling on fruit, seated beneath the chair of a banqueter.

But baboons also appear in Old Kingdom genre scenes, performing chores or being led on leashes, like modern dogs. For an example showing leashed baboons see the illustrations in Frank Yurcos "The Ancient Egyptian Marketplace," *The Field Museum of Natural History Bulletin* 60, 2 (1989), pp. 12–16. Seurat was far from alone in turning both to the Italian "Primitives" and to ancient Egyptian art for inspiration. Other avant-garde artists of the period also mined these rich sources as part of the growing movement away from the High Renaissance tradition of picture making.

30. One wonders whether Seurat might also have been influenced in the development of Pointillism by the regular, repetitive shapes of the tiny tessarae of the Byzantine mosaics, with their glowing surfaces.

31. See the catalogue entries in Dorra and Rewald 1959, no. 116 pp. 124–25; no. 138 pp. 150–51; no. 139 p. 165, describing these changes. For a discussion of these problems, see Inge Fiedler, "A Technical Evaluation of the *Grande Jatte*," in the present issue, pp. 176, 178–79.

32. For a detailed discussion of the meaning of optical luster and optical mixture, see Homer 1970, pp. 1–12, 131–64.

33. It seems likely that this picture-within-a-picture possessed some special significance for Seurat. The provocative juxtaposition of the virginal nude with the elegantly dressed woman portrayed in the *Grande Jatte* recalls a similar pairing in Titian's *Sacred and Profane Love* (Rome, Galleria Borghese). For an illustration of the latter and a discussion of its symbolism, see Harold E. Wethey, *Titian: The Mythological and Historical Paintings* (London, 1975), pp. 20–21, pl. 20.

34. The author conducted interviews with more than a dozen leading painters during the winter of 1985–86 in preparation for a small exhibition honoring the centenary of the *Grande Jatte* by examining its impact on current Chicago painting. This exhibition, "The Grand Example of *La Grande Jatte*," opened at the Roy Boyd Gallery on May 18, 1986. For a more complete discussion of this topic, see the exhibition catalogue, as well as the related essay, "Chicago Artists Celebrate '*La Grande Jatte*,'" *New Art Examiner* 13, 7 (Mar. 1986), pp. 26–28.

35. Certainly none of the artists interviewed suggested any reading of this type, though a number of them had literally spent years studying the painting in intimate detail and probably know it better than many art historians. See Gedo (note 34).

36. Seurat introduced significant changes in the figure of the rower between the time he completed the final study and the definitive painting. In the study, the figure appears less prominent in size and wears a long-sleeved red sweater or jacket and a bowler hat. One wonders whether Seurat saw Renoir's *Luncheon* again between the time he worked on the study and completed the painting proper and was so impressed with the Impressionist artist's depiction of the two young rowers that he introduced changes in his reclining man. It is also quite possible that these changes reflect a more personal valence the image acquired for Seurat as the painting progressed.

In his *Impressionism: Art, Leisure, and Parisian Society* (New Haven and London, 1988), which appeared after this essay had gone to press, Robert Herbert also observed that "the contrast of male types (in Renoir's *Luncheon of the Boating Party*) foretells Seurat's *Sunday on the Island of the Grand Jatte* of 1886."

37. See Thomson (note 28), pp. 186–87.

38. Daniel Wildenstein, *Claude Monet: biographie et catalogue raisonné*, vol. 1 (Lausanne and Paris, 1974), no. 420 p. 296. In 1885, in an effort to find a subject that would appeal to his dealer more than his recent landscapes had, Renoir planned a painting of a young woman fishing. Eager to please Durand-Ruel's wealthy customers, the artist most assuredly did not intend that this composition be interpreted as a reference to prostitution. The drawing for this unrealized project survives, depicting a typically wholesome Renoir girl, who exudes the innocent eroticism he portrayed so masterfully. For the relevant passage from Renoir's letter to his dealer and an illustration of the drawing, see Barbara Erlich White, *Renoir: His Life, Art, and Letters* (New York, 1984), pp. 157–58.

39. (Ed. note: The term "deconstruction" has not been used by Clayson in the written version of her symposium lecture; see S.

Hollis Clayson, "The Family and the Father: The *Grande Jatte* and its Absences," in the present issue, pp. 155–64.)

40. For an interesting hypothesis about the possible reasons for the contrasts between the personae of these two paintings, see House 1980, pp. 346–49; and idem, "Reading the *Grande Jatte*," in the present issue, pp. 125–29.

41. In a perception that seemed deliberately idiosyncratic, Clayson characterized the *Grande Jatte* in her lecture as a very sad picture. In a recent review, Carol Zemel alluded to the "social optimism" reflected in the *Grande Jatte*, an assessment quite different from Clayson's. See Zemel's assessment of Diane Lesko's monograph, *James Ensor, The Creative Years*, in *The Art Bulletin* 70, 1 (Mar. 1988), p. 156.

42. In creating his range of types, Seurat may have been influenced by earlier paintings such as Annibale Carraci's *Hunting* and *Fishing*, already in the collection of the Musée du Louvre, Paris, in Seurat's time. As Robert Cafritz points out, these paired pictures—in which the personae play a central role, depict "an engaging, heterogenous mixture of social classes"; *Fishing*, with its riverbank setting might have been of special interest to Seurat. See Cafritz's essay, "Classical Revision of the Pastoral Landscape" in Washington, D.C., The Phillips Collection in association with the National Gallery of Art, *Places of Delight: The Pastoral Landscape*, exh. cat. (1988), pp. 87, 91–2, figs. 84–5. In his essay "The Modern Vision" in the same catalogue, Lawrence Gowing classifies Seurat as a latter-day pastoral painter, an identification which seems incompatible with the reading of the *Grande Jatte* proposed by Clark and others, p. 283.

43. The fact that Seurat included personae whose ages ranged from that of the babe in arms to the elderly woman with the nurse companion suggests that he intended at least a passing reference to the ages of man, that time-honored concept so often depicted in paintings from the Renaissance onward. If so, Seurat updated the reference in a way that would please modern-day feminists, for he substituted female protagonists for the male figures so often used to symbolize these stages.

44. See p. 142, figs. 10a–b for the diagrammatic presentation in Rich 1935 of the principal curves, lines, and angles in the picture.

45. One should note however that the greater sensuality and immediacy apparent in *The Models* reveal that Seurat was not so withdrawn as to be unresponsive to the erotic pull of the female nude, a responsiveness even more obvious in the late drawing of a fleshy reclining woman (present whereabouts unknown), probably modeled after Madeleine Knobloch. See Hauke 1961, vol. 2, no. 660, pp. 236–37.

46. Herbert 1962 mentioned the connection between Seurat's cadet figures and "the sheets of [images] of toy soldiers he had in his studio" (pp. 110–11).

47. The musical production *Sunday in the Park with George* presents a quasi-fictional account of the creation of the *Grande Jatte* which stresses Seurat's personal relationship with his protagonists, including the figure of the old woman with the nurse. The play, with music and lyrics by Sondheim and book by James L. Lapine et al., opened in New York at the Booth Theater on April 23, 1984.

48. On the topic of the artist as priest, see Jacques Barzac, *The Use and Abuse of Art* (Princeton, N.J., 1975), pp. 26–42.

Provenance and Exhibition History of the *Grande Jatte*

Provenance

Mme Seurat (the artist's mother, d. 1899), Paris, from 1891; Emile Seurat, Paris, until 1900; Casimir Brû, Paris (acquired for his daughter Lucie in 1900 for 800 francs); Mme Lucie Brû Cousturier and Edmond Cousturier, Paris, until 1924; Mr. and Mrs. Birch Bartlett, Jr., Chicago (acquired in Paris via the dealer Charles Vildrac in 1924 for $20,000); The Art Institute of Chicago (Helen Birch Bartlett Memorial Collection, 1926.224).

Exhibitions

(excluding those at The Art Institute of Chicago)

1886

Paris, Maison Dorée, 1, rue Laffitte, *VIIIème Exposition de peinture* [of the Impressionists], May 15–June 15, no. 175, "Un Dimanche à la Grande-Jatte (1884)"

1886

Paris, Tuileries, *IIème Exposition de la Société des Artistes Indépendants*, Aug. 21–Sept. 21, no. 353, "Un Dimanche à la Grande-Jatte (1884)"

1887

Brussels [Musée de l'Art Moderne], *IVe exposition annuelle des XX*, Feb., no. 1, "Un Dimanche à la Grande-Jatte (1884)"

1892

Paris [Pavillon de la Ville de Paris], *VIIIème Exposition de la Société des Artistes Indépendants* (retrospective exhibition incorporated into larger salon), Mar. 19–Apr. 27, no. 1082, "Un Dimanche à la Grande-Jatte, 1884 (1886)," lent by Mme Seurat

1900

Paris, 23, boulevard des Italiens, *Exposition de La Revue Blanche, Georges Seurat: Oeuvres peintes et dessinées*, Mar. 19–Apr. 5, no. 17, "Un Dimanche à la Grande-Jatte (1884–1886)"

1905

Paris, Grandes Serres de la Ville de Paris (serre "B" de la Champs de la Reine, Aval-Alma), *21me Exposition de la Société des Artistes Indépendants* (retrospective exhibition incorporated into larger salon), no. 18, "Un Dimanche à la Grande-Jatte (1884–1886)"

1908–09

Paris, Galeries Bernheim-Jeune et Cie, 15, rue de Richepanse, *Exposition Georges Seurat*, Dec. 14, 1908–Jan. 9, 1909, no. 58, "Un Dimanche à la Grande-Jatte (1884–1886)," lent by M. E. C. [Monsieur Edmond Cousturier]

1920

Paris, Galeries Bernheim-Jeune, 15, rue de Richepanse, *Exposition Georges Seurat*, Jan. 15–31, no. 23, "Un Dimanche d'été à la Grande-Jatte"

1925

Minneapolis Institute of Arts, *Exhibition of Modern French Paintings from the Birch-Bartlett Collection*, Apr.–Sept., checklist no. 9
Boston Art Club, *Birch-Bartlett Collection of Modern French Paintings*, Dec. 9–16, checklist no. 26

1958

New York, The Museum of Modern Art, *Seurat*, Mar. 24–May 11, after being shown in the same exhibition at the Art Institute, Jan. 16–Mar. 7, no. 101, "A Sunday Afternoon on the Island of the Grande Jatte"

Selected Bibliography on Georges Seurat and the *Grande Jatte*

ADAM 1886. Paul Adam. "Les Peintres impressionnistes." *La Revue contemporaine, littéraire, politique et philosophique* 4, 4 (Apr.–May 1886), pp. 541–51.

AJALBERT 1886. Jean Ajalbert. "Le Salon des impressionnistes." *La Revue moderne* 30, 20 (June 20, 1886), pp. 385–93.

BRETTELL 1986. Richard R. Brettell. "The Bartletts and the *Grande Jatte*: Collecting Modern Painting in the 1920s." *The Art Institute of Chicago Museum Studies* 12, 2 (1986), pp. 102–13.

BROUDE 1978. Norma Broude, ed. *Seurat in Perspective*. The Artists in Perspective Series. Englewood Cliffs, N. J., 1978.

CANNING 1980. Susan Marie Canning. *A History and Critical Review of the Salons of "Les Vingts," 1884–1893*. Ann Arbor, 1980.

CHRISTOPHE 1886. Jules Christophe. "Chronique: Rue Laffitte, No. 1." *Le Journal des artistes*, June 13, 1886, pp. 193–94.

CHRISTOPHE 1890. Jules Christophe. "Georges Seurat." *Les Hommes d'aujourd'hui*, no. 368 (1890), pp. 2–4.

CLARK 1984. T. J. Clark. *The Painting of Modern Life: Paris in the Art of Manet and His Followers*. New York, 1984.

COQUIOT 1924. Gustave Coquiot. *Seurat*. Paris, [1924].

COURTHION 1968. Pierre Courthion. *Georges Seurat*. New York, 1968.

DORRA AND REWALD 1959. Henri Dorra and John Rewald. *Seurat: L'Oeuvre peint, biographie, et catalogue critique*. Paris, 1959.

FENEON 1886. Félix Fénéon. "Les Impressionnistes en 1886 (VIIIᵉ exposition impressionniste)." *La Vogue* (June 13–20, 1886), p. 261–75.

FENEON 1966. Félix Fénéon. *Félix Fénéon: Au-delà de l'impressionnisme*. Ed. by Françoise Cachin. Paris, 1966.

FEVRE 1886. H. Fèvre. "L'Exposition des impressionnistes." *La Revue de demain* (May–June 1886), pp. 148–56.

FIEDLER 1984. Inge Fiedler. "Materials Used in Seurat's *La Grande Jatte*, Including Color Changes, and Notes on the Evolution of the Artist's Palette," in the American Institute for Conservation of Historic and Artistic Works, *Preprints* (May 1984), pp. 43–51.

FRANZ AND GROWE 1983. Bielefeld Kunsthalle, and Baden-Baden, Staatliche Kunsthalle. *Georges Seurat: Zeichnungen*. Exh. cat. by Erich Franz and Bernd Growe. English ed.: Erich Franz and Bernd Growe. *Georges Seurat Drawings*. Boston, 1984.

FRY 1926. Roger Fry. "Seurat." In *Transformations*. London, 1926. Reprinted in *Seurat*. Essay by Roger Fry, foreword and notes by Anthony Blunt. London, 1965.

GAGE 1987. John Gage. "The Technique of Seurat: A Reappraisal." *The Art Bulletin* 69, 3 (Sept. 1987), pp. 448–54.

GOLDWATER 1941. R. J. Goldwater. "Some Aspects of the Development of Seurat's Style." *The Art Bulletin* 23 (June 1941), pp. 117–30.

HALPERIN 1970. Joan Ungersma Halperin, ed. *Félix Fénéon. Oeuvres, plus que complèts.* 2 vols. Geneva, 1970.

HALPERIN 1988. Joan Ungersma Halperin. *Félix Fénéon: Aesthete and Anarchist in Fin-de-Siècle Paris.* New Haven and London, 1988.

HAUKE 1961. César de Hauke. *Seurat et son oeuvre.* 2 vols. Paris, 1961.

HERBERT 1962. Robert L. Herbert. *Seurat's Drawings.* London and New York, 1962.

HERBERT 1968. New York, The Solomon R. Guggenheim Museum of Art. *Neo-Impressionism.* Exh. cat. by Robert L. Herbert. New York, 1968.

HERBERT 1970. Robert L. Herbert. "Les Théories de Seurat et le néo-impressionnisme." In *Les Néo-Impressionnistes,* ed. by Jean Sutter. Neuchâtel, 1970. English ed.: "Seurat's Theories." In *The Neo-Impressionists.* Trans. by C. Deliss. Greenwich, Conn., and London, 1970.

HERBERT AND HERBERT 1960. Robert L. Herbert and Eugenia W. Herbert. "Artists and Anarchism: Unpublished Letters of Pissarro, Signac, and Others—I." *The Burlington Magazine* 102, 692 (Nov. 1960), pp. 473–82.

HERMEL 1886. Maurice Hermel. "L'Exposition de peinture de la rue Laffitte." *La France libre,* May 28, 1886, p. 2.

HOMER 1959. William Inness Homer. "Notes on Seurat's Palette." *The Burlington Magazine* 101, 674 (May 1959), pp. 192–93.

HOMER 1970. William Inness Homer. *Seurat and the Science of Painting.* 2d ed. Cambridge, Mass., 1970.

HOUSE 1980. John House. "Meaning in Seurat's Figure Paintings." *Art History* 3, 3 (Sept. 1980), pp. 345–56.

HOUSE 1986. John House. Review of Clark 1984. *The Burlington Magazine* 128, 997 (Apr. 1986), pp. 296–97.

KAHN 1891. Gustave Kahn. "Seurat." *L'Art moderne* 11 (Apr. 5, 1891), pp. 107–10.

KAHN 1971. Gustave Kahn. *The Drawings of Georges Seurat.* Trans. by Stanley Appelbaum. Rev. ed. New York, 1971.

LEE 1987. Alan Lee. "Seurat and Science." *Art History* 10, 2 (June 1987), pp. 203–26.

MINERVINO 1972. Fiorella Minervino. *L'opera completa di Seurat.* Milan, 1972.

MOORE 1886. [George Moore]. "Half-a-Dozen Enthusiasts." *The Bat* (May 25, 1886), pp. 185–86.

NOCHLIN 1966. Linda Nochlin, ed. *Impressionism and Post-Impressionism 1874–1904.* Sources and Documents in the History of Art. Englewood Cliffs, N.J., 1966.

PAULET 1886. Alfred Paulet. "Les Impressionnistes." *Paris* (June 5, 1886), p. 2.

REWALD 1943. John Rewald. *Georges Seurat.* New York, 1943. 2d ed.: New York, 1946. French ed.: *Georges Seurat.* Paris, 1948.

REWALD 1949. John Rewald, ed. "Extraits du journal inédit de Paul Signac, 1, 1894–1895." *Gazette des beaux-arts,* ser. 6, 36, 989–91 (July–Sept. 1949), pp. 97–128. Trans.: "Excerpts from the unpublished journals of Paul Signac, 1, 1894–1895," pp. 166–74.

REWALD 1978. John Rewald. *Post-Impressionism: From van Gogh to Gauguin.* 3d ed. New York, 1978.

RICH 1935. Daniel Catton Rich. *Seurat and the Evolution of "La Grande Jatte."* Chicago, 1935.

RUSSELL 1965. John Russell. *Seurat.* New York and Toronto, 1965.

SAN FRANCISCO 1986. San Francisco, The Fine Arts Museums of San Francisco. *The New Painting: Impressionism 1874–1886.* Exh. cat. directed and coordinated by Charles S. Moffett. 1986.

SCHAPIRO 1935. Meyer Schapiro. "Seurat and 'La Grande Jatte.'" *The Columbia Review* 17, 1 (Nov. 1935), pp. 9–16.

SCHAPIRO 1978. Meyer Schapiro. "Seurat." In *Modern Art: 19th and 20th Centuries.* New York, 1978.

SIGNAC 1891. Un Camarade impressionniste [Paul Signac]. "Impressionnistes et revolutionnaires." *La Révolte* 4, 40 (June 13–19, 1891), p. 4.

SIGNAC 1964. Paul Signac. *D'Eugène Delacroix au néo-impressionnisme.* Miroir d'art series. Intro. and notes by Françoise Cachin. Paris, 1964.

STUCKEY 1984. Charles F. Stuckey. *Seurat.* Madaenas Monographs on the Arts. Mount Vernon, N.Y., 1984.

STUMPEL 1984. Jeroen Stumpel. "The *Grande Jatte,* that patient tapestry," *Simiolus* 14 (1984), pp. 209–24.

THOMSON 1985. Richard Thomson. *Seurat.* Oxford and Salem, N. H., 1985.

VERHAEREN 1891. Emile Verhaeren. "Georges Seurat." *La Société nouvelle* (Apr. 1891), pp. 420–38.

WARD 1986. Martha Ward. "The Eighth Exhibition 1886: Rhetoric of Independence and Innovation." In *San Francisco 1986,* pp. 421–42.

ZERVOS 1928. Christian Zervos. "Un Dimanche à La Grande Jatte et la technique de Seurat." *Cahiers d'art* 3 (1928), pp. 361–75.